C000241318

OXFORD
TOWN AND GOWN

OXFORD
TOWN AND GOWN

PETER COLLISON

AMBERLEY

First published 2011

Amberley Publishing
Cirencester Road, Chalford,
Stroud, Gloucestershire, GL6 8PE

www.amberley-books.com

Copyright © Peter Collison 2011

The right of Peter Collison to be identified as the Author
of this work has been asserted in accordance with the
Copyrights, Designs and Patents Act 1988.

All rights reserved. No part of this book may be reprinted
or reproduced or utilised in any form or by any electronic,
mechanical or other means, now known or hereafter invented,
including photocopying and recording, or in any information
storage or retrieval system, without the permission in writing
from the Publishers.

British Library Cataloguing in Publication Data.
A catalogue record for this book is available from the British Library.

ISBN 978-1-4456-0023-9

Typeset in 10pt on 12pt Sabon LT.
Typesetting and Origination by Amberley Publishing.
Printed in the UK.

CONTENTS

Tables

Maps

Introduction

I explain in Chapter 1 that I ran into a problem of town-gown relations in my first days in Oxford. I reflected on this and looked at its historical context. There seemed good reason to think there might be animosity to the University on the part of local citizens, and to assume too that such animosity might be widespread. Occasionally I raised this question with various dons in Oxford, but got little response. One or two thought that relations with the town might be bad, but there was little concern and little, if any, interest shown in the town at all. So far as they were concerned the town was as remote as Timbuctu. Situations change, of course, and the University today is sufficiently engaged to have a special officer, 'Head of Government and Community Relations', to attend to the local community and related matters. But at the time there was little concern. This was not necessarily how local citizens saw the situation. Their position seemed worth exploring, and when the opportunity arose I conducted a survey to examine the viewpoint and experience of the town. Comparable studies were conducted in Reading and York. The results appear in the following pages.

I have acquired numerous debts in the preparation of this study. Norman Bailey and Gerald Draper of Oxford's Biometry Unit advised me on sampling. My students conducted the interviews in Oxford and Reading with enthusiasm and splendid effect. I am grateful to the Economic and Social Research Council, and its Chief Executive Dr Cyril Smith, for making a grant which made possible the survey in York, and to Len England and Mass Observation who conducted it with exemplary efficiency. Chris Stevens subjected the survey data to further detailed statistical examination. Chelly Halsey, Director of the Department of Social and Administrative Studies (Barnett House), fashioned an atmosphere in the Department which was both socially easy and intellectually stimulating. He also squeezed money from the departmental budget which enabled me to conduct the survey in Reading. I owe heavy debts, although of different kinds, to Graham Fennell, James Millen, and John Kennedy. And I remember with gratitude stimulating conversations on the subject of universities and their various problems with Ahmed Al-Shahi, Kathleen Bell,

Ed Cooney, Norman Dennis, Alan Fox, Ernst Honigmann, Bill Pickering, Harry Powell, and Peter Selman. I am deeply grateful to all. Responsibility for what follows rests entirely with the author, and any shortcomings that remain do so in spite of the help I have received.

Some of the material appearing in Chapter 4 appeared previously in *The Oxford Review of Education*. I am grateful to the Editor and to Routledge for permission to republish. Some of the material in Chapter 10 appeared originally in *Official Architecture and Planning*. I am grateful to the Editor and publisher for permission to republish. I am grateful to Heather Armitage and to Visitoxfordshire for permission to use the photograph which appears on our dust jacket.

It will be convenient at this point to draw attention to some features of the tables. It is common practice to provide at the bottom of columns of percentages the numbers on which the percentages are based. In some cases, where the convenience of the reader dictates, we follow this practice. In others, to simplify the table we leave out the number base altogether. The number base (the number of people successfully interviewed – see Appendix 1) is for Oxford 238; Reading 217; York 292. But in some instances, the number is less. This is the case with sub sets, arising usually because some informants have been 'filtered out' by a question posed earlier in the interview. Attention is drawn to these cases in the text, and/or the relevant number(s) is given in the table.

Peter Collison
University of Newcastle upon Tyne

Jude in Oxford?

We arrived in Oxford in September 1953 to take up a research studentship in sociology. Sociology was little recognised in British universities at that time, and at Oxford there was but one University lecturer in the subject. Anxious both to make his acquaintance and to make a good impression we hastened to attend his first lecture of the academic year. After the lecture we chatted. During the course of the conversation he asked if we would like to help in a research project he was conducting. We agreed eagerly, and went to his office to receive further information from his research assistant. The task was to interview a number of informants in various parts of the city. Furnished with instructions, a list of names and addresses, and a sheaf of questionnaires we set off.

The work went badly. Our informants seemed unusually inaccessible or difficult in one way or another. One man in particular was difficult to get hold of, and it became almost a point of honour that we should capture him. But in spite of many attempts we failed, and in despair we turned to Miss Hope, the assistant on the project, and told her of this particular case. Miss Hope was a person of great charm, and we suggested to her she would succeed in this case where we had failed. She agreed to try.[1]

But even Miss Hope didn't succeed in getting the interview. She had the good fortune, though, to arrive at the house just as our intended informant was leaving to exercise his dog. He allowed her, although with some reluctance, to walk alongside him. Under her influence his attitude softened as the walk progressed. Like many people, our intended informant was happy to talk, particularly if he could talk about himself to an obviously interested listener. And this he did. But there was one thing he would not do. And this was, he made clear, a matter of firm principle. He would have nothing whatsoever to do with the University of Oxford. We had mentioned our connection with the University as part of our initial introduction to informants, explaining who we were and what we were about, and this information we had given to his wife on our first attempt at contact. It had clearly been passed on by the

wife, ensuring that her husband was subsequently 'at work', 'unwell' or otherwise unavailable when we called. Obviously, in the case of this informant our connection with Oxford University ensured that our informant would be unhelpful, and our questions unanswered.

This informant had, he told Miss Hope, left school at fourteen and had been employed subsequently in 'dead-end jobs'. He had come bitterly to regret and resent his lack of higher education, and this was clearly a burden on his mind. He also thought the lack of educational opportunity in society generally to be a great social injustice. Living and working daily under the massive presence of the University was a constant reminder of this injustice, and a chafing of his own personal disappointment. For him, the University had come to symbolise these things, and his attitude to it was entirely hostile. He was resolved to have nothing to do with it or with our survey which he associated, quite properly, with the University.

Reflecting on this case brought to mind Hardy's novel, *Jude the Obscure*.[2] When it appeared in 1895, the book was seen principally as an attack on marriage and was much reviled on that account. A second and important theme in the book is the situation of Jude, a young man with a burning desire for learning and a vocation for the academic life, but without the material means to pursue these ends. Hardy gives a stark and moving depiction of Jude's situation.

After much preparatory study on his own and in the most discouraging circumstances, Jude eventually makes his way to Oxford[3] and spends his first few hours in the city in something of a trance, his whole being suffused with what he feels to be the magic of the University presence. He finds employment in the University in the mason's workshop and this is as close as he gets to the life of learning and scholarship.

> It was not until now, when he found himself on the spot of his enthusiasm, that Jude perceived how far away from the object of that enthusiasm he really was. Only a wall divided him from those happy young contemporaries of his with whom he shared a common mental life; men who had nothing to do from morning till night but to read, mark, learn, and inwardly digest. Only a wall – but what a wall! ... he saw them coming and going also, rubbed shoulders with them, heard their voices, marked their movements ... Yet he was as far from them as if he had been at the antipodes ... He was a young workman in a white blouse, and with stone dust in the creases of his clothes; and in passing him they did not even see him, rather saw through him as through a plane of glass at their familiars beyond. Whatever they were to him, he to them was not on the spot at all ...[4]

Eventually, Jude writes to four heads of colleges whom he thinks might be sympathetic to his situation. The head of Biblioll College is the only one to reply:

I have read your letter with interest; and, judging from your description of your self as a working-man, we venture to think that you will have a much better chance of success in life by remaining in your own sphere and sticking to your trade than by adopting any other course. That, therefore, is what we advise you to do.

Yours faithfully, T. Tetuphenay.[5]

Mr Tetuphenay's reply, brief and to the point, so thoroughly sensible and realistic, and so completely lacking in sympathy and understanding for Jude's position, is, for the reader, heartbreaking. Once more, it illustrates vividly 'the wall' and serves, as H. G. Wells put it, 'as an indictment of the system which closes our … English … universities to what is, and has always been, the noblest material in the intellectual life of this country – the untaught'.[6]

Hardy sends Jude to an early death, still in Oxford, and with his academic ambitions unfulfilled.

In the book, Jude shows no hostility to the University or resentment of the privileged young students, but he is presented, in some ways at any rate, as passive and accepting. The informant we attempted to interview did not share these characteristics, nor had he stirred himself to remedy his educational shortcomings by his own efforts as had Jude; he seemed simply to reside permanently in a state of passive resentment. So he does not present an exact parallel to Hardy's Jude. But reflecting on what he told Miss Hope raised the question of how many people like him were there in the city? Or how many Judes? And, more generally, what were the attitudes of the citizens to the University?

It seemed a question worth exploring, and when the opportunity arose in the early 1960s, we began to conduct pilot interviews in the city preparatory to a systematic survey. This was undertaken in 1964. To provide comparative data, surveys were also conducted in two university cities roughly the same size as Oxford – Reading in 1965 and York in 1967.[7]

Hardy published Jude in 1895, so a seventy-year-old interviewed in our Oxford survey would have been one year old when Jude appeared, and twenty-six when William Morris moved into the motor car industry in a significant way and so began a radical transformation of the city forty-four years before our Oxford study. It hardly needs to be stated that the interval saw some large changes. But the distribution of educational experience which our surveys found seemed still to provide a fruitful ground for the breeding of Judes, or of Jude-like attitudes. Of our Oxford sample, 49 per cent left full-time education by the time they were fourteen, and 66 per cent had left by fifteen. Comparable figures for Reading are 51 per cent, 72 per cent; for York 58 per cent, 79 per cent. In Oxford, 6 per cent left at twenty-one years or later, and may be assumed to have attended university or some institution of higher education. This figure for Reading is 5 per cent, and for York a tiny 1 per cent. Connection with the university system through children was also small. Only 3 per cent of our Oxford

sample had a child who was at, or had been at a university. In both Reading and York this figure was a little below 5 per cent. In each place, this figure for attendance at the local university was less than 1 per cent.

Full-time education is only part of the picture, of course. We asked our informants if they had received education or training subsequently. In Oxford, 35 per cent of the men, and in both Reading and York, 48 per cent of the men reported that they had. In each place the percentage for women was much smaller.

But this may be to miss part at least of what may be called the 'Jude point'. 'Education' is a broad term, and the institutions providing it are highly differentiated. There had always been something special about a *university* education, and something special again about Oxford (and Cambridge). The continuing controversies about university admissions well illustrate this. Miss Laura Spence, a pupil at a Tyneside comprehensive school, failed to gain admission to Oxford in 2000. Her rejection became the subject of a huge public controversy entered by no less a person than Gordon Brown, then Chancellor of the Exchequer, as well as other prominent figures in government. No other university in the land would do for Miss Spence. She was offered places at other institutions. But it had to be Oxford, and she left the country to pursue studies abroad. It seems for Miss Spence, as for Jude, that an Oxford education was a 'positional' good, something unique and not reproducible elsewhere, or not in her homeland at least. If widely shared, it would seem that this 'positional' characteristic could only serve to increase the frustrations and resentments of those denied access to the University, and further to inflame hostility to it among some, at any rate, of the citizens destined to live in the University's shadow.[8]

There were some small indications about that time which further suggested there might be hostility to the University. Norman Chester, Warden of Nuffield College, himself at one time a city councillor thought, when we mentioned our proposed study to him, that relations at that time between town and gown, 'had never been so bad'. Later, Oxford's Gladstone Professor of Government opined that the University had '… ever since the Middle Ages been regarded by some of the citizens as an excrescence as though they did the University a favour by permitting it to be there'.[9] And there was anxiety in the city about the burden that the colleges placed upon the city's finances, and about special University representation on the city council. A councillor representing a Cowley ward reported his constituents seething with indignation on these matters.[10]

And if a long historical perspective is taken, then it has to be recognised that relations between town and gown were over centuries as bad as they could be. From the beginning of the thirteenth century, there were disputes and frequent violence between the parties. The St Scholastica's Day riots of 1355 were the bloodiest and best known of the battles. Some sixty students were killed and the remainder driven away. Underlying the long conflict may have been a growing anti-clericalism related to changes in the larger society, but even without this there were still fertile grounds locally for conflict. The town was the supplier of goods and services, and

the University was the principal purchaser, so there were disputes over prices and qualities and struggles to gain control of the body charged with determining these matters, as well as more general control of the town's market. Legal jurisdiction was another point of friction. Each party had its own courts, and as these were a source of revenue as well as power and authority each side was eager to extend the scope of its own institutions, and this could be done only at the expense of the other side. Friction in this area may have been further inflamed by the secular courts of the town awarding different sentences from those awarded by the University for what was, or seemed to be, the same offence. There was too the related matter of policing, largely in the hands of the 'proctors', i.e. the University police, who for many years imposed a highly unpopular curfew requiring citizens to be indoors by a certain time at night. The rights of the University to control the streets of the city at night were not completely forgone until 1868.

The town may have enjoyed a triumph in the fighting on St Scholastica's Day, but in every other way it suffered defeat and humiliation. The two arbiters, Crown and Church, decided the issues by supporting the University on all points. The Mayor was required on election to swear to uphold the privileges of the University, and the subordinate position of the town was given further symbolic expression every year by a requirement imposed upon the Mayor and other representatives of the city to attend a Mass in the University Church for the souls of the students killed on St Scholastica's Day, as well as to pay fines. Over the years the University made concessions by modifying the form of this service, as well as in other matters, but it finally gave up all its rights here only in 1825. The University's resistance to industrial development in the nineteenth century,[11] and the suggestion in the twentieth century that the motor car factories be removed from the city[12] might further be thought to leave memories in the public mind little conducive to good relations between town and gown. And some features of the University's special position continued for many years. Until 1948, for example, it was able to elect its own MPs independently of the general franchise, and at the time of our surveys the University still had privileges in respect of local government and taxation[13], but by the time we conducted our studies most of the sharp and acrimonious conflicts of the past were beyond the memory of the living. Subsequent friendly relations were given expression in 1955, when town presented the Vice-Chancellor with the Freedom of the City and the University presented the mayor with an honorary degree. Still, it seems worth remembering that historical events sometimes live in the present. William of Orange remains a powerful name in Ulster, as is Cromwell in Eire. In 1997 a British Prime Minister apologised for the Irish Famine. In 2006 the Archbishop of Canterbury apologised for missionaries who had 'imposed' the Anglican Hymnal on Africa. The Church collectively has apologised for its participation in the slave trade in times past, as has the City of Liverpool. And today the use of the word 'crusade' seems still to be a factor in relations between the West and nations of the Middle East. It seems possible, therefore, to imagine that the collective unconscious in Oxford might contain some

traces of the past, and if these are rehearsed, perhaps before local children in school history lessons, then it seems not entirely fanciful to assume that some awareness of Oxford's past might be active in her present.

Quite apart from the historical record, common sense suggested continuing points of friction. Many of the citizens, it seemed, must resent the flood of young students who poured into their city from elsewhere each autumn. Many, if not most of them, public school boys, large, well fed, well-off, confident and brash. Here is a butcher's son from Leeds describing his first contact with a group attending for entrance exams at a Cambridge college – 'That weekend was the first time I had come across public school boys in the mass and I was appalled. They were loud, self-confident and all seemed to know one another, shouting down the table to prove it while also being shockingly greedy … Unabashed by the imposing surroundings in which they found themselves … these boys hogged the bread, they slurped the soup and bolted whatever was put on their plates with medieval abandon. Public school they might be, but they were louts'.[14] And the 'public school' behaviour was not restricted to college confines. We were astonished, on a Guy Fawkes Night in the early 1950s, to find the Randolph Hotel in the middle of Oxford invested by a mob of hooting and swaying students filling the whole of Beaumont Street from Worcester College to the Martyrs Memorial. The occasion seemed, though, to attract little official attention. There were no police vans, sirens, or dogs and if there was a police presence at all it was discreet to the point of invisibility. And here is J. R. R. Tolkein recollecting a 'not untypical evening's entertainment':

> At ten to nine we heard a distant roar of voices and knew that there was something on foot so we dashed out of college and were in the thick of the fun for two hours. We ragged the town and the police and the proctors all together for about an hour. Geoffrey and I captured a bus and drove it up to Cornmarket making various unearthly noises followed by a mad crowd of mingled varsity and townees. It was chockfull of undergrads before it reached Carfax. There I addressed a few sterling words to a huge mob before descending and removing to … the Martyrs Memorial where I addressed the crowd again. There were no disciplinary consequences of all this![15]

This aspect of student life is epitomised by the Bullingdon Club,[16] and it does seem to give offence - to some at any rate.[17] Roy Hattersley,[18] when asked whether David Cameron, the Tory Party leader, would be damaged by allegations of drug taking, thought that those allegations would leave his reputation quite untouched, but that pictures of him posing as a member of the Bullingdon Club would offend the public deeply and greatly damage him.[19]

The generous income which many undergraduates enjoyed must also have been contemplated by many local citizens with a trace at least of envy. The average income for adult males in the manufacturing industry in 1900 was £73 p.a., in 1931 it was

£153 p.a. Compton Mackenzie had an allowance of £300 a year in the early 1900s, '… which was what most undergraduates at Magdalen were given'.[20] He still went down with large debts. In the 1920s, it was considered that the minimum an Oxford undergraduate required was £200 a year;[21] Maurice Bowra had a scholarship of £80 together with an allowance of £350.[22] In the 1930s, Angus Wilson had £300 a year to spend in term in addition to all college fees and expenses. He lived 'like a lord'.[23] Also in the 1930s, Maurice Wiggin was at St Catherine's Society, 'the cheapest way of living as a student in Oxford'. He had lodgings and full board in 'a slum' costing £2.9 a week. His parents bought his books and paid his fees, and he had five shillings (60p) a week 'pocket money'. He notes that these costs were a real sacrifice, and came to more than twice as much as the rents of seven properties his mother owned. It hurt him to take the money, but 'on the other hand we were surrounded at Oxford by evidence of another world, a world of wealth, where three pounds meant nothing … In the ambience of Oxford I was one of the poorest of the poor'.[24]

Wiggin's recollections suggest that not all experiences of Oxford have been unalloyed delight. After a brilliant undergraduate career at Glasgow, Ernst Honigmann, the distinguished Shakespearian scholar, went to Oxford where he found himself miserably poor and generally uncomfortable.[25] Professor Hobbs of the London School of Economics, in an interview to celebrate his receipt of an award for helping undergraduates from modest backgrounds, was encouraged by the interviewer to describe his own passage through the educational system, and to dilate on his own background. Apart from an early setback when he failed the eleven-plus test, his passage was reasonably smooth, except for a period in Oxford where he was barred from the Bodleian because, presumably, of his evident working class provenance.[26] Not all the rubs and disappointments relate to money or class. Evelyn Waugh, for whom Oxford was 'all that one dreams', heartily disliked his tutor, a dislike returned in good measure.[27] Kingsley Amis found Lord David Cecil to be negligent and inaccessible as supervisor of his research. 'Oh no, sir. Lord David? Oh, you'd have to get up very early in the morning to get hold of him', chuckled the New College porter as Amis sought to track his supervisor down.[28] And after he had diplomatically negotiated a change of supervisor, the unfortunate Amis found Lord David appointed his examiner. He was failed. And particular aspects of college or University life can give offence. The vicar of the University church in Cambridge preached against college feasts, and although he continued to attend them, he found himself only barely able to do so because of the trouble they occasioned his conscience.[29] But that was Cambridge. Perhaps a more latitudinarian tradition protects Oxford from similar tremors. C. S. Lewis and J. R. R. Tolkein objected to the dandyism and implied homosexuality of University aesthetes, and reacted to it by adopting themselves 'plain, masculine clothing'.[30] On the other side, the historian A. L. Rowse, undoubtedly an aesthete, lay fearful and trembling in his rooms in Christ Church as hearties roistered outside and thumped on his locked door.[31]

Although these discomforts and disappointments do no more than illustrate negative features and experiences that probably accompany life in any institution, they must still feed out into the general population and leave a tarnish on the University's image and leave some, at any rate, persuaded that old Oxford is not all beauty, sweetness and light.

Above I drew attention to Hardy's protest in his novel *Jude the Obscure* at the socially exclusive nature of the University. Hardy's protest is particularly poignant and affecting because his character Jude, by natural ability, temperament and enthusiasm, is ideally suited to the life of scholarship. But in addition to what may be described as the particular Jude case there are, as I have indicated, other circumstances too which could lead one to suppose that there might be hostility to the University in the local community. Several decades after the appearance of *Jude*, Evelyn Waugh presented another picture of the University in his classic *Brideshead Revisited*. In essence, the University portrayed by Waugh was as socially exclusive, and in many ways much the same as it had been in Hardy's time. So it remained until the 1960s, when fundamental shifts in society at large forced change on the University. *Brideshead*, like Hardy's *Jude*, emphases the socially exclusive nature of the University, although for Waugh, unlike Hardy, this is a matter of indifference, perhaps even of congratulation, rather than condemnation.

It cannot be pretended that the above as a whole, or in any of its parts, represents a serious *hypothesis*, that is, a sharply defined proposition embedded in theory and ready to be taken into the field for definitive testing. It is rather a swirl of ideas, impressions and facts which gathered in our mind, and took shape as a curiosity. The following chapters represent an attempt to satisfy this curiosity.[32] But before presenting the material, we must emphasise its historical character. The Britain of the early 1960s, when our Oxford survey was undertaken, has passed away. For British universities, and for Oxford in particular, it was the end of a time, which, in deference to Waugh, we might call the Brideshead period. Established ideas and practices of that time were beginning already to be challenged and changed. The Robbins Report,[33] which set British universities on a new course, appeared in October 1963. Oxford's own Commission of Inquiry published its report in 1966.[34] In retrospect the Brideshead time does seem now to have been rather special, perhaps even odd or peculiar, like a society plucked from the literature of social anthropology. In order to put our material into its historical context, we look in the following chapter at some of the changes which brought the Brideshead time to an end, so that by way of contrast they may serve to highlight the principal features of that now vanished period.

Brideshead, *Farewell!*

There are, broadly, two concepts which have governed the way universities are viewed and treated by society at large, as well as the way they see themselves. One has seen universities as properly busy in the world and contributing greatly to practical matters of one sort and another. The other has seen them as detached from the world, concentrating on scholarship and pure rather than applied science with little concern for practical matters. Clark Kerr in his Godkin Lectures[1] can be taken as representing the first position, rejoicing in the number of lawyers trained in the university law faculty, the numbers of babies delivered in the university teaching hospital and other similar contributions and involvements. The rival concept is probably best illustrated by, or at least attached to, Cardinal Newman.[2] Here, the everyday concerns of the world are largely set aside in the university to leave the mind free for the consideration of more general matters and, so far as students are concerned, the development of civilised behaviour, a balanced judgment, and a well-formed mind which, although not possessed of any particular skill, is capable of acquiring such skills. Neither concept has ever had an absolute hegemony but Newman has been a powerful influence, even though frequently attacked. Kenneth Minogue, for example, notes that, '… from the 17th Century to the 20th, there has been a continuous tradition of attack on the Universities, which takes the form of regretting their isolation from the world, and which despises their "monkish erudition"'[3].

Attacks there may have been, but they were over many years singularly ineffective and for someone of Clerk Kerr's disposition, the detachment of Oxford (and Cambridge) from many of the discoveries that underlay the great changes of the nineteenth century must seem astonishing. Tull, Coke and Bakewell in agriculture, Arkwright, Hargreaves and Cartwright in spinning and weaving, Trevithick, the Stephensons and Brunel in engineering and Priestly, Faraday and Tyndall in science owed little or nothing to the universities. But these men were largely concerned with practical and commercial matters and under the Newman philosophy it was

to be expected and quite proper that the universities would have little or no concern for them. The great mathematician Hardy, who occupied chairs at various times at both Oxford and Cambridge, was more than content to declare towards the end of his life that he had never done anything useful.[4] Lord Rutherford thought that atomic energy was of no value commercially, and was unlikely ever to be so.[5] In this tradition Howard Florey, leader of the Oxford team which discovered the clinical properties of penicillin, discoveries with huge commercial potential, declined to take out patents on its discoveries[6] and shunned publicity.[7] Perhaps the greatest tribute to Newman's notion of academic detachment was the University Grants Committee. It was created in 1919. The purpose of the committee was to channel public money to the universities. It reported directly to the Treasury, by-passing other branches of government, including the Ministry of Education. The committee advised the Treasury as to the universities' requirements, and the Treasury, in the light of this advice and no doubt with an eye on the proper use of public money, made a grant which the committee then distributed to the universities. Delegations from the committee visited each university at five-year intervals, and grants were made for the same five-year period. Altogether it was the lightest form of control compatible with a degree of concern for the public purse, and must be as far as can be imagined for any government to go to guarantee university autonomy and academic freedom. Oxford received its first public money in 1922, and Oxford and Cambridge were formally incorporated into the UGC system in 1925.

Nor does there seem to have been much interest outside government circles to breach academic detachment and to draw the universities into the mainstream, nor to exploit the commercial advantages that a university might bring, so far, at any rate, as that interest can be judged by willingness to back it with money. The idea for a university institution in Brighton was bruited as early as 1855, a committee was formed in 1907 to appeal for an endowment fund of £250,000, and a large public meeting in 1911 passed a resolution in favour of a college, possibly affiliated to London University. By 1914, no more than a sixth of the proposed endowment fund had been raised. Another appeal failed in the 1920s, and an approach to the government in 1948 met with a 'cool' response.[8] A delegation seeking funds from the government for Southampton in 1910 was scolded by Lloyd George for failing to raise funds locally,[9] and an appeal for funds inaugurated in 1920 hardly got under way at all.[10] An appeal in Sheffield in 1884 for money for technical education raised less than £5,000, and of this, £3,000 was provided by the Duke of Norfolk.[11] The particular exigencies of war did something to change the situation after 1914. A stream of requests for help came, for example, from local industry to Sheffield University, and a committee was formed to deal with these requests. One result was the establishment of a delegacy for training and research consultancy for the glass bottle industry. Within a few years most glass manufacturers in the country were subscribing to the delegacy.[12] The Second World War produced dramatic demonstrations of the importance of science and universities. Fundamental work in physics over many years created a basis from

which Watson-Watt was enabled to develop radar, which was an essential element in defence against the Axis forces. The creation of the first nuclear chain reaction by Szilard and Fermi at the University of Chicago opened the way to the manufacture of the atomic bomb, and the subsequent use of the bomb broke the Japanese war effort and ended the war. These and other developments pressed upon politicians and society at large the importance of science for defence and, in turn, of the universities where scientists were trained, and where most of them worked. Although these events weakened the Newman ideal of detachment, they did not destroy it, at least not in this country.[13] At the end of the Second World War Bruce Truscott, in an influential book, advised, '… we ought to regard with suspicion the demand that the University should be continually thinking of "society" … supplying experts to local industries, taking part in local activities and the like'.[14] And the Association of University Teachers, in reports issued towards the end of the war, thought, 'The growing tendency of industries and individual firms to subsidise ad hoc research in universities of their own particular problems ought to be resisted …'.[15]

So far as the university's local community was concerned, the situation was also one of university separation, tempered by the fact that the university was dependent on the local community for services of various kinds. But given the central interests of the university, scholarship, and science, there could be little common ground with the local population. The university world was esoteric, and to enter it required a level of education beyond that possessed by most local people, given a school leaving age of fourteen years until 1947, when it was raised to fifteen years and where it stood at the time of our studies.[16] As Edward Shils put it, 'Only a very small part of what is studied, taught and investigated in a university refers to the locality, and when it does it refers to it … as an instance of a more general class of phenomena which exists beyond the local community'.[17]

Separation was epitomised in Oxford by the college architecture. Typically the colleges were enclosed spaces, walled and entered only through portered gates. They gave the appearance of 'total institutions',[18] maintaining largely impermeable boundaries against life outside, and with a distinct life of their own within their walls. Given the particular concerns of the University, and the fact that these concerns could not be shared, this separation would arise in a way that can be described as natural, and would not require any special provision to maintain it. This could be true even for those with a close family connection with the University. For one University wife, for example, '… the University seemed an almost impenetrable fortress, a phalanx of imposing buildings where important-looking men passed to and fro in gowns, and where Ronald (her husband) disappeared to work each day'.[19]

But in addition to science and scholarship, the university had another major concern – its undergraduates. They presented a particular problem. Typically they were young people in late adolescence, away for the first time from the close supervision of home and school, and still short of the age, twenty-one years, when they could be regarded as fully responsible adults. Lacking experience of life and

the judgement that this can bring, and at the height of their energies and appetite for life, they were vulnerable to a variety of temptations. To meet this situation, and the understandable concern of parents, the university adopted a guardian role by placing itself *in loco parentis* and its students *in statu pupillari*. In Oxford, each college had a dean responsible for discipline. Students were allocated a 'moral' tutor, whose concern was the conduct and general well being of his charges as distinct from concern about academic studies, although in practice the two areas obviously overlapped. In addition, the university in Oxford elected from among the dons proctors to oversee discipline generally, to adjudicate in matters of discipline. and with the power to impose fines and other penalties. The physical enclosure of the colleges meant that students could be confined and their comings and goings monitored. Further, college provision, in the nature of total institutions, provided for a wide range of activities and requirements. Students lived in college. College kitchens provided meals, and servants provided personal services. There were college libraries, chapels and chaplains, studies and lecture rooms. Internal arrangements fostered in-college friendships, and this was enhanced by college groups for various leisure and academic activities. Sport was important, both because it brought college members together to play and because rivalry between colleges magnified the college image and intensified personal relations within the institution. Ritual of one sort and another expressed and further fostered college identity and importance. These arrangements had the effect of concentrating student life in the college where the desired influences, intellectual, moral and spiritual, could be brought to bear, and other influences reduced or removed altogether. As one Oxford don observed, 'The very core of Oxford life is the internal life of the College ...'[20]

But colleges were not prisons. Many students lived out of college in lodgings. And students resident in college were allowed to go and, in fact, had to go, for one reason or another, out of college and into the local community. University authorities attempted, therefore, to manage student behaviour outside college, and to shelter students from undesirable contacts by regulation and the policing of these regulations.

Looking at these regulations today is to look into another world. At Reading[21] in 1921, a male student wishing to take a female student for a walk had to ask permission from the girl's warden of hall. Permission would be granted at the warden's discretion, and then only if the warden were satisfied that the privilege would not be abused. In 1926 students were not permitted to leave Reading in term time, and not permitted to enter it in vacation. Permission was required to possess a motor vehicle, and some local institutions were out of bounds. In 1930 the rules at Wantage Hall for men required the gate to be closed at 9 p.m., after which no student was permitted to leave. Students coming in after 9 p.m. had their names taken and were reported to the warden. No one was allowed in after 11 p.m. In 1932 women were not allowed to be absent from hall after dinner without permission, although senior students could be granted leave to be out until 10.30 p.m. for a limited number of nights each term.

In 1975 all students under twenty-one were required to spend their first year in hall, although by that time the hall was not locked until midnight and, anyway, students were permitted to have keys. In Oxford, students matriculating in 1953 were given an eleven-page pamphlet setting out the rules they were to observe[22]. Academic dress (cap and gown) was to be worn at lectures and certain other occasions, and dress altogether was specified in some detail for both men and women at examinations and the matriculation ceremony. Dances, dancing, parties, entertainments and acting, public meetings, flying, loitering and the 'frequenting of places where undesirable acquaintances are likely to be made' all came under the University's purview. Motor cars were controlled, and where permission was given to keep one the owner had to fix a green light to the front nearside of the vehicle, and to ensure that it was illumined after dark. Part three of section sixteen of the rules read:

> A man undergraduate may not receive into or entertain in his lodgings after 10 p.m. a woman, whether a member of the University or not, except by special leave of the Dean of his College. A woman undergraduate may not receive into or entertain in her lodgings after the beginning of Hall Dinner, or such other time as may be fixed by her College, a man, whether a member of the University or not, except by special leave of the Principal of her college.

After 1945, ex-service men and women streamed back to the universities, their numbers peaking in the period 1947-50. It seems doubtful if ex-service men, having served in the forces for years and possibly commanded men in action ('Ex-majors with MCs, wives and moustaches ...'[23]), would have been altogether amenable to regulation, and although formally in force, regulations were widely disregarded.

After the tide of ex-service students receded, student numbers in the university system as a whole stood at some 90,000, rather less than twice the pre-war figure. Numbers then fell back slightly until 1956. At the Home Universities Conference in December 1955, it was assumed by some, at any rate, that the system as a whole would stabilise at about 90,000 students, and with most of its earlier characteristics restored where they did not still remain intact.

Any such assumptions were swept away by changes on the world scene. The growing interest in science, and in universities generally, occasioned by the Second World War was given a further impetus in 1957, when the Russians launched Sputnik into space. Sitting confidently upon many earlier triumphs, Britain and the West generally imagined that the Soviet Union, its Cold War rival, could never match it in the field of science. It was supported in this view by the idea that science could properly flourish only in a liberal democratic society, and that science in the Soviet Union, by contrast, must be hampered if not suffocated by its subordination to Marxism, the official ideology. If proof were required, it came with the Lysenko controversy in which Lysenko, a false or mistaken scientist according to the West, but whose work conformed to Communist ideology, had his work accepted and

lauded by the Soviets while his rival Vavilov, an orthodox scientist admired in the West, disappeared into the Gulag or beyond. Of course, Soviet scientists made an atomic bomb too, and they made it sooner than western experts had thought possible. But this success could be attributed plausibly to Soviet superiority in spying rather than to excellence in science. No such comfort was available in 1957, when Sputnik soared. Here the Soviets were ahead of the West, so the achievement had to be one of Soviet science, and not something stolen from the West by espionage. The Soviet leader Khrushchev flaunted this success, and teased the West by loudly inviting competition in space, so in addition to defence the matter had huge propaganda relevance too.

These events moved minds, and had an effect on government policy toward universities. In the United States, Arthur S. Fleming, who served as Secretary of the Department of Health, Education and Welfare in Eisenhower's cabinet, noted that after Sputnik there was alarm over the quality of education in science and mathematics, and that Congress in 1958, in response to this alarm, made substantial sums of money available for various initiatives including loans for students and support for graduate programmes.[24] Defence research contracts were concentrated in areas which were 'centres of learning', and commercial firms, too, located in these areas.[25] Impulse to change also came from another direction, with the publication in 1956 of a much-publicised paper which argued that a college education could increase lifetime earnings by $100,000.[26] This suggested that universities had to be seen not simply as an ornament on society, and higher education as no more than personal enrichment, but also as an investment with material returns making individuals and society as a whole richer. There followed a burgeoning of interest among economists, and phrases such as 'human capital' and 'investment in man' soon dotted the literature and the speeches of policy makers.[27] In the light of these events, government policy and attitudes generally to universities changed. In this country, the Robbins Committee was formed in 1961 to study the situation, and to advise as to what should be done.

Lord Robbins presented his report towards the end of 1963. It gave shape and impetus to what was happening anyway. Student numbers in the country as a whole began to rise in the late '50s, reaching more than 118,000 in 1963. By 1990 there were considerably more than 300,000 students, and governments aspired to enrol in university no less than half the relevant age group in each succeeding generation. At the end of the Second World War there were sixteen universities in the country as a whole, together with five university colleges associated with London University. Now new universities were created, and the university colleges associated with London were granted independence. There was reluctance to have the whole of higher education expansion included in the traditional university sector, and some technical colleges were chosen and designated colleges of advanced technology. And Anthony Crosland, in a famous speech in 1965, announced the creation of polytechnics, which were to exist side by side with the universities in a

binary system. These new institutions seem gradually to have undergone a process of 'academic drift', taking on more and more the characteristics of the traditional university and, perhaps inevitably, the colleges of advanced technology were swept into the university sector in 1966, thirty polytechnics following them in 1992.

One result of this expansion was that universities became common, instead of rare features in the environment. By 2007 there were more than a hundred universities in the country, and Secretary of State John Denham in the following year invited towns and cities without a university to enter a bidding competition to be accorded a university. He had in mind as many as twenty new institutions. No less than twenty-six towns took up his invitation. Another result was that university students, too, instead of being rare figures in society came to be met everywhere. Oxford University, which had just over 4,000 students in 1924, and just over 9,000 at the time of our survey in 1964, had over 18,000 in 2008, and in this year Oxford Brookes University, the city's former polytechnic, had nearly 13,000. Altogether, therefore, Oxford was host in that year to some 30,000 university students. Reading University had some 2,000 students at the time of our survey in 1965. In 2008, it had over 10,000. York University in the same year had 11,000. For young people in the population at large a university education became something readily to hand and not, as it had been for Hardy's Jude and for most people up to the 1960s, something distant and almost mystical, reserved to a privileged few.

In Oxford, the increase in numbers had an effect on college life. Accommodation previously spacious became cramped, and less domestic and intimate in character. Brasenose grew from 140 undergraduates to 340 in the decades following the Second World War, and the median size of men's colleges grew to 325. The number of fellows at high table at University College grew from thirteen to thirty-five. At Keble it grew from nine to thirty-five. Suites of rooms were converted to bed-sits.[28] The composition of the student body changed. Increased public financial support for students permitted more to enter Oxford. Competition for places, almost unknown before 1945, grew and entry came to be determined almost solely on academic criteria. Handsome actors and powerful oarsmen had at least to match prowess on the boards or on the river by performance in the examination hall before the door was opened to them. Internally, the results of final examinations were published in the 'Norrington Report' league table, focussing attention on academic achievement, and sharpening competition in this area between the colleges. The great safety net of fourth class honours was abolished altogether in 1975.[29] The number of postgraduate students increased until, in the first decade of the twenty-first century, they constituted in Oxford University rather more than a third of the student body. The numbers of 'grey men' in college grew inevitably.

The number of scientists increased dramatically. This was important for colleges, since the working life of the scientist lay outside college and in the laboratory. The tension between arts tutors in the colleges and the dons who were scientists, or whose work lay outside the main undergraduate courses, grew until the middle 1960s,

when it exploded in protest by the scientists, resulting in the creation of three new graduate colleges for those previously outside the college system, or their admission into existing colleges.

The increasing size and cost to the public purse of the university system, together with a growing recognition of the importance of education and research, meant that government had to take a closer interest in what the universities were doing. The system whereby intending students applied to each university separately began to look uneconomic, and after enquiries a national body, the Universities Central Council on Admissions, was created to manage a centralised system. Oxford was drawn into this system in 1965. This meant that the colleges' control of admissions had eventually to be lost, and the special college entrance examinations abandoned. The position of the colleges was further weakened by the increasing importance of state money which went to the University, leaving the colleges as poor relations. Colleges also sat uneasily in relation to the growing emphasis on research and the increasing demands which research made in time and effort. Departments were created in deference to this new emphasis and became of rising importance, with a consequent decline in the importance of the colleges.

The University Grants Committee became rather less a buffer between the government and the universities, and more an instrument of government policy. This movement was accelerated when the country ran into economic difficulties in the 1970s. The quinquennial planning arrangements were replaced by annual or ad hoc arrangements, or by block grants. Sharp economies were imposed on the total university budget by the Conservative governments of Mrs Thatcher, and the University Grants Committee was required to decide how to differentiate between competing institutions in distributing the reduced budget. The University Grants Committee was eventually abolished altogether and replaced by a new Universities Funding Council. Departments in universities were subject to inspection and graded, research activity was assessed, and altogether a sharper and more closely supervised discipline was imposed from the centre by government. Significantly, university tenure, which meant that a university teacher, once having survived a short probationary period, was virtually free from any threat of dismissal, was abolished. Concerned about the efficiency of British business, the government set up a committee under Lord Franks to look at the question of management training; Franks recommended a number of new business schools, with a principal school at London University and another at Manchester University. The proposal was adopted, and many universities followed Franks' lead and entered the field of business and management training. Oxford, although with reluctance in some quarters, accepted a huge private donation to found, in 1996, its own Said Business School. Subsequently it regularly published advertisements in the press offering its services to business and commerce, thereby marking a departure from the old Newman ideas.

These policy initiatives by government pulled universities in the direction of a standard pattern, directed and disciplined from the centre. Oxford, too, was pulled

in the same direction. Its philosophy and practice, which we have associated with Newman, were modified at least, and its famous collegiate system was weakened. It might even be asked whether the colleges, apart from the architecture, were, by the twenty-first century, much more than the standard hall of residence found everywhere in the national system.

Apart from changes coming largely from government policy, there were also changes in society at large which had implications for the universities. The shortages of the war and the post-war years began, during the later 1950s, to be replaced by a new amplitude which, apart from other effects, opened worlds previously closed. Car ownership spread widely through society, cheap flights, package holidays and television extended experiences, once the preserve of the middle class, to all levels. Subsequently, computers and the internet gave ready access to information previously inaccessible to all but a few. Rising incomes, full employment, health and social services, the replacement of heavy manual labour by machines, and a rising school leaving age served to move the great majority of people in the town in the direction of the middle-class university. The disappearance of the domestic servant, the relative decline of the university teachers' income,[30] and the absolute decline in his conditions of work, together with the huge increase in his numbers moved the university teacher in the direction of the town population.

The age group from which students are principally recruited underwent a change with the appearance of a 'youth culture'. New styles in dress and music emerged, and were widely diffused through the media and advertising until they came to encompass all young people. University students, instead of standing apart as previously with distinct styles, embraced the new culture with enthusiasm. The working class was redefined as something to identify with. Academic gowns disappeared, and donkey jackets, bovver boots and denims were widely adopted. In this new uniform of youth the university student was no longer distinguishable from his age peers.

Following the Latey Report of 1967, the age of responsibility was reduced from twenty-one to eighteen. For universities and their host towns this meant that undergraduates could for the first time appear on the electoral roll, and be involved directly in the political process. For universities, their students could claim now to be treated as fully responsible adults rather than being *in statu pupillari*. The university claim to be *in loco parentis* to undergraduates collapsed, and the responsibilities associated with the claim took on a new character, if they continued at all. Many of the regulations imposed on students were designed to prevent or control association with the opposite sex. This made sense, since these associations could have disastrous consequences such as unexpected and unwanted pregnancies. While at Oxford Kingsley Amis and his fiancée found themselves with an unexpected pregnancy, and took steps to arrange an abortion, illegal and expensive at the time.[31] They decided eventually not to have the abortion, but to marry instead. The position changed when the contraceptive pill was discovered in the 1950s, and made available on the NHS in 1961. Abortion was made legal, and also made available on the NHS. Antibiotics

removed much of the fear of what were then known as venereal diseases. Medical discoveries and legal changes, therefore, together introduced a new time unlike anything seen in society previously. In this new time, many of the old university regulations and assumptions began to look outdated. Adventurous spirits began to ask if it were even necessary to have men and women segregated in separate halls and colleges. Feminism appeared, and the old gender imbalance in the student body and among dons was entirely upset. From the late 1960s, many regulations were abandoned or allowed to fall into disuse, and segregation disappeared from one institution after another.[32]

The 1960s is a decade famous for protests against the existing order. A journalist, Henry Fairlie, in a magazine article in 1955 suggested there was an 'establishment' of interlocking social circles at the head of the major institutions of British society. Fairlie's concept was developed in a subsequent book[33] and the idea of an establishment was taken up everywhere, and the establishment itself became the object of attack and derision in all its parts. Politicians and other public figures began to be treated with less than respect by interviewers in the media. A new style of satirical comedy became popular, and served to pull down the icons of the past. In one famous show, *Beyond the Fringe*, a talented and successful performer presented a young Second World War pilot not as an hero, but as a bumbling, immature idiot, a Colonel Blimp in the making. This sort of assault on the establishment and its symbols delighted and thrilled the young in the 1960s.

The universities could not expect to escape the general assault. Protests and demonstrations occurred at universities in California in the early 1960s, and spread to many parts of the world. The first outbreak in this country was at the London School of Economics, and was followed by outbreaks throughout the country. The outbreaks received much publicity. No campus escaped. There were rent strikes at Reading, the Clarendon Building in Oxford was occupied, and All Souls was invested by the Oxford Revolutionary Socialist Students. The protest movement continued until the early 1970s, when it departed as suddenly as it had come. The student protests of that time had considerable effect on the internal situation in universities, and staff–student relations were never the same again. But the particular concern in our context must be what, if any, were the consequences for relations between universities and their local communities?

The new protests were different from the old student larks and rags. They were nationwide, and were overtly political. When the Oxford Revolutionary Socialist Students invested All Souls they expressed the hope that the town would join them, and in a petition to the Vice-Chancellor they demanded the town be given free access to the University libraries and playing fields.[34] The new protests were also institutionally purposeful in demanding changes in university structures and procedures. It might be imagined, too, that in the view of many of the older generation the new protests would seem violent and altogether uglier than anything seen previously.

Our study in York[35] was undertaken shortly after the student turbulence appeared there. Although the incidences were widely reported in the local press, they seemed, so far as our survey and experience went, to have had little effect on local opinion. Students were, we found, well regarded and encompassed in a warm and protective attitude which, for the middle-aged and elderly, embraced at that time all young people. Further, incidents at York and elsewhere mostly took place on campus, away from the public gaze, and away from places where they could cause general inconvenience. To the disappointment of the Revolutionary Students, the citizens of Oxford ignored the invitation to join in the assault on All Souls. And it is said that London bus drivers pulling up at stops adjacent to the London School of Economics at the time of the student disturbances would announce arrival to their passengers by shouting, 'London School of *Comics!*' This seems nicely to sum up the attitude of local people in our three cities and, perhaps, in the country at large too. We suggest that the outbreaks in the late 1960s were generally regarded with the amused tolerance that had always been extended to student rags and larks.

Although students may still have been regarded tolerantly, the university system from Robbins in 1963 and Franks in 1966 began, as we have indicated, to change, and to move away from the old Newman pattern and ideal. Universities became larger and more numerous, and a university education something experienced by many more. Universities ceased to be separated from the world but became increasingly engaged in it, a vital part of the 'knowledge industry' on which it is now widely recognised the country's fortunes depend. And universities are now closely monitored by government and run increasingly to a standard pattern. Research is now emphasised, universities are highly competitive one with another, and run increasingly like commercial businesses, cost conscious and seeking keenly to attract students and contracts. Students, paying fees, are more like customers now, and can be expected increasingly to behave as such.

Our studies reflect a different world. We call it the Brideshead time. Although beginning to change, that world was still substantially intact. The universities then were few in number, comparatively small, generously financed, secure, sitting comfortably at the margins of society, and left to do very much what they chose themselves to do, and to do it in their own way. For students, they were a never-never land in which they spent three years, funded from the public purse, largely without responsibility, finding and developing interests, looked after by an indulgent institution, with examinations the only cloud in their sky. In the following chapters, we looked at the relations of our three communities with their universities at the end of this Brideshead time. We can only speculate as to how these relations may have changed following the large changes both in universities and in society which we sketch above.

CHAPTER 3

Awareness

Generally, there seems to have been little popular interest in the universities, or even awareness of them, until the early 1960s. A poll conducted by Gallup in 1960 asked a sample in England, Scotland and Wales how many English universities they could name. Nine per cent failed to name any at all. Oxford and Cambridge were each named by 82 per cent and the remainder by various proportions. London University, for example, was named by 50 per cent, Manchester by 33 per cent, Bristol by 26 per cent, Durham by 21 per cent, Exeter by 10 per cent, Reading by 8 per cent and Keele University, with the lowest proportion, by only 1 per cent. The *Daily Mail* and the *Daily Express* appointed their first university correspondents as late as 1963.[1] Paying a visit to Reading University before our survey commenced, we took the opportunity to ask a group of social scientists what they thought the prospects of our proposed study were. The general opinion was that we would find a great part of the local population unaware even of the University's existence.[2] One person illustrated this by claiming that on arriving at Reading station for the first time, he had been unable to find anyone able even to point him in the general direction of the University.[3] In fact, we found no one in our Reading pilot enquiries who was unaware of Reading University, but, not wishing to assume too much, we commenced the full survey interviews in Reading and York by asking informants if they had heard of the local university.[4] In Oxford we assumed that everyone would have heard of the University. In Reading 99 per cent, and in York 98 per cent, declared they had heard of their local university. Put in another way, there was in each of these two places roughly a thousand residents who claimed to be unaware of the local institution. Of the eight 'unaware' people, seven were women, most of them elderly. The one man was a migrant labourer in Reading who seemed to have little local connection or knowledge.

We also asked informants where the university was located. In Reading 93 per cent, and in York 89 per cent, gave the correct answer. 'Correct' was interpreted broadly. In Reading there were two principal locations – London Road and Whiteknights Park. Either or both was taken as a correct answer. In York the University commenced life

in Kings Manor, a building in the centre of the city, and it had also a number of other properties as well as its principal site at Heslington. A mention of any or all of these places or properties was taken as evidence that the respondent knew the University's location.

Taking a different approach to 'awareness', we asked for the name of the Vice-Chancellor. From almost every viewpoint the Vice-Chancellor[5] is the most visible, if not the most important, figure in the university. His role forms part of every piece of administrative machinery, he is the principal spokesman for the university when it addresses the outside world, and he is always a prominent, if not the central, figure on occasions of academic ceremony. So far as any one figure identifies the university, it is its Vice-Chancellor. In Reading this office was held by Mr H. R. Pitt, and in York by Lord James of Rusholme. Pitt was installed only in 1964, the year before the survey, so in Reading we asked for the name of the present or the former Vice-Chancellor. Pitt's predecessor was Sir John Wolfenden.

In Reading 39 per cent named Pitt or Wolfenden, or both; in York 27 per cent named James.[6] This might suggest the Vice-Chancellor is more visible in Reading than in York. But for Reading, either or both of two names constituted an acceptable answer, whereas in York there was one only. And the effect of accepting 'Wolfenden' as an answer was considerable, because he was the person mentioned in replies. Pitt was little known.

Wolfenden was in office in Reading for thirteen years, and was a well-known national figure. Before Reading he had been headmaster at Shrewsbury, and before that headmaster at Uppingham. He was knighted in 1956, and became chairman of the University Grants Committee in 1963. But from comments gathered by our interviewers, it was obvious his name had lodged in the public mind principally because he was regarded as the author of the Wolfenden Report.[7] This was a report of a government committee on homosexuality and prostitution. Wolfenden was chairman of the committee.

James was appointed to York in 1961, and took up the post in 1962. He had been in office for five years at the time of our survey. Previous to York, he had been High Master of Manchester Grammar School for seventeen years, and had become known as a broadcaster and a controversialist in educational matters. He was created Life Peer in 1959. The establishment of the University was a large event in the life of York, and it was featured heavily in the local media, as was its first principal officer, so it might be thought that Lord James would have been impressed on the public mind more widely than our survey results suggest he had been.

A reading of the York press indicated that the appointment of professors attracted interest, and that the incoming professors were seen as potential 'personalities' in the community. Accordingly, we asked York informants to tell us the names of all the professors they had heard of at the University. At least one name was given by 11 per cent, and 4 per cent gave two or more. A further 7 per cent gave the names of people on the academic staff, but not in the rank of professor. For people outside the university distinctions of academic rank are probably of little consequence, even if they are aware of them. So, stretching the notion of 'correct answer', we may say that 18 per cent of our York sample was able to give a positive answer to this question.[8]

A survey conducted in Sydney, Australia, found 93 per cent of the population reporting some awareness of Sydney University.[9] This figure seems high, given that Sydney had a population of some two million. A national survey completed just before our Oxford study found 50.1 per cent able to name their local MP.[10] Further comparisons may be provided by a study[11] carried out into local government in England and Wales in 1965. It found 35 per cent of the population of county boroughs able to name the local mayor and 6 per cent in other areas able to name the chairman of their county council.[12] In county boroughs, 98 per cent knew where their council offices were located, although this figure was only 83 per cent for rural districts.[13] County boroughs varied in size and character, and our two areas, Reading and York, may not be typical. But so far as our results go, it seems that the proportion of the population able at that time to name the Vice-Chancellor of the local university was of the same order as that able to name the mayor. Most of the population knew where both the town hall and the university were located, although the figure was slightly higher for the town hall.

To explore another dimension, we asked respondents if they thought their local university was especially noted for any particular branch of research[14] or teaching. Since York was so recently established, we invited informants to include also in their answers fields in which they thought the University would be noted in the future. At Reading 49 per cent said 'yes' to this question and 48 per cent 'no', the remainder replying 'don't know'. At York comparable figures were 30 per cent and 51 per cent, with 19 per cent saying 'don't know'. We then asked those who had replied 'yes' to tell us what these branches were. Table 3.1 provides a summary of the replies.

Table 3.1 (per cent)
Fields of Distinction

What would you say are the branches of research or teaching for which the University is (will be) especially noted?

	Reading	York
Agriculture	68	0
Dairying	20	0
Science/Technology	11	44
Arts/Letters	9	0
Horticulture	7	0
Physics	4	10
Music	0	10
Chemistry	3	0
English	0	8
Other	8	47

It is important to note that this question was put only to those who had indicated in reply to the previous question that they thought that the university was noted for one or more branches of research or teaching. Thus, the 68 per cent replying 'Agriculture' for Reading represents only about one third of the total sample. The other point to note is that some respondents were able, and sometimes did, mention more than one branch.

For people engaged in university education, the salience of agriculture and related disciplines shown in the Table 3.1 for Reading will occasion no surprise, but the high degree of awareness among the local citizens may be thought surprising. Other fields seem not to have made an impression comparable to that of agriculture, although 11 per cent mentioned science and/or technology in a general way, and 9 per cent made a general reference to arts and/or letters. At York 44 per cent referred to science and/or technology without mentioning any specific area. Physics and music were each mentioned by 10 per cent and English by 8 per cent. There were in addition a number (47 per cent) of other references, although none was mentioned by a significantly large number. York University established early on an Institute of Historical Research and an Institute of Advanced Architectural Studies, although by the time of our surveys these areas seem not to have made an impression on the local mind.

At York we asked in addition how many students there were currently at the University and then how many students it was planned to take when the University was completed. These questions are particularly relevant in the case of an entirely new university where planners are unencumbered by an existing situation and where they can, in theory at any rate, imagine an institution of almost any size. With the creation of many new institutions from the early 1960s there was much discussion of the ideal size for a university. Size is also a matter of concern for the local community. The larger the size the greater the impact, whether positive or negative, the new institution is going to have.

Table 3.2 (per cent)
York: Estimates of Student Population

How many students do you think there are at present at York University?
How many students is it planned to take when completed in the early seventies?

Number of Students	At Present	When Completed
−1250	58	28
1251–1750	6*	4
1751–2750	13	13
2751–3250	7	11*
3251–5251	5	23
DK	11	21

There were 1,657 students at the time of the survey, so 6 per cent (*) may be considered as having given the right answer or something close to it.

In the matter of future student populations, no figure can be described as a correct answer, so it is not surprising that 20 per cent replied 'don't know' (DK). At the time of the survey Lord James thought that 3,000 students was the largest number that should be taken, and if numbers were to exceed this then an entirely new and separate university should be created.[15] It is evident that 11 per cent (*) of our sample accepted Lord James's figure or something close to it. A higher figure was given by 23 per cent, and of these 11 per cent thought the figure would exceed 5,000. Events were to prove these higher figures closer to what in the future came about. It is striking that more than half the respondents underestimated the size the student population had already reached at the time they were interviewed, and more than a quarter (28 per cent) thought that the eventual ceiling for the student population would be only a little more or less than 1,000.

In many circumstances, people do not think in precise numerical terms. Often notions such as 'big' or 'small', or 'bigger than' or 'smaller than' something or other are used. It may be, too, that as numbers become larger so they become increasingly remote from everyday experience. We presented no categories to informants and recorded simply the number given, so there was no indication of possible parameters. Altogether we find it surprising that so many of our interviewees were prepared to give us numbers at all, and that the numbers they gave were as 'realistic' as they were.

We noted above that before embarking on our Reading survey, we took the opportunity of a visit to Reading University to ask a group of academics what they thought the prospects of our study were. The general view was that we would find large numbers of the local population unaware even of the University's existence. This, as it turned out, was not our experience. But there was substance in the observation. Our findings suggest that Reading University sat more distantly in its home town than the other two institutions. If we look at the answers to the questions[16] in which we pressed our subjects to tell us the particular ways in which the university made their city a better place in which to live, only 26 per cent in Reading, as opposed to 38 per cent in York, gave one or more instances. When we put the same question on the civic instead of the personal dimension, comparable figures were: Reading 52 per cent, York 81 per cent. When we raised the question of the disadvantages the presence of the university occasioned the town, again many fewer in Reading than in York mentioned particular items. And the replies to other questions throughout the survey show a relatively large proportion of Reading respondents falling in the DK category. If comparisons are made between Reading and Oxford, Reading emerges again as having generally relatively large numbers in the DK category, suggesting once more that it sat more distantly in its town environment. But given the facts of history and of relative size, this Oxford–Reading difference, unlike the Reading–York difference, was to be expected. But our findings do not indicate that

Reading people were unaware of their University. Virtually the whole population had heard of, and had seen the Reading student rag. About a third of the Reading sample was aware of their University's distinction in agricultural studies. Many had been in Whiteknights Park and had views on the architectural merits of the buildings there, and more than a third had been in University buildings other than those in Whiteknights Park. Our findings suggest that the impact of the University was less overall in Reading, perhaps more concentrated on particular features and that awareness of the University in consequence sat differently in the minds of local Reading people.

But it would be surprising if there were no differences. Universities vary one from another, and towns too vary in their history, economic conditions and social structure. Reading University received its charter when what we have called the Newman philosophy was in the ascendant. The regulations that the University created at that time to monitor its students suggest that the town was seen if not as a threat, then as a diversion, tempting its charges away from their proper academic concerns. York came into existence at a different time, and into a different world. And it came at a *point* in time, not crescively and gradually, emerging from the transformation of pre-existing institutions such as technical and commercial colleges. When York came into being a new philosophy was emerging and the pressure group which was promoting it had to sell the idea of a university to local citizens as well as to the University Grants Committee. This led to a general discussion of the place of a university in the town, its advantages and disadvantages. One consequence was to spread widely across the community awareness of the institution and its possible effects. It may be that as the University gradually became a familiar and accepted part of the town so awareness of it and its details fell to the back of the local mind, and survey results such as ours would fall into the proportions such as we found in Reading.

CHAPTER 4

Oxford Disputes and the Reading Rag

In the early 1960s two particular disputes between the University and the city in Oxford were exercising local opinion. The disputes were said by some to be of wide concern, and to be the occasion of considerable hostility to the University. The disputes concerned special University representation on the city council and the amount to be paid in local taxation by the University to the city. The first concerning the democratic process, and the second concerning the amount to be paid in local taxes and touching, therefore, the personal finances of every householder in the city, seemed both to be matters likely to stir the local community deeply and to provide something of a litmus test of town–gown relations. The disputes were at their height at the time of our Oxford survey, and we took the opportunity to ask our informants about them. The results together with an account of the disputes are given below.

Reading University had each year a 'rag' in which its students were released on the town to raise money for charity and with something of a license to 'lark', that is to go beyond the normal conventions in dress and behaviour. No doubt the Reading Vice-Chancellor held his breath each year at rag time, and hoped that students, police and citizens were all mutually tolerant and 'sensible'. How the citizens felt about these occasions when they were face to face with their University students, with numerous points of potential friction, seemed again to provide something of a test of town–gown relations.

Accordingly we put questions to our Reading informants to determine the matter. The results appear below.

University Representation on the Oxford City Council

In the early 1960s, Oxford University elected its own representatives to the Oxford City Council independently of the general franchise. This arrangement was established in 1889 and survived until 1974. The council had sixty-eight members.

Forty-two were elected in the ordinary way from the seven wards of the city, and these forty-two elected fourteen aldermen. The University elected nine councillors, and these nine elected three aldermen. Thus the University supplied twelve of the sixty-eight members of the city council. Three of the nine University councillors were elected by Convocation, and the remaining six by the heads and bursars of the colleges. Convocation consists of all those holding the Master of Arts or higher degrees of the University, and is obviously a large and widely dispersed body, most of whose members would not be expected to vote or to be seriously interested in the concerns of the city. The heads and bursars of colleges numbered fifty-four in all.

In the early '60s, Britain was still a relatively homogeneous society, and there was little thought that electoral arrangements might, or ought to be managed in such a way that particular groups or types of person were ensured some degree of representation. There were examples other than the one in Oxford of particular interests being represented, but they were few in number and regarded as historical anomalies. Generally, 'one man one vote'[1] was taken as the acid test of democracy, and if some arrangement failed the test that was sufficient to condemn it. There was no question that Oxford failed the test here. The University had elected its own MPs and the University electors had, too, a Parliamentary vote in other constituencies. This privilege was swept away by Attlee's Labour government in 1949. The Labour Party in Oxford was enjoying an upsurge in support in the early '60s.[2] In 1950, at a low point in its fortunes, it had only five councillors as against fifty Conservatives. By the time of our survey in 1964 Labour had twenty-five, as against twenty-four Conservatives.[3] The newly resurgent Labour Party quickly turned its attention to the question of special University representation and mounted a campaign to abolish it or, at least, to reduce it.

In June 1963, Oxford City Council passed a resolution adopting the principle that University representation be reduced to three councillors elected by Convocation, and one alderman elected by these three councillors. The council instructed its parliamentary committee to enquire into the best means of putting its resolution into effect. In November, the parliamentary committee recommended that the council proceed with a Petition to Her Majesty in Council under Section 25 of the Local Government Act, 1933. This was accepted, but by a majority of only one, and as the total vote in favour fell short of a majority of the full council, it was not possible to proceed according to the parliamentary committee's advice. It was, therefore, decided to open negotiations directly with the University and the matter was put to the University's Hebdomadal Council.[4]

The Hebdomadal Council was prepared to move, but not to move as far as the city council was demanding. It informed the Town Clerk that it would recommend to Congregation a reduction in University representation to eight, but not to four. The parliamentary committee looked at this counter proposal, advised against it and recommended the council press for its original demand that representation be reduced to four. When the matter came again before the city council a compromise was proposed, putting University representation at six councillors and two aldermen.

This was carried by thirty-one votes to twenty-eight. This was the position at the time of our Oxford survey.

The campaign on University representation had the support of Labour councillors. Its prime movers were G. T. Fowler[5] and J. Briscoe, who were dons and also councillors elected in the ordinary way, i.e. they were not special University representatives. Fowler and Briscoe carried the campaign into the University, and when the question was debated by Congregation in May 1964, Fowler proposed that University representation be reduced to four as the city had proposed. Fowler's motion was rejected, and Congregation accepted the Hebdomadal Council's suggestion that the University should have eight seats.

Arguments both for and against Oxford's special form of representation, as well as University representation altogether, were put in the city council, in Congregation and in the press.[6] The principal objection to representation was that it was undemocratic. It was pointed out that six councillors represented Cowley Ward, with an electorate of more than 17,000. Six representatives were also elected by the heads and bursars of colleges, who numbered only fifty-four. Congregation was said to be an inappropriate body to elect councillors, being too widely dispersed and too little concerned with local affairs. An election of a councillor by Congregation in 1964 was described as a scandal and a 'thoroughly discreditable affair' because of the small turnout of voters, and because neither of the two candidates published any statement of his views on any major local issue.[7] It was also argued that University representatives, although not formally aligned with any party, tended to be conservative in their views, thus giving the Conservative Party an advantage. In addition the two main parties were fairly evenly divided in the city, with the possible consequence that the University representatives could find themselves in the embarrassing position of holding the balance between them.

No one seems publicly to have defended the then existing system, which was widely regarded as an anomaly. The general idea of University representation was, however, vigorously supported. In its defence, it was argued that the University people had proved to be particularly valuable members of the council and as evidence, attention was drawn to the frequency with which they were chosen to chair committees. It was also argued that the University should be represented because it was such a large and important element in the life of the city. On the other side it was acknowledged that some University members had given notable service although others, it was alleged, had not. In any case, it was argued, University men who were specially qualified to serve, or thought themselves so qualified, could offer themselves for election in the ordinary way. It was also agreed that the University was a large and important element in the city. But, it was contended, the University was no more important than the motor works at Cowley and no one was asking for special representation in that case.

The local newspapers reported the debate and it featured in the correspondence columns, but it is difficult to judge how far concern spread beyond the small group

of city politicians. Those opposed to change thought that public opinion was not greatly excited. R. W. Blake, a Conservative representative of North Ward and a don[8], thought there was no 'burning sense of grievance on the issue' among the people of Oxford. G. T. Fowler, on the other hand, thought there was considerable concern in the eastern part of the city, where, he claimed, the University seats were regarded as an 'anachronistic remnant of an anti-democratic system based on class privilege'. 'This argument,' he wrote, 'has a special appeal in the wards of the City which lie to the east of the Cherwell,' and partly because of 'years of political propaganda by the Labour and Communist Parties in this area.'

> But these Parties [he continued] had an already fertile ground in which to sow their seed. The population of that area is largely made up of first or second generation Oxonians, attracted here over forty years by the prospect of secure employment and reasonable wages in the car industry. To them the traditions of the University mean nothing. The physical presence of the University crowding the centre of the City with a migrant student population, aloof and often arrogant, means a great deal to them, and they do not like it. It is inevitable that this suspicion of Town for Gown has crystallized around some specific issues: one of the issues has been that of University representation.[9]

We asked all our respondents in the survey: 'Do you know that the University elects its own councillors to the Oxford City Council?' Everyone replied, 53 per cent claiming that they did know and the remaining 47 per cent that they did not. Questions of this sort are usually considered to produce answers biased to the affirmative answer, since some people may be reluctant to admit ignorance. If this were the case here, our figure of 47 per cent may be regarded as a minimum.

Those claiming to know of University representation were next asked: 'Can you tell me how many councillors and aldermen altogether the University has on the Oxford City Council?' 'Twelve' was the correct answer, and two respondents gave it. A further sixty-three respondents gave numbers other then twelve, the numbers ranging from one to twenty. Twenty-five came close to the correct answer by putting the figure at either eleven or thirteen. Sixty respondents said that they did not know how many University representatives there were.

Table 4.1 (per cent)
Knowledge About University Representation

1.	Giving correct number	1
2.	Giving incorrect number	27
3.	Don't know how many	25
4.	Unaware that the University has representation	47

Table 4.1 summarises the position. Line 1 shows that 1 per cent knew of representation and also knew how many representatives there were. Line 2 shows that 27 per cent thought they knew the number of representatives but were mistaken or unlucky in guessing the wrong number. Line 3 indicates that 25 per cent said that they did not know the number of representatives, while line 4 shows that 47 per cent declared they were entirely unaware that the University had special representation on the council.

After putting these questions, we told our informants that there were actually twelve University members on the council out of a total of sixty-eight members. We then put two further questions to the 126 informants who had claimed to know that the University had representation:

Are you personally in favour of having the University elect its own councillors to the Oxford City Council?

and

Do you think the number of University representatives on the city council should be: increased; decreased; or remain as at present?

In reply to the first question, 86 per cent declared themselves to be in favour and 14 per cent opposed.

In reply to the second question, 13 per cent thought University representation should be increased, 17 per cent that it should be decreased, 70 per cent that it should stay unchanged at twelve members. Three respondents gave no reply.

All the interviewees who knew of representation, regardless of whether they were in favour or not, were asked two additional questions, the first inviting them to tell us of any *advantages* they saw coming from University representation. The second invited them to tell us of any *disadvantages*. The questions and the distribution of replies are shown in Table 4.2.

Sixty-nine informants mentioned one advantage, and eighteen two or more. Forty-five mentioned one disadvantage, and one mentioned two. Advantages, therefore, preponderate. The number (86) mentioning at least one advantage is the basis for the percentages shown in column II of Table 4.2, and the number (46) giving at least one disadvantage is the basis for the percentages in column IV. The percentages do not sum to 100 because we have taken answers and not respondents as a base. Some respondents gave more than one answer.

Table 4.2 (per cent)
University Representation: Advantages/Disadvantages

Can you tell me any advantages (disadvantages) which you think come from having special University representation on the city council?

	Advantages			Disadvantages	
	I	II		III	IV
1.	Importance of the University to the city	45	1.	Gives the University too much influence	30
2.	Educational qualifications of the University representatives	23	2.	The system is undemocratic	17
3.	Character of University representatives	17	3.	Conservative influence	15
4.	Conservative influence	9	4.	Interests of University and city diverge	13
5.	Raising standards	4	5.	Character of University representatives	6
6.	Providing enterprise and ideas	1	6.	Contrary to the interests of working people	2
7.	Other	17	7.	Other	20
	N(=100 per cent)	86		N(=100 per cent)	46

After studying the answers given, we took categories into which they could be grouped. The categories appear in columns i and iii of Table 4.2. It is evident from this table that the advantage seen most widely is the importance of the University. A young skilled manual worker told us '… the University definitely should have representation because it comes within the city and is a great part of it'. An electrician in late middle age took a practical view and thought there should be representation because '… it saves time by enabling the University to state their point of view immediately without the need for separate and then further joint meetings'.

Apart from 'importance' and 'conservative influence', the topics in the Advantage Column relate to the type of person a University councillor is thought to be. Attention was drawn to his educational qualifications, and it was stated that he was intelligent, enterprising, fertile in ideas and likely to raise standards. An elderly college scout told us 'University people will be intelligent people who study a wide field of subjects and they have fewer chips on their shoulders'. A buyer in his thirties told us '… University representatives will undoubtedly be men of high intelligence

and learning, they will have the interest of the city at heart'. The wife of a car body inspector thought '… the Oxford Council is bad, it wastes its money and there is far more manual labour – road sweepers etc. – than is necessary. The more clever people there are on the council the less likely they will be to spend the rates foolishly'.

Respondents included in 'conservative influence' (line 4) thought the University would oppose anything likely to promote radical change, particularly in the physical aspects of the city. Hostile themselves to such change, they welcomed the increased power which representation conferred. A shop manager in his thirties told us that University representation '… had protected buildings of architectural value in the city'. The wife of a porter in her fifties thought that the University had helped in the preservation of the beauty of the buildings which had made Oxford more attractive for tourists.

Looking at disadvantages (Table 4.2, column III), we may take 'gives the University too much influence', 'the system is undemocratic', and 'interests of the city and University diverge' together since they all relate to the notion that representation gave the University an unduly large and unfair influence. Illustrative of the points of view expressed is the opinion of the young wife of a hotel proprietor who said '… things wanted by the city but not in the interests of the University are shouted down by the large University representation'. An elderly widow told us 'The University representatives are too strong. They are very intelligent and get more hearing than the others'. The wife of a service officer objected on the grounds that 'The system is not proportional'. Those who complained of conservative influence sometimes had party politics in mind. A press operator in his thirties complained 'The University supports the Tories'. Others were thinking of more general matters, like a man who thought '… they should not be able to elect a block of councillors and then be able to stop city improvements'. Among complaints about the character of University people was that of a young metal worker, who said '… they like to feather their own nests'. An accountant in his forties thought '… the senior people in the University are not in touch with the life of the ordinary people of Oxford'.

The Oxford Rates Issue

How much the University as opposed to the town should contribute for the provision of local services is a controversy having a long history in Oxford. The colleges in Oxford were charities. For many years there had been provision for relieving charities of part, at any rate, of the burden of rates. And charities had also looked to local authorities for sympathetic treatment in respect of local taxation even when there was no statutory provision for relief. In most cases charities represent only a small part of rateable value, so relief can be granted without revenue being seriously affected. Further, many charities are local in character, conferring a benefit on the home community. In their absence the local authority might find itself responsible for the work the charities do, with a consequent increase in its own expenditure.

The situation in Oxford was quite different. Over 14 per cent of the rateable value was in University institutions, and the University was clearly not just a local body performing tasks for the local population. Situations similar to that in Oxford occurred elsewhere. Durham, for example, had a high proportion of properties in University institutions but qualified for rate-deficiency grant. Oxford qualified for no such special payments, and any reduction in rates accorded the colleges meant that a sum equal to the reduction had to be imposed on the city's other ratepayers.

The situation was complicated by the technical difficulty of assessing the value of university institutions. The usual procedure was to take the rent a property would command if let year to year in an open market. Most University property, though, was not bought and sold, as, for example, shops and houses are, and for much of it there is nothing passing through the market which might serve as a model for valuation. Valuation was of necessity, therefore, a matter of judgement or even, perhaps, of guesswork. In Oxford, each college was first assessed as a single heriditament for rates in 1900.[10] The colleges appealed to Quarter Sessions against the assessments. They were successful, and obtained a reduction of some 40 per cent in the sums that had been demanded by the city.

A further result of the appeal was that a new method, the 'contractor's method', was adopted for assessing the colleges. This method required the valuation officer to assume a new building being provided for the institution being assessed. Then a proportion of the estimated capital cost of this hypothetical new building was taken as the amount to be paid in rates. Even with this new method it was clear that the assessments had still to be largely a matter of judgement, leaving plenty of room for differences of even expert opinion, and as the interests of the University and the city were here clearly in opposition, it is not surprising that differences should arise between them. However, the judgement obtained by the University at Quarter Sessions provided a basis for college rate assessments which lasted for almost half a century. There were increases in the amounts the colleges were required to pay, but they were kept proportional to increases generally in the city's rates.

This accommodation between the two parties was upset in 1948 when responsibility for valuation in the country as a whole was removed from local rating authorities and transferred to the Inland Revenue. A new test valuation prepared for three Oxford colleges and using the contractor's method produced figures three times larger than those obtained previously. The colleges appealed to the Lands Tribunal against the method of assessment. Their appeal failed. However, the tribunal disagreed with the amounts that had been set and it reduced these by half. This meant that the colleges had to pay more in rates than previously, but the increase was not much more than those imposed on residential properties and was less than those required of commercial premises.

Charities everywhere opposed the Inland Revenue rating proposals, and legislation was passed in 1955 linking them once more to the old rating list, so giving charities relief from the Revenue's assessments. The government also set up a committee, the Pritchard

Committee[11] to look at the whole matter. This committee reported in 1959, and paid particular attention to the problem posed by the Oxford colleges. It acknowledged that there was a problem, but was of the opinion that all university institutions should be treated alike, and that relief from rates ought not to be denied all universities because of any special effect this would have on Oxford and a few other places.[12]

The government did not follow its committee's advice. Not, at any rate, in a simple way. It announced that all universities would be required to pay their full share of local taxation. The local authorities were, therefore, satisfied. But so were the universities, for they were given special grants to meet the increased taxes now put upon them. In addition, Oxford (and Cambridge) colleges were given mandatory relief as charities in the Rating and Valuation Act, 1961. Everyone, apart, perhaps, from the taxpayer at large, seemed, therefore, amply satisfied. This was not so: a point of serious friction remained in Oxford.

So far we have spoken of the colleges and the University as though there were no distinction of consequence between them. But there is a difference, important in this context. The University had received grants of public money since the 1920s. The colleges, on the other hand, are private bodies not eligible for grants of this kind. The government's decision to allow local authorities to levy rates in full on university premises and then to compensate the universities with grants solved the problem in Oxford in respect of the University, but not in respect of the colleges. As already noted, the Rating and Valuation Act, 1961, granted the colleges mandatory relief as charities. This meant the rate assessment of the colleges was reduced by half the amount fixed previously by the Lands Tribunal. Much of the tax burden was, therefore, shifted from the colleges to other local taxpayers. The colleges were now required to pay less even than they were paying on the old rating list in force before the Inland Revenue appeared on the scene. The city suffered a loss in annual revenue of some £123,000.

A loss of this order was serious, and resolutions and deputations were sent to London to bring it to the attention of government. A joint deputation of Oxford and Cambridge city councils saw Sir Keith Joseph, Minister of Housing and Local Government. Sir Hamilton Kerr, MP for Cambridge, sponsored a Private Members Bill to provide relief for both places. It had First Reading in February 1964, but its prospects were poor and it was withdrawn in April. The approaching general election in 1964 drew the question into party politics, and there were exchanges between C. M. Woodhouse, the sitting Conservative member for Oxford, and Evan Luard, his Labour challenger. Woodhouse found himself at odds with his party on the issue, and after the defeat of the Conservatives at the 1964 general election, Woodhouse withdrew from the opposition front bench.

This degree of political swirl, together with the interest shown in the press, led us to believe that there might be a comparable level of concern in the public at large, so we put two questions in the survey: 'Have you heard at all of the present controversy in the city about the amount of rates payable by the colleges?' Sixty-five per cent claimed to have heard of the controversy, and 35 per cent admitted they had not.

Those who claimed to have heard of the controversy were next asked: 'Is it your opinion that the colleges should pay: More in rates than at present? Less in rates than at present? About the same in rates as at present?' Five respondents replied 'don't know'. Of the remaining 149 who had an opinion, 81 per cent thought college rates should be raised, 1 per cent thought they should be reduced and 17 per cent thought they should remain unchanged. Table 4.3 summarises the position.

Table 4.3 (per cent)
Colleges and Rates

Have you heard at all of the present controversy in the city about the amount of rates payable by the colleges?
Is it your opinion that the colleges should pay: More in rates than at present? Less in rates than at present? About the same in rates as at present?

1.	More	51
2.	Less	1
3.	About the same	11
4.	DK	2
5.	Never heard of the rates controversy	35

Thus, when these two issues are looked at through the lens of empirical sociology, public opinion seems less excited than some people assumed at the time. Almost half our sample was unaware even that the University had special representation on the council, and more than a third had never heard of the rates dispute. Eighty-six per cent of those who were aware of the issue approved of University representation and only 14 per cent opposed it. Seventy per cent thought the number of University representatives should remain as it was, only 17 per cent wanted it decreased and 13 per cent actually wanted it increased.

On rates the picture is different. More knew about this question, although this proportion was still only a little more than two thirds. Of those knowing about it, 80 per cent thought college rates should be increased. A large number of local citizens seem, therefore, to have rested in ignorance of either dispute. Of those who were aware of them, a majority supported the University on the question of representation and opposed it on the question of rates.

These two issues throw an oblique light on the general question of town gown relations. In the next chapter, we take the question directly. Before doing so we look at the Reading Rag.

The Reading Rag

Reading was one of a number of universities which staged in town each year a 'rag'. The object of rags was to raise money for charity. They were student activities, although permitted and encouraged by the university authorities. The authorities probably thought it better to have rag activity occurring in a more or less controlled way over a limited period rather than to have it bursting out spontaneously throughout the academic year. The pattern everywhere was much the same, although there was some variation from place to place and from year to year according to the interest and inspiration of the time. There were concerts and shows, prizes were raffled, dances arranged, a magazine was produced and street collections taken. Highlights were a ball and a procession of floats through the streets of the town. A coordinated programme of this kind requires considerable organization, and served to give students experience and an opportunity to show their capacities as administrators. Rags, too, provided an opportunity for students to release energy and high spirits, for some larking as well as some teasing of authority. Among the Reading Rag escapades were the suspension of a skeleton from the boiler house chimney, painting on the roof of the West Cloister, the commandeering of a Thames Valley bus and, more adventurously, the landing of a light aircraft in the University grounds.[13] Any reluctance on the part of the town or the university authorities to countenance the larking and teasing, if not overcome, was at least softened by the avowed charitable objectives of the rag. And, of course, rags did often succeed in raising considerable sums for worthy causes. But the line between what is and what is not acceptable is not always clear, and high-spirited students under the inspiration of rag could, and often did, behave in ways which the more sober citizens might have found unacceptable. The rag was an occasion in which the Reading student body showed itself in a face-to-face fashion to the town. It seemed worthwhile to ask how many in the town had actually heard of it, seen it, and how it had been received.

Table 4.4 (per cent)
The Reading Rag

Have you seen and heard of the annual rag which the University students put on?

Have you ever seen anything of these rags yourself?

1.	Heard of and seen	94
2.	Heard of but not seen	3
3.	Never heard of	1
4.	DK	2

Table 4.4 shows that the rag was certainly known about. And it was probably the most widely perceived of all Reading University features. Virtually the whole population had not only heard of it, but had seen it too. Perceiving is not necessarily approving, so we put the question shown in Table 4.5 to all those who had seen or heard of the rag.

Table 4.5 (per cent)
Rag: Approval or Disapproval

On the whole would you say you approve of these rags?
Or disapprove?
Or not mind one way or the other?

1.	Approve	84
2.	Disapprove	5
3.	Not mind one way or the other	10
4.	DK	1

With 84 per cent expressing approval, it is apparent from Table 4.5 that the overwhelming body of Reading citizens gave the rag their support. This rosy picture is not entirely unclouded, though. A tiny minority of 5 per cent expressed disapproval, and a further 10 per cent were indifferent. Given the things that might go wrong when hundreds of young people are loosed onto the streets with something of a licence to 'lark', together with the explosion of publicity that must follow larks that go wrong, the degree of support Reading people accorded the Reading Rag is impressive. Any politician getting a vote of this order in a free election would regard himself not only supported and elected but positively beatified.

CHAPTER 5

The University:
An *Advantage?*

Many universities began life as commercial or technical colleges, often going through amalgamations and transformations into higher technical colleges and polytechnics until their final emergence as universities. York did not follow this pattern. It was envisaged and created quite specifically as *York University*, an entirely new institution of university status and created from scratch. This meant that it *arrived* in the city in a way that institutions growing crescively out of previous creations did not, and in consequence attracted more attention and some debate. We look at anticipations of this new institution, the debate surrounding it and early experience of it before presenting survey results.

Given the historical connections between the Church and education, York seems an obvious place for the location of a university, so it is not surprising to find a group of York citizens petitioning Parliament on the subject as early as 1652.[1] The matter came up again in 1825, when the foundation of a university was seen as a way of helping at a low point in the city's economic fortunes[2]. Shortly after the Second World War Mr Oliver Sheldon, chairman of the York Georgian Society, wrote to *The Times* suggesting York as the headquarters of a new, combined University of Yorkshire. He was enthusiastically supported in an editorial in the *Yorkshire Evening Press*[3] and in a subsequent interview he drew attention to the advantages of York as a university centre with its redundant churches and large houses in the city centre which could be put to university use.[4]

Support for the idea of a new university quickly came from various quarters. Dr Corlett the local MP, the headmaster of St Peter's School, the principal of St John's College and Mr J. B. Morrell, as well as others prominent in education all expressed support.[5] There were encouraging reports that the government was considering the creation of at least one new university and it was thought that Miss Wilkinson, Minister of Education, favoured the scheme. Dr Garbett, Archbishop of York, devoted a sermon to supporting the idea of a university in York and a public meeting established a committee to take matters further.[6] The committee included the Archbishop, the Dean, the Lord Mayor and Lord Halifax.

At that time the creation of a new university was not a matter taken lightly, and there were signs that government was inclined to be cautious. The chairman of the University Grants Committee observed rather coolly that there was nothing to stop the citizens of York starting their own university college if they so wished, and that this had been done at Hull.[7] But after receiving a petition the University Grants Committee agreed to meet a deputation from York, and a deputation was duly sent.

Mr Sheldon described the deputation's reception by the University Grants Committee as one of 'qualified good will'. But there was competition in the field, as the committee had also received a deputation from Bradford requesting that Bradford Technical College be granted university status.[8] In the circumstances it was thought that a long view, perhaps of ten years, needed to be taken. Later the Lord Mayor of York reported that an executive committee had been established to prepare a scheme for the long term, and that funds had been provided to enable preparatory work to be set in hand.[9] In 1954 Mr J. P. West-Taylor, who had been appointed secretary of the committee, reported it had established the Borthwick Institute for Historical Research as well as the York Institute of Architectural Study, and had provided courses for overseas students as well as organising conferences for social scientists.[10] In 1959 a gift of £100,000 from the Rowntree Memorial Trust was announced.[11] In the same year further large sums were donated by the Cuthbert and K. B. Morrell Trust, the Joseph Rowntree Social Service Trust and Rowntree and Co., Ltd. The committee was also given a property, Heslington Hall, with the suggestion that it could serve as the administration centre for a new university. These gifts were strategically timed, because at the end of the year another deputation, headed this time by the Archbishop of York, was to wait once more on the University Grants Committee to present the case for a new university.[12] Further promises of financial support came from local authorities during the crucial period when the University Grants Committee was considering York's case.[13]

There was some debate about the proposed new university. The large grants of money made by industrial interests and associated charities together with those from public bodies spoke eloquently in favour of it. And most other opinion was also strongly supportive. The Archbishop and the Dean were enthusiasts for the enterprise, the Dean noting that York '... can provide both the graciousness and the historicity which is ideal for the highest of purposes of education'.[14] V. A. Heigham recommended York because it had escaped the worst of Victorian industrial development and stood close to unspoilt countryside.[15] Miss Louise Browne, 'international comedy and ballet personality', spoke supportively at the York Citizens Theatre Club and hoped she could look forward to a York school of fine arts under the auspices of the University.[16] The Marquess of Anglesey, in a Presidential Address to the Friends of Friendless Churches, welcomed the enterprise and noted that York had at least half a dozen churches without friends, further suggesting that these churches might be linked to the University for use as lecture rooms, halls and libraries.[17] The *Yorkshire Evening Press*, which throughout gave consistent and

enthusiastic support, noted the prestige which the proposed institution would bring to the city, to its Lord Mayor and Corporation. It also drew attention to economic advantages. It calculated that at Nottingham University, expenditure on food alone was £50,000 a year, and total expenditure was of the order of £1.5 million, two thirds of which was spent locally in Nottingham. And this was in addition to capital expenditures.[18] In the light of figures of this sort, it is not surprising that the Lord Mayor, in a burst of enthusiasm, suggested that workers in York might have a pound a week deducted from their wages to support the proposed university.[19] Sadly, nothing seems to have come of this bold idea.

In some quarters a certain hesitancy was apparent. The Corporation itself was slow in offering financial support and was upbraided for 'dragging its feet'.[20] Sometimes even those giving support felt it necessary to allay doubts. Doubts related principally to fear of a burden that might be placed on local finances. Combating this fear, the *Yorkshire Post* argued that 90 per cent of maintenance expenditure would come from central government and the remainder from fees and private grants.[21] The secretary of the York Labour Group argued that whatever contribution the city might have to make would be offset in one way or another and the chairman of the group, while acknowledging that there would have to be expenditure, expressed confidence that the city would benefit by the additional work and money that the university would bring.[22]

Inevitably, perhaps, there was the occasional sour note. A correspondent in the *Yorkshire Evening Press* doubted if the enthusiasm for the proposed university permeated the whole community, and in particular whether redundant railwaymen and disadvantaged school leavers would share the enthusiasm.[23] Another correspondent wrote: 'To my mind the only people who will benefit are a few trades people, and people with accommodation to let. The vast majority, however, appear to be saddled with an extra three pence in the pound on their rates ... (A) remark which really amazed me was that if we took a cross section of the community, ninety out of every hundred would say that a university would be an advantage to York ... I think a more likely result would be: for university 20%; against 20%; couldn't care less, 60%'.[24]

But, fuelled by a general enthusiasm, preparations for the new institution went ahead with dispatch. An academic planning board headed by Lord Robbins was formed in 1960 and presented proposals in April 1961. Robert Matthew and Johnson–Marshall were appointed to take charge of initial architectural planning, and in February 1961 it was announced that Lord James of Rusholme was to be Vice-Chancellor, and in the following year it was announced that Lord Harewood had accepted the post of chancellor. The Development Plan was published in 1962, and a general appeal for £2 million was launched. The first three professors were appointed in June 1962, and the first two hundred students were admitted in October the following year.

An open day was held at Heslington in October 1963, and Lord James expressed delight at the large number of citizens attending. The newly arrived students were

reported to be satisfied with their University, although there were some complaints about high fares and the absence of night life in the city.[25] A suggestion that the University might expand over time to cater for ten thousand students led, early in 1964, to protests from farming interests in the Heslington area concerned about the possible loss of land to the University.[26] And visitors to the University, although impressed by the quality of provision, were also sometimes 'appalled' by what they considered to be the extravagance of the furnishings.[27]

Outside forces in the student world made themselves felt at this time, and York students too, influenced by these forces, soon became an aggressive presence. In March 1965 there was a report of vandalism in a student common room, and a suggestion that the Registrar was considering closing the room because of the damage.[28] In May there was a protest about the number of nights students were permitted to spend off campus during term.[29] In the following year there was a protest against the 'suppression' of a film by the BBC and a coach load of students went to London to carry their views directly to Broadcasting House.[30] It was forecast[31] that the first visit by the UGC to York in 1966 would be a time of friction between the students and the University authorities and, duly, the students presented complaints about inadequacies in the provision made for them and those planned for the future.[32]

In November, an article in the York student newspaper raised the question of drug taking. Lord James found the article shocking and irresponsible, and threatened to censor future issues.[33] Two months later Lord James, in company with two doctors, issued a warning to the students against drugs[34] and shortly after it was learned there was to be a prosecution in connection with drug offences.[35] Subsequently police raided the campus, seizing copies of the *International Times*, said to be the 'newspaper of the psychedelic movement'.[36] Not surprisingly, perhaps, there was dissatisfaction on the part of students over discipline, and a broadsheet was put out voicing their complaints[37]. In February a dawn to dusk teach-in was held on the subject of student riots, and in March a York branch of the Radical Student Alliance was formed.

At this point our social survey researchers descended on the city.

We asked informants in all three of our cities a number of questions designed to explore dimensions of approval/disapproval. These questions were put early in the interview so that answers to subsequent questions would not be coloured by these replies. Minor adjustments were made to adapt questions to each place. We made a distinction between the 'personal' view and the 'civic' view. The main questions relating to 'personal' and the distribution of replies are shown in Tables 5.1 and 5.2.

Table 5.1 (per cent)
Effect of University: Personal

Would you say that for *you personally* the fact that the University and the colleges are here makes (Oxford):

		Oxford	Reading	York
1.	A better place to live in?	59	41	36
2.	A worse place to live in?	4	1	3
3.	Neither a better nor a worse place to live in?	36	56	57
4.	DK	1	2	4

For all three places, it is evident that virtually the whole population has an opinion. Even in York, where the University was still very new, only 4 per cent replied 'don't know'. In Oxford a clear majority declared the city to be a better place to live in because of the University. A substantial minority of 36 per cent found the University did not affect them or, if it did, that advantage and disadvantage were evenly balanced. For Reading and York the patterns are similar, roughly 40 per cent declaring the university to make the town a better place and a little less than 60 per cent thinking it made no difference. Everywhere only small minorities found the town a worse place because of the university presence. Oxford is different in having more (59 per cent) in the 'approving' category and fewer (36 per cent) in the 'neutral' position.

In the case of York, it might be assumed that the activities of the students and the publicity they attracted just before our survey took place would impact on local opinion, driving some, at any rate, of the citizens into attitudes hostile to students and, perhaps, hostile to the University altogether. Our survey findings suggest (Tables 5.1 and 5.2) this was not the case. If local people attended to the adverse publicity at all they seem to have shrugged it off, perhaps attributing it tolerantly to larking, characteristic of young people everywhere.

We approached the same area of opinion in a more general way by asking respondents to imagine they had to move to another city, and then asking them if the presence or absence of a university would weigh in their evaluation of the new place. Since considerations such as work and family connections are powerful ties to place, we asked them to imagine further that the supposed move would leave the balance of job and other matters about the same. The question and replies are given in Table 5.2.

Table 5.2 (per cent)
Moving to a University City

If you had to move to another city, and if job and other considerations were about the same, would you:

		Oxford	Reading	York
1.	Prefer to go to a city which had a university?	37	26	19
2.	Prefer to go to a city which did *not* have a university?	4	1	2
3.	Not mind one way or the other	57	73	77
4.	DK	2	0	2

Clearly the presence or absence of a university would not figure in the minds of most people. Even so, 37 per cent in Oxford have a preference for a university town, and in Reading rather more than a quarter and in York nearly a fifth shares this preference.

Preferences expressed in this way may cover a wide range. At one extreme we might have someone for whom the presence of a university was highly valued, and at the other there might be someone who would weigh the presence or absence of a university but lightly. To take account of this, we asked all those who made a choice for or against a university town (Table 5.2, lines 1 and 2) whether they would feel strongly or not particularly bothered. In Oxford and Reading about half (Oxford, 52 per cent; Reading 51 per cent) and in York some two thirds (64 per cent) declared they would feel strongly.

For a slightly different perspective we may look at those expressing a preference and saying they felt strongly about it. Put as a percentage of all those interviewed, this group constitutes for Oxford 23 per cent, Reading 13 per cent, York 13 per cent. In terms of our material, therefore, about one in four of the adult population in Oxford and one in eight of the comparable group in the other two places gave a significant place to the presence (or absence) of a university when evaluating the sort of urban environment they would choose for themselves.

We also looked at the question from the angle of parenthood. We put the two questions shown in Table 5.3 to respondents who had one or more children less than eleven years of age. We restricted the question in this way on the assumption that for children over eleven years at that time, their educational future in respect of university would have been pretty much settled. It is clear that large majorities in each place (Oxford 92 per cent, Reading 90 per cent, York 88 per cent) had university aspirations for their children. Only small minorities rejected the idea or

were unsure about it. Most, too, would be content for children to go to their local university, although the Reading figure (18 per cent) for people wanting university education but rejecting the local institution seems larger than that for Oxford and, perhaps, for York too. The dominant fashion at the time was for study away from home and the system of grants supported it, so we think the figures in Table 5.3 can be taken both as enthusiasm for university education and confidence in the local institution.

Table 5.3 (per cent)
Parental Aspirations for University Education

Would you like him (her, some of them …) to go to university?
Would you like him (her, some of them …) to go to (Oxford) University?

		Oxford	Reading	York
1.	Yes (Oxford) University	84	72	75
2.	Yes not (Oxford) University	8	18	13
3.	No	6	4	8
4.	DK	2	6	4
	N (=100%)	67	77	85

We turn now to the replies obtained when we asked for opinions from the *civic* instead of the personal viewpoint. The question and replies appear in Table 5.4.

Table 5.4 (per cent)
Effect of University: Civic

Would you say that for the City as a whole, the presence of the University and the colleges is:

		Oxford	Reading	York
1.	An advantage?	77	88	81
2.	A disadvantage?	6	0	2
4.	Neither an advantage nor a disadvantage?	15	11	14
5.	DK	2	1	3

Line 1 of Table 5.4 shows that a large majority in each place indicated that the presence of the university is an advantage. Those thinking it a disadvantage constitute no more than a small minority in Reading[38] and York. In Oxford, though, this figure is 6 per cent, still a small proportion but large enough, perhaps, to have some social significance. Those thinking the university brought neither advantage nor

disadvantage or, if it does, that there is no balance one way or the other, constitute 15 per cent in Oxford, 11 per cent in Reading, 14 per cent in York.

Comparing Tables 5.1 and 5.4, it is evident that shifting from the personal to the civic viewpoint produces a different pattern. It brings a substantial move away from a stance that finds no balance of advantage or disadvantage to one which finds the university to be an advantage. This shift, however, is less for Oxford, partly because a relatively large proportion in Oxford finds the University a personal advantage, and partly because a relatively small proportion finds the University a civic advantage. From another perspective we may say there is a closer correspondence between the personal and civic viewpoints in Oxford than in the other two places.

We noted earlier that in 1355 the citizens of Oxford drove the University out of the city and killed large numbers of students in the process. But the University quickly came back, and, supported by both the Crown and the Church, established a dominance over the town which continued over the subsequent centuries. This dominance enabled the University to settle disputes to its own satisfaction, and to shape and manage the town in ways to fit its own understanding of academic requirements. The survey findings presented above suggest that the past has left no legacy of bitterness or hostility. At the time of our study, the citizens as a whole contemplated the University in their midst with some satisfaction. The same is true of Reading and York, and if true generally Vice-Chancellors everywhere can rest in office with ease, so far as their local community is concerned.

There remains the question of what advantages or disadvantages in particular did our correspondents think the presence of a university brought. We turn to this in the next chapter.

CHAPTER 6

Advantage/Disadvantage

To explore the dimension of advantage/disadvantage in more detail we put four questions to our informants:

> Can you tell me any ways the University and colleges make (Oxford) a better place to live in for *you personally*?

> Can you tell me any ways in which the University and colleges make (Oxford) a worse place to live in for *you personally*?

The other two questions used the same format, except the 'civic' dimension was used instead of the 'personal'. The four questions were put to *all* informants regardless of responses to earlier questions. Thus, someone who had indicated that the University made the city a better place would have been asked to tell us not only how it was a better place, but also to relate any ways the University made it a worse place. Conversely, someone indicating that the city was a worse place would have been asked both to give the ways in which it was a worse place and to relate any ways in which it was a better place.

After studying the replies to these open-ended questions, we grouped them into categories according to the topic or topics raised. Thus, if a respondent, in telling us what advantages the university brought for him personally, had said that the young people coming with the university improved things by livening up the town or in some other way, then this answer would have been classified under 'Youth'. The reply of a respondent mentioning some financial advantage, perhaps by providing customers or lodgers, then this reply would have been put under 'Employment and Trade'. This procedure enabled us to obtain an overall quantitative picture of the replies, and this is presented in Table 6.1. There were seventeen of these categories altogether. They are given in Tables 6.2 and 6.3. It will also be seen from these tables that the categories are, for the purpose of presentation, further clustered into four groups: 'Physical Environment', 'Social Climate', etc.

The percentages in Table 6.1 relate to informants mentioning a particular number of topics from our seventeen categories. From line 1, column 11, of Table 6.1 it is evident that 41 per cent of our Oxford sample mentioned no features at all when asked what personal advantages they derived from the presence of the University. Line 2, column 11, of Table 6.1 shows that 37 per cent mentioned one feature, and line 3, column 11 that 22 per cent mentioned two or more. As a base for the percentages in Table 6.1, we take for each place all people interviewed.

Glancing along line 1 of Table 6.1 shows the percentages for Oxford to be smaller, so fewer Oxford people have failed to produce a reply. This indicates *more* people in Oxford feel themselves to be personally affected by the University than is the case in either Reading or York and, further, a larger proportion in Oxford is aware of some impact the University has upon the city. An examination of the figures in lines 2 and 3 of the table provides confirmation, although the 37 per cent for York (line 3, column vii) seems an exception. The greater impact in respect of Oxford is evident both for disadvantage as well as advantage. For obvious reasons, the greater relative impact of Oxford University on its local community is hardly surprising.

A comparison of the figures for Reading with those for York may occasion surprise. At the time of our studies Reading University had been in existence for more than forty years, and it had been established in the city in some form for longer. It had more students than York. Its physical presence in the heart of the town was considerable, and in addition it had for many years occupied the huge area of Whiteknights Park. The figures in Table 6.1, though, suggest at all points that York University figured more prominently in the minds of local citizens than did Reading University. From Table 6.1, lines 2 and 3, columns iii and iv, to take one example, it is apparent that 38 per cent in York mentioned one or more matters of personal advantage as against only 26 per cent in Reading. These differences may be explained by the public discussion at York which preceded and accompanied the arrival of the University.[1] The effects of having the University in the city were much canvassed, so awareness of them would have been heightened and spread widely. Anticipations of possible future effects, too, must have been in minds in York when the University was still in an early stage of formation.

A striking feature in Table 6.1 is the predominance of advantage over disadvantage. Comparing column 11 with column viii, it is apparent that 59 per cent in Oxford gave at least one personal advantage, whereas only 34 per cent mentioned a disadvantage. Comparing column vii with column xiii shows that 81 per cent in York mentioned a civic advantage, and only 25 per cent a civic disadvantage. Four other such comparisons can be made in Table 6.1 with the same result.

Table 6.1 also makes clear that in each place the civic dimension predominates. Comparing figures in column 11 with those in column v it is evident that 59 per cent of Oxford respondents mentioned some personal advantage, whereas 84 per cent mentioned some civic advantage. The same predominance of the civic over the personal is evident in each of the other four comparable pairings that can be made.

Table 6.1 (per cent)
Advantage and Disadvantage

i	Personal Advantage			Civic Advantage			Personal Disadvantage			Civic Disadvantage		
	ii	iii	iv	v	vi	vii	viii	ix	x	xi	xii	xiii
Number of topics	Oxford	Reading	York	Oxford	Reading	York	Oxford	Reading	York	Oxford	Reading	York
None	41	74	62	16	28	19	66	97	87	55	92	75
One	37	20	28	58	50	44	22	3	12	37	8	25
Two or more	22	6	10	26	22	37	12	0	1	8	0	0

Answers analysed in this way indicate that the impact of the university from both personal and civic viewpoints is greater in Oxford than in the other two places. The impact is also greater in York than in Reading. Further, the advantages of a university presence predominate in all three places over the disadvantages. And, finally, the civic impact is more widespread everywhere than the personal impact.

Particular Advantages

A disadvantage of pushing material from open ended questions into statistical form is that the flavour and idiosyncrasy of replies are lost. We compensate below for this when presenting material on the particular advantages the university is thought to bring by quoting replies which we judge to be typical or illuminating for the category in question. The seventeen categories employed are given in Tables 6.2 and 6.3. The material from the two dimensions – personal and civic – overlaps to a high degree, so we here treat them together.

Table 6.2 (per cent)
Personal Advantage

		Oxford	Reading	York
	Employment/trade	12	2	10
Physical Environment	Architecture	18	0	2
	Gardens/open space	5	0	0
Social Climate	Atmosphere	13	8	6
	Interesting/attractive people	6	3	7
	Youth	5	3	2
	Civic prestige	2	3	5
	Livelier atmosphere	–	–	7
Activities	Cultural activities	11	3	3
	Local sport/sport provision	3	1	0
	Rag	–	3	–
	Local services	6	5	2
	Traditional union	2	0	0

Table 6.3 (per cent)
Civic Advantage

		Oxford	Reading	York
	Employment/trade	55	20	51
Physical Environment	Architecture/gardens/open space	9	0	1
	Pleasant place	2	0	0
Social Climate	Civic prestige	10	16	17
	Atmosphere	9	13	6
	Interesting/attractive people	3	9	5
	Youth/students	2	4	3
	Education: general approval	0	9	7
	Visitors/tourists	0	0	11
Activities	Cultural activities	5	0	9
	Local sport/sport provision	5	0	1
	Rag	0	7	0
	Charities/voluntary work	0	0	1
Local Standards	Local services	5	5	4
	Local education	0	3	4
	Civic expansion	0	1	2
	Traditional union	3	0	0

Employment and Trade

Looking down the columns in Tables 6.2 and 6.3, it is clear the widest appreciation of advantage relates to employment and trade. From Table 6.3, line 1, it can be seen that over half the people in Oxford and York and a fifth in Reading mentioned this. One lady in York, the wife of a slater and tiler, told us: 'It will make it better for spending; for restaurants, cinemas, and for shopping. It does bring trade in. It brings work, too, for a lot of women. They have good jobs and I hear it's good money'. In Oxford we were told, 'It brings a living to many, for example, the boarding houses.' And, 'It brings money to the city.' Much the same considerations were raised when the advantage was seen personally. One lady in Reading said: 'There is a financial gain. I have a student as a lodger.' A middle-aged factory executive in Oxford told us both his father and grandfather had been employed in the University. A businessman in York said: 'I have a business and it's good for trade because they have installed my equipment at many houses of the staff.'

Many mentioned tourists and visitors. Oxford and York were clearly conscious of themselves as tourist centres, and there was a lively sense of the advantages of this trade. Some replies were placed in this category, although it was not clear exactly what respondents had in mind. In addition to commercial considerations some had, and others may have had, in mind the liveliness and the cosmopolitan air which accompanies tourism. There seemed greater appreciation of this in York, and we have classified under a special heading (Table 6.3, line 9) replies relating to it. There was little evidence in Reading that citizens saw their city as a tourist centre, nor did they see their University as a tourist attraction. In Oxford particularly, but in the other two places too, in addition to the 'ordinary' tourist population there is another population attending courses and conferences in the university vacations as well as scholars coming to use library and other research resources. So the university population merges to some extent with tourists, and our categories, 'employment and trade', 'atmosphere', 'interesting and attractive people' must run into each other.

Physical Environment

The most widely sensed personal advantage (Table 6.2 line 2) is the appreciation of the University architecture in Oxford. For Table 6.2 we have separated (line 2) those mentioning gardens and open space, although these are probably associated with architecture. In Table 6.3, line 2, we have combined these categories since numbers are small.

No one raised these topics in Reading. In York, 2 per cent mentioned them as a personal and 1 per cent as a civic amenity. A man in Oxford told us, 'I find the historic buildings interesting. It gives me a bit of a thrill to live in a city that has such buildings.' A young industrial manager said, 'I like being in an old city, a place of architectural beauty,' adding, 'perhaps this is because I spent three years in similar surroundings in Cambridge.' In York the widow of a shop manager said, 'I love the idea of the University being here. It has made the place more beautiful, the buildings are very up to date and the lake is very pretty.'

We have separated under the heading 'Pleasant Place' a few Oxford replies. They relate to awareness that a university is less damaging to environments than some sorts of industry. The point was nicely put by an elderly manual worker who said, 'The existence of the University has meant that industry and subsequent industrial conditions of dirt and so on were prevented from encroaching on the city.'

Social Climate

It is evident from the Tables 6.2 and 6.3 that the broad category 'atmosphere' figures in all three places. An Oxford lady told us, 'I like the atmosphere, it has an air of learning.' Another lady, widow of a college servant, thought, 'The University gives

Oxford a quiet, passive quality, you learn to live with its ways. In my dealings with the colleges I have always found them decent.' A cook in his thirties said, simply, 'It makes the town more interesting.' A nurse in her twenties thought, 'The students give the town a cosmopolitan atmosphere.'

In York there was some feeling that the town was dull, and that the University brought more 'life'. We recognise this separately in Table 6.2 line 8. One respondent included here thought, 'The University brings more interest into the town, eventually more entertainment will come because of it. There isn't a lot in York for youngsters.' Another thought the University might '... do something to develop night life, which is pretty dead at the moment. Probably get more clubs for young people, perhaps more dance halls that won't cost so much to run and put on on a reasonable scale for young people'. Sometimes, parents expressed a particular interest in this expected atmosphere of liveliness; one father told us that in due course he expected his young children to benefit from it.

Some said the university drew into their city people they approved of. These replies appear in the tables under 'Interesting/attractive people'. A Reading professional man told us that the University ensured the presence in the city '... of a large number of people of decent social standing and intelligence'. The widow of a manual worker in York thought that because of the University, 'we get a better class of people'. A York resident connected with local schools observed that University staff sending their children to local schools so ensured that these schools got a 'better class of child'. The wife of an Oxford mechanic thought, 'There are nicer people in Oxford because of the University', while the wife of a farmer thought the city to be more 'select' and to suffer less from hooliganism because of the University presence. Another perspective came from a young Oxford businessman, who found that the cosmopolitan population drawn in by the University provided him with clients of different types and nationalities which extended his interests and horizons.

A few in each place drew attention to the presence of young people and/or students (Table 6.2, line 6; Table 6.3, line 7). The wife of an Oxford semi-skilled worker told us that the University brought more young people, and without it 'the majority of citizens would be old people'. The wife of a York skilled worker welcomed the University because '... it brings more young people into the city ... they will have to have more facilities for them'. A Reading executive in his fifties thought 'students give a better intellectual outlook to people in contact with them'. A skilled manual worker, also from Reading, may have been making the same point, nicely touched perhaps with irony, when he told us, 'It's something for people to look forward to. There *is* a certain amount of intelligence in the students.'

It is evident from the tables that some respondents thought the University conferred prestige on their city. A woman in Oxford told us that when she travelled about the country she felt proud to be able to say she came from a famous university city, while a Reading factory worker said that Reading University made Reading a 'superior place', adding, 'Compare Oxford, everyone knows the University and it's a bit like that here'. These figures for 'Civic prestige' in Table 6.3 are relatively large. In all three places, they stand next in size to those for 'Employment and trade'. It is

striking that in Oxford only 10 per cent mentioned civic prestige compared with 16 per cent in Reading and 17 per cent in York.

'Education: general approval', the one remaining category under the heading Social Climate, does not appear at all for Oxford, and only as a civic advantage for Reading (9 per cent), and York (7 per cent). Respondents here seem to be expressing general approval of education, and concluding that since the university is providing education it must then be conferring a local benefit. A clergyman in York told us, '… all learning is an advantage,' while the wife of a Reading builder thought, 'The University improves learning. A university on the doorstep is a good thing.'

Activities

In Tables 6.2 and 6.3, four items are given under 'Activities'; two of these, 'cultural activities' and 'rag', appear both in the civic and personal dimensions. The other two, 'local sport/ sport provision' and 'charities/voluntary work', appear in the civic dimension only.

Both 'cultural activities' and 'sport/sport provision' relate to the idea that a university provides, by accident or design, facilities which the local population can also enjoy. A Reading sales representative told us, 'There are facilities, for example music. The choir is open to all … as a small town Reading could not provide all this if it were not for the University.' An Oxford factory worker reminded us that the University enabled people to watch first-class cricket free of charge, and a nurse who enjoyed watching rugby told us that this gives the hospital staff something to do in the winter.

Student rags,[2] common at the time of our studies and an annual event in Reading, have now largely disappeared. They involved a number of activities designed to raise money for charities, and centred on a carnival-like procession with floats and students in fancy costume collecting money from spectators. It can be seen that in Reading 3 per cent raised the rag as a personal advantage and 7 per cent as a civic advantage. A young housewife thought the rag served to 'cheer Reading up', and another lady gave it as an example of the many good things the University did for the town.

The remaining item, 'charities/voluntary work', emerged only in York. The few informants here put nothing specific forward, but had a general feeling that many good causes could expect to find support in the academic community as the University grew.

Local Standards

Replies grouped under 'Local Standards' relate to the idea that local services and activities are improved in some way by the presence of the university. A young professional trainee in Oxford told us, 'The high standard of the Radcliffe Hospital is probably due to the colleges,' and a retired man thought, 'The University improves standards of local government … there is the availability of special information and experience.' The wife

of a York labourer had been impressed by a television programme in which a member of the University had discussed architecture and town planning, and she concluded that the University could benefit the city in these areas. Some replies bore upon education, and of these, those on the 'civic' dimension appear in Table 6.3, line 15. Some interviewees included here thought that better school teachers would be attracted to the area by the presence of the university, or that school activities would be stimulated in some way. Others may have thought that local children would be given preference in admission to the local institution, although it was not always clear from the record what exactly the informant had in mind. One wife of a manual labourer in Reading, for example, told us that the University meant more education opportunity for Reading children.

We have included here also ('civic expansion') the replies of a small number who, wanting their city to grow larger, thought the presence of the university would help accomplish this.

The last group (Table 6.2, line 13; Table 6.3, line 17) we call 'traditional union'. Informants here had in mind the long historical association of the University and the city, regarding this as a self evident benefit. One interviewee said, 'Oxford would not be Oxford without the University. It must be a better place because of it ...' Another asserted, '... the University is the reason for the city's existence.' This opinion was found only in Oxford.

Following the form of presentation for advantages, we set out below the topics raised when our subjects were asked about disadvantages. Some features put to us as advantages reappear in these tables as disadvantages; the Reading rag is an example. The figures for Reading are so small that they are given in the tables as raw numbers *not* as percentages, and so are not comparable with the figures for the other two places.

Particular Disadvantages

Table 6.4 (per cent)
Personal Disadvantage

		Oxford	Reading	York
Physical Environment	Overcrowding	9	1	3
	Traffic	8		
	Expansion of city	0	1	1
Economic Costs	Rates	8	0	0
	Prices	7	1	3
	Accommodation	2	0	0
Social Climate	Students	6	1	6
	Atmosphere	1	0	0
	Rag	–	2	–

Table 6.5 (per cent)
Civic Disadvantage

		Oxford	Reading	York
Physical Environment	Traffic	11	1	3
	Overcrowding	8		
	Landlord/property	2	o	o
Economic Costs	Rates	9	2	4
	Prices	6	o	o
	Accommodation	2	4	4
	Occupation of land/property	o	3	1
Social Climate	Students	5	4	12
	Conservatism	4	o	o
	Local institutions distorted	1	o	o
	Rag	–	2	–

Physical Environment

Of the three items appearing in the tables under 'Physical Environment' two, 'traffic' and 'overcrowding', appear in both tables. For Reading and York the numbers are small and the categories closely related, so we have collapsed them into a single category. 'Expansion' appears only as a personal disadvantage, and 'landlord/property' only as a civic disadvantage.

'Traffic' and 'overcrowding' related to an opinion that congestion in streets, shops and other facilities was consequent upon the university in some way and degree. A young research technician in Oxford complained of 'traffic congestion because the roads could not be widened without pulling down old buildings'. And a factory employee in his forties thought that the city was 'more crowded, the cinemas, transport and so on'. A housewife in Reading was persuaded the University caused crowding in the city centre, and in York a skilled manual worker told us 'The students are a damn nuisance on the buses, not personally but the number of them – it seems they could do with a bus service of their own, one bus starts from the University and its filled before it gets near us.'

A few Oxford respondents complained of the University's or the colleges' conduct in the area of 'landlord/property'. A middle-aged factory worker told us, 'They own a lot of property which they allow to deteriorate. They let many houses stand empty in a bad state of repair, especially college properties in — Road.' The wife of a shopkeeper complained of the high rents charged by the colleges.

People in Reading and York included in 'expansion of city' objected to their town becoming larger and/or to the loss of surrounding countryside. They considered the university to be responsible. A young professional in York said that his main grumble about the University was that it has '… taken away some of the countryside which is on our doorstep'.

Economic Costs

Topics grouped under 'Economic Costs' refer to complaints that the university caused local rates[3] and prices to be inflated, that it made accommodation scarce and expensive and that it took to itself an undue amount of land and property. A businessman in Oxford thought the University '… puts up prices and rates and we have to live up to a certain standard'. A widowed pensioner complained of '… the way the rates go up because of them,' adding, '… if the government wants to have people educated it should pay for them'. In Reading a maintenance foreman complained of increased rates, and in York the wife of a labourer asserted that since the arrival of the University, '… the city has become more expensive, it just makes things dearer'. The wife of an Oxford factory worker thought that because of the University '…there was too much competition for places to rent,' a complaint echoed by a Reading housewife. Complaints about land and property (Table 6.5, line 7) reflect a fear that the University took, or would take, real estate to the detriment of other interests. A company director in York, for example, objected to the University '… taking up more agricultural land'.

Social Climate

Of the five topics appearing under this head in Tables 6.4 and 6.5, 'students' is the only one to appear in all six columns and the figures are relatively large. A young Oxford nurse found the students '… sometimes wild and destructive. In term time they monopolise the city's facilities such as cinemas and restaurants. They receive special and privileged treatment.' An elderly widow found the students 'rude'. The young wife of a scientist in Reading regretted the 'rowdiness' of the students, and pitied the landladies who had to put up with it. In York, a middle-aged civil servant observed '… long-haired students all over the place,' and thought they set a bad example to other young people. The wife of a foreman in her fifties was also concerned about appearances, and thought '… an intellectual community shouldn't dress so rough and crude,' adding, 'I hope they don't carry on as they do down south and there are these demonstrations.'

The subjects 'atmosphere', 'conservatism' and 'local institutions distorted' were raised only in Oxford, and it is evident from the tables that the respondents concerned are few. One Oxford lady who appears under 'atmosphere' complained, 'The attitude of the University – one gets the feeling of intruding into its own little

world when one goes into the town centre. It's a tight-knit community bound by stodginess and archaic rules. It's difficult to live up to what the University expects of town people; one feels one ought to go shopping in a ball gown.'

People whose replies have been categorised under 'conservatism' felt that progress was hampered by the influence and interests of the University. One such was a young man employed as a civil servant. Another was the wife of a shopkeeper, who instanced the problem of roads. In a related area was the feeling that local provision was bent to serve University interests, or made inadequately, or not made at all. The young wife of a business executive told us, 'The city wants to provide things at one's own level; a skating rink and bowling alley. The amenities are all oriented to university type people who own their own cars.' A young mother claimed that '… cinemas cater for the University during term, showing mostly A and X films which means that children can only go to the cinema during vacations'.

The remaining topic, the Reading rag, is illustrated by the reply of a skilled manual worker's wife, who told us 'The students show themselves up by making a nuisance of themselves during rag.' She then qualified her view, adding, 'But this has been better lately.'

The replies to these questions confirm that attitudes to the university in all three places were positive rather than negative. In Oxford, 59 per cent mentioned one or more ways in which the University made the city a better place in which to live for them personally compared with only 34 per cent who mentioned ways in which it made the city a worse place. The impact of the University is clearly greater in Oxford, but the preponderance of positive attitudes is evident everywhere. In the matter of the impact the University has on the city as a whole, 84 per cent mentioned one or more advantages in Oxford compared with 45 per cent who mentioned disadvantages. This contrast is evident in both Reading and York, with the University in Oxford having once more the greater overall impact.

Regarding personal advantages we may put together our categories, 'architecture', 'gardens and open space' and 'atmosphere' under 'Environment'. Of our Oxford respondents, 36 per cent mentioned one or more of these environmental features as an advantage. Other personal advantages in Oxford seem slight, and altogether personal advantages seem minimal in the other two places, although we may draw attention to the 10 per cent in York finding a personal advantage arising from trade and employment.

In both Oxford and York, more than half our respondents gave employment and trade as a civic advantage. The figure for Reading, although only 20 per cent, was still the largest Reading figure for civic advantage. So, when asked to cast his gaze in the direction of the advantage the university brings to the town, the largest feature to appear for the local citizen in all three places is trade and employment. The second feature, following at some distance, is the prestige the university is thought to confer on the town. Perhaps surprisingly, this view on prestige is more widespread in Reading and York than in Oxford.

As regards disadvantage, there is virtually none in Reading or York at either the personal or the civic level. In Oxford, practical issues of traffic, crowding, prices and rates are of concern, although for no more than minorities of the local citizens. In all three places students were mentioned in negative terms, but only by small numbers, the largest being 12 per cent in York in terms of civic disadvantage. And on the other side of this question, minorities of the citizens referred to the youth brought in by the university as an advantage.

The above reports on matters informants brought up in response to our enquiries. It might be thought there is a remaining question in relation to matters they did *not* bring up. In some quarters there is a continuing flow of complaint against Oxford (and Cambridge) for being elitist and socially exclusive. These complaints, which are frequently echoed in the media, are directed against Oxford with particular force, but may also be directed against other universities and, perhaps, against universities in general. At the time of our surveys the local populations were aware of a class dimension, and saw the university in its terms[4]. It seems not, though, to have been a matter of complaint, a cause of envy, resentment or any ill feeling. None of our subjects replied to our questions in ways which indicated they thought their university disadvantaged themselves or their town by being socially superior and elitist. Expressions which are the common currency to disparage, deflate, or destroy claims to superiority, such as 'snobbish', 'stuck up', 'proud', 'hoity toity', or 'egg head', 'big head' and 'anorak', were entirely absent. Such evidence as there is in our surveys seems to point in the opposite direction. The lady in York, for example, who told us she welcomed the University because it meant the city got a 'better class of people'.

As already noted, when asked what advantages the university brought to the town, more than half the respondents in Oxford and York, and one fifth in Reading mentioned economic matters such as employment and trade. This consideration was, by a large measure, greater than any other feature mentioned. Even at the personal level, 12 per cent in Oxford and 10 per cent in York referred to employment and trade. Given the salience of this issue, we look in the next chapter at the reputation of the three universities as employer.

CHAPTER 7

The University as Employer

Universities are significant employers of local labour and, as already reported,[1] the benefit most widely perceived by the local population in having a university in its locality is the employment and trade opportunity the university brings. Our three institutions had large pay rolls[2] in addition to the academic staff, so it was important in the context of town–gown relations to establish the university's reputation as employer. We used four questions to this end. The first question and the distribution of replies appear in Table 7.1.

Table 7.1 (per cent)
The University as Employer

Is it your impression that, taking all things together, the University is …

		Oxford	Reading	York
1.	A very good place to work?	40	42	67
2.	About average?	37	29	21
3.	Not a very good place to work?	12	1	2
4.	DK	11	28	10

The table brings out differences between the three places. The figure of 67 per cent for York describing the University as a very good place to work is high in any terms, and strikingly higher than the comparable figures of 40 per cent for Oxford and 42 per cent for Reading. Very few in any of the places gave a negative judgement except in Oxford, where a small but significant 12 per cent pronounce the University to be not a very good place to work. Once again, the university in Reading seems little-known relatively to local people, with 28 per cent having no opinion.

The remaining three questions concerned pay, working conditions, and security of employment. In each case, the interviewee was asked to compare the university with

the general run of employing institutions in his city. The questions,[3] together with the distribution of replies, appear in Table 7.2.

Table 7.2 (per cent)
Pay, Working Conditions, Security

Compared with most other places in (Oxford) is it your impression that the University as a place to work is: good; about average; or not so good; as regards (a) pay; (b) working conditions; (c) security of employment?

		Oxford	Reading	York
Pay	Good	11	42	46
	About average	38	29	37
	Not so good	37	1	3
	DK	14	28	14
Working Conditions	Good	43	15	61
	About average	32	25	23
	Not so good	8	16	2
	DK	17	44	14
Security of Employment	Good	75	35	65
	About average	10	23	22
	Not so good	0	1	3
	DK	15	41	10

Looking at the figures for 'don't know' (DK), it is apparent that they are again relatively large in the case of Reading, particularly the figures for working conditions and security, indicating again that opinions were less widely disseminated in Reading.

As regards pay, the situations are similar in Reading and York, a majority of those having an opinion describing their university as 'good'. In York 37 per cent gave its University an average rating on pay, while 3 per cent put it below the local norm. The figures for Reading are: 29 per cent, 1 per cent. By comparison, Oxford University had a poor reputation as pay master. Only 11 per cent described it as 'good', 38 per cent put it at the average and 37 per cent thought it 'not so good'.

Clearly, York had a good reputation for working conditions (Table 7.2, line 5). Oxford's reputation was also good, although not so good as that of York. The large number in Reading giving no opinion makes comparisons difficult, but it may be noted that the 16 per cent (Table 7.2, line 7) describing their University as 'not so good' in working conditions is larger than either York's 2 per cent, or Oxford's 8 per cent.

In respect of security of employment (Table 7.2, lines 9–12) the position of Oxford is striking, three quarters describing it as 'good', 10 per cent as 'about average' and no one at all thinking it 'not so good'. York's standing here was not quite so handsome as Oxford's, but with almost two thirds describing it as 'good', and only 3 per cent putting it below other employers in the town, its reputation was obviously high. In Reading, again, a high proportion (41 per cent) had no opinion to offer, but just over a third described their University as 'good' in this respect, and no more than a tiny 1 per cent thought it 'not so good'.

In Oxford, then, the University's reputation for the security it offers employees could hardly be better. For working conditions its reputation shines less brilliantly, but is still certainly good. It was not seen as a source of heavy pay packets, most thinking of it as no better than the average employer and some thinking it to be a relatively poor paymaster. The Reading results suggest the University figured less widely here as a place of employment in the local mind. So far as it did figure, though, its reputation was good, although the view on working conditions might be something of an exception. In York, opinions were disseminated to a surprisingly wide degree and were favourable to the University, although perhaps rather less favourable in the matter of pay. Given the recent arrival of the University in York and its relatively small size at the time, it may seem surprising that opinion on it as an employer was so widely dispersed. We suggest this can be accounted for by the prominence given to economic advantage in the publicity and public discussion accompanying the University's birth.

Our questions asked for a comparison with the general run of local employers, and our results are to be seen in this context. In Oxford an important influence, if not the pace setter, in employment and work was the motor works. The motor industry had a reputation for high wages and insecurity of employment. If it were a point of reference for our informants, then it would not be surprising that the University by comparison would emerge in the local mind as poor on pay but high on security. Considerations of this sort must also apply in Reading and York.

CHAPTER 8

Personal Association

There is a huge literature about Oxford. Much of it is biographical or autobiographical, about or by people who have been to the University. One of the striking features of this literature is the absence of any references to the town as distinct from the University. 'This is the other Oxford, the one never written about,' as one author perceptively remarks.[1] If reliance were placed entirely on this literary source, one conclusion would have to be that Newman's ideal of academia isolated from the surrounding society was not merely theory but fact as well. Twelve graduates in the volume *My Oxford*[2] give their recollections ranging over the half century from the end of the First World War. There are few references to the town in any of its aspects. Local girls appear for Martin Amis and Alan Coren, but only as sex objects. Amis tells us that when eyeing girls, his gaze extended to the locals as well as to those from the University.[3] Coren does, admittedly, know that one local girl of his acquaintance was a seat trimmer at Morris Motors, but the only other fact he records about her is that '… she had a bust you could stand a carriage clock on …'.[4] Otherwise, the town and its inhabitants are invisible. A companion book on Cambridge[5] leaves much the same impression so, in Cambridge too, as Gwen Raverat remarked, 'The town … did not count at all.'[6]

Tom Driberg was a member of the Communist Party carrying, when an undergraduate, a special commission from the party to liaise between members in the University and local party members in the town.[7] He was an active gay with a marked preference for deprived working-class youths and, from his school days, a practiced 'cottager', making contacts in public lavatories. It might be assumed, therefore, that Driberg in particular would be busy in the local community, discharging his political responsibilities and continually crossing from Christ Church, his college, to enter the neighbouring slum of St Ebbe's in search of sexual partners. He relates but one cottage experience in Oxford. It was with a University don.[8] For his whole time in Oxford there are plenty of references to dons and students, but virtually none[9] to the town in general, or to St Ebbe's. For the Oxford don Dacre Balsdon

writing on Oxford in 1957 and 1970, the town was virtually invisible.[10] Many other examples suggesting town 'invisibility' could be cited.[11] And some writing does suggest that the University was inward looking and obsessively concerned with its own domestic affairs. The historian Trevor-Roper, writing to Bernhard Berenson, gives an account of his exposure of his colleague,[12] the 'charlatan' historian Stone, and long accounts of University elections.[13] One can only wonder what Berenson, an octogenarian American art critic resident in Italy, made of it all. Isaiah Berlin was immensely successful in the embassy in Washington in the Second World War, his work reportedly attracting the attention of Churchill himself. At the cockpit of momentous world events and *persona grata* everywhere, he still had time to be concerned as to why Stuart Hampshire was not to have a job at Balliol,[14] and is intensely concerned with what most people would regard as the trivia of Oxford life, to which he was obviously eager to return.[15] And to those outside the University it must be a matter of surprise that Lord Cherwell, professor of physics, Churchill's friend and wartime scientific advisor, altogether a cosmopolitan figure of wealth and sophistication, entirely at home in the large world outside Oxford, should be sufficiently concerned about a local matter to take steps to sue his college over the precedence it accorded him at the college table.[16]

Written records are not an entirely reliable source. We cannot assume that things not written about do not, therefore, exist. Nor can it be assumed that all participants in encounters see them in the same way as the person writing about them. In fact, contacts of various kinds are, obviously, maintained across the boundary with the local community. Most dons' households up until the Second World War would have employed servants. A study in the 1930s found 'an enormous preponderance of females' in the Summertown and Wolvercote wards of North Oxford. It was suggested that their presence could be explained by the fact that the area was occupied by 'servant-keeping families'.[17] Students, too, in college or residence halls are looked after by servants and necessarily have contact with them. Only just over half of Oxford students lived in college or University hostels in 1964, the remainder living in local lodgings with landlords and landladies.[18] Such contacts are sometimes mentioned. Alan Bennett, who spent eight years in Oxford, refers to his Oxford landlady, 'a good soul', but only to record she cooked breakfasts which he found inedible.[19] And contacts may be close and in some ways intimate, but they are tightly structured and strictly separated from other social relations, which have a different social significance and a different value. Emlyn Williams learnt about these matters in the 1920s when he met his scout for the first time. Williams attempted to shake hands and invited the scout to sit down. These were 'dreadful solecisms'. The scout did shake hands but only just, and Williams comments, 'I knew that I would never get any nearer to him than this'.[20] In Cambridge for John Vaizey[21] in the late 1940s, and for Piers Paul Reid[22] in the late 1950s, college servants make a fleeting appearance but only as grotesques, socially and intellectually remote from the authors.

Physical proximity and social distance is familiar enough, and is a combination frequently used in drama and literature for dramatic effect. As already noted,[23] it provides the terms in which Hardy describes Jude's Oxford. Much biography, autobiography and other writing, as we suggest, indicate the town–gown relationship is indeed to be seen in these terms. Our surveys provide a view of the same scene, not necessarily different, but from another angle and perspective from that found in the literature. Before taking this view, we need to make some general observations. We asked about direct contacts. There are indirect contacts which might be important, but about which we have no information. In Oxford, for example, wives and daughters of dons[24] appeared on the scene from the late nineteenth century, when dons were first permitted to marry. They were active in social life and were 'ubiquitous' in social services[25] where, necessarily, they made contacts with poor and deprived citizens outside the range of their own social class. This sort of contact was made possible by the availability of domestic servants, which released the time and energy of their employers which could then be directed elsewhere. It was attenuated, if not stopped altogether, by the disappearance of the domestic servant at the time of the Second World War.

We may note, too, that at the time of our first survey in the early 1960s, universities were overwhelmingly male institutions. Three quarters of students[26] were men, as were no less than 90 per cent of dons. Only one fifth of the female dons had children and two thirds were spinsters. We can only speculate what effect this demographic profile may have had on relations with local communities. Children are frequently bridges into the community. Given the domestic division of labour, with wives being principally responsible for child rearing, it seems that this bridge would have served secondary contacts with dons through their wives, rather than direct contacts.

There are other features, too, which have a bearing on contacts. There were some 9,000 students in Oxford, and some 2,000 in Reading. So there were about nine students for every hundred citizens in Oxford, and some two for every hundred in Reading. Undergraduate students would be absent in vacation, so this would reduce opportunity for contact. Only 2 per cent in Oxford lived at home and 51 per cent lived in college. In Reading, 5 per cent lived at home and 56 per cent lived in 'hall'. More women than men were accommodated in college or hall than men. There is also an historical dimension which is important in, for example, comparing Oxford with Reading. Oxford has been a relatively large institution for a long time, so the opportunity for local contacts to have been made over time is that much greater. Reading has been a smaller institution, although it had expanded by 74 per cent in the decade prior to our interviews. There were 1,000 dons in Oxford, rather less than one to every 100 citizens and 400 in Reading, roughly one to every 250 citizens.

We asked questions to determine how far our samples had personal contact with dons, students and employees of their local university. The questions concerning dons, together with the distribution of replies appear in Table 8.1.

Table 8.1 (per cent)
Contact with Dons: Acquaintance

Are you, or have you ever been, personally acquainted with any of the (Oxford) dons?

			Oxford	Reading	York
1.	Yes	One only	11	5	8
2.	Yes	Two or more	24	21	7
3.	No	–	64	74	83
4.	DK	–	1	0	2

From Table 8.1, it is apparent that a little more than a third in Oxford and a little more than a quarter in Reading claimed personal contact at this rather minimal level. The figure for York is 15 per cent. This rank order was to be expected, given differences in size and age between the universities. Comparing Oxford with Reading, though, it might be expected that the numbers claiming contact would be in proportion roughly to the size of the university. From this perspective the Reading figure is large, or the Oxford figure small. But the pattern of residential distribution and a host of other factors must bear on personal contacts. In Oxford, for example, 16 per cent of the dons lived in college, and a further 48 per cent lived in central or north Oxford; only 11 per cent lived in East Oxford and 28 per cent lived outside the city boundaries.[27] In addition to the contacts uncovered here, there must, too, have been others where our informants were unaware that their acquaintance was a don.

Looked at from the other end of the telescope, as it were, our figures indicate that almost two thirds of people in Oxford and almost three quarters in Reading had no acquaintance, and had never had any personal acquaintance with their local dons. There is not much that can be said about the 83 per cent in York having no acquaintance, given the youth of the institution. The figure has certainly diminished as time passed.

Interviewees claiming an acquaintance were next asked if they had ever visited, or been visited at home. In Oxford 52 per cent, and in both Reading and York 42 per cent, claimed a visiting relationship with at least one don. These figures represent 18 per cent of the sample for Oxford, 11 per cent for Reading and 6 per cent for York. Pursuing the subject further in Oxford, we asked all those on 'visiting terms' if they numbered any of the dons among their best friends. Thirteen, or 5 per cent of our total Oxford sample, said they did.

Table 8.2 (per cent)
Contact with Students: Acquaintance, etc.

Are you, or have you ever been, personally acquainted with any of the University students here?
Have you ever been visited at home by any of the University students?
Have you ever had any of the University students staying with you as lodgers or guests?

		Oxford	Reading	York
1.	Acquaintance: yes	58	37	15
2.	Acquaintance: no	42	61	83
3.	DK	0	2	2
4.	Visit: yes	18	17	5
5.	Lodger or guest: yes	22	5	2

From Table 8.2, it is evident that 58 per cent in Oxford claimed an acquaintance with at least one student, the proportion declining to 37 per cent for Reading and declining further to 15 per cent at York. The questions about visiting and lodgers were put only to those with an acquaintance.[28] Projected to the total sample, our figures indicate that some 10 per cent in Oxford had received a visit from a least one student and 13 per cent had had a student as a lodger or guest. Comparable figures for Reading are 6 per cent and 2 per cent.

For York, the figures are too small to be of significance. This was anticipated so, as already reported,[29] we also asked our York informants if they would be prepared to take a student as a lodger, assuming they had room. Thirty-six per cent said they would and 61 per cent declared they would not, the remaining 3 per cent saying they did not know or simply failed to reply. It would be a mistake to assume that a large part of the population in York would, if asked, come forward with offers of student accommodation. But as an expression of general good will towards the local University and to its students too, the figure is impressive.

It is important to note the wording[30] of the questions. They ask for any acquaintance at any time. Thus a respondent who had made, say, one acquaintance thirty or more years previously and had made no other should have answered in the affirmative, indicating he had an acquaintance. This means that results cannot be taken as showing that in Oxford, say, 58 per cent of the local population had an acquaintance with a student at the time of the interviews in 1964. The figure is almost certainly less. As noted above, this 'historical' dimension needs to be borne in mind when comparing Oxford with Reading.

In an Australian survey in Sydney, the large figure of 90 per cent claimed to have met a university student. The Sydney student was thought by local people to be generally, 'a decent chap'. The Sydney sociologists further report that women students were thought to be 'attractive, bright and interesting and the sort of person who would make a good wife and mother'.[31]

If we invert our attention and look at the negative side, it is evident that in Oxford 42 per cent of the local population has never at any time had personal acquaintance with any of the University students. For Reading the figure is 61 per cent, and for York it is 83 per cent. Again, the figure for York is relatively small because of the youth of the institution. The York figure for those with no acquaintance will have fallen with the passage of time.

Universities are significant employers of local labour and, as we have reported,[32] one of the benefits widely perceived by the local population was the employment opportunity a university brings. Each of our three institutions, in addition to its academic staff, employed a considerable number of people in support roles.[33]

Reading University, at the time of our survey, employed 789 full-time or part-time craftsmen, domestic, ground and laboratory staff. We call this group 'servants'. In addition, there were 170 administrative, library and clerical workers. We call this group 'clerks'. The ratio of servants to students was 1:2.8; and of servants and clerks together to students 1:2.3. York University employed 455 servants and 177 clerks. The ratio of servants to students was 1:3.6, and of servants and clerks to students 1:2.6.

Oxford University, as distinct from the colleges, employed 1,584 servants and 808 clerks.[34] It was not practicable to obtain details of employment for each of the colleges,[35] so we obtained details for two colleges which we judged to be in the middle of the range for size. One had seventy-eight servants and twelve clerks, and the other had fifty-eight servants and eleven clerks. Taken together, the two colleges had one servant for every 4.9 students, and one clerk for every 30.6 students. Projecting these figures to all the colleges taken together suggests there were 1,840 servants and 310 clerks in college employ. Then, combining the figures for the University and the colleges, we have totals of 3,423 servants and 1,118 clerks. So, on these figures, the ratio of servants to students for Oxford was 1:2.7, and for servants and clerks together the ratio is 1:2.0.

Putting this material together, we have for Reading: total support staff 959; ratio, support staff/students 1.23. Comparable figures for York are 632 and 1.26. And for Oxford, 4,541 and 1.2. Figures of this order seem to have been general for British universities at the time. A study at Birmingham University, for example, found there was approximately one full time employee for every two students.[36]

Our figures demonstrate that in each of our three cities the university was a large employer, and it can be assumed that the web of association through employment is a significant feature in town-gown contacts. Some of the jobs would have been part time, and many of them were for women. In York 61 per cent of the servants and 85 per cent of the clerks were women, and at Oxford University as distinct from

the colleges, 37 per cent of the servants and 80 per cent of the clerks were women. In addition to posts created directly, there were those created indirectly. Many of these would have produced contacts between employees of contractors and servicing firms and the university in one or more of its aspects.

To examine the extent to which direct contact had been established with the local community through employment, we asked informants if they were currently, or if they had ever been, employed by the university. Twelve per cent in Oxford,[37] 4 per cent in Reading and 1 per cent in York replied in the affirmative. In our Oxford sample, 47 per cent with this direct employment experience were clerks, and this figure seems large in relation to figures for Oxford given above. The majority of the 'clerk' category was female, and it seems likely that there was a large labour turnover in this group as women entered and left employment in ways determined by marriage and family responsibilities. This could account for the size of this figure. But whatever the explanation, it means that, so far as gross numbers are concerned, contact in this area is weighted towards people in clerical work.

We explored another dimension by asking our interviewees if they knew, or had ever known, an employee of the university. In Oxford we asked those who claimed any such contact whether it was one employee only, or more than one. 'To know' is clearly open to a range of interpretations, so to obtain a level of consistency our interviewers were instructed to take the term in a broad, inclusive sense, and to press the question until they were satisfied that all contacts, even if only of a slight kind, had been reported. Forty-two per cent in Reading and 47 per cent in York claimed a contact. Almost three quarters made a similar claim in Oxford, and 62 per cent claimed two contacts or more. Table 8.3 summarises the position.

Table 8.3 (per cent)
Contact with University Employees

Do you know, or have you ever known, anyone who as been employed by the University?

		Oxford	Reading	York
1.	Yes: one person only	11	42	47
2.	Yes: more than one person	62	0	0
3.	No	26	54	51
4.	DK	1	4	2

Disregarding respondents who had themselves worked or were working in the university, the proportion claiming contacts with university employees was: Oxford, 61 per cent; Reading, 38 per cent, York; 46 per cent.

The relatively large figure for Oxford was to be expected. But the figure for York, large in relation to that for Reading, is surprising since Reading employees were more numerous and Reading University longer established. There seems no obvious explanation. Staff turnover in Reading may be low. Or it may be that the web of personal associations through kin and friendship is more extensive in York, increasing the likelihood of any one resident falling in with a University employee. York University being a new institution, growing rapidly and taking on labour, attracted attention as a place of employment, and this feature was much canvassed as one of its advantages in the public discussion which accompanied its foundation. So the subject was probably a topic of widespread discussion. Work opportunities in the University were expanding rapidly as the University grew so, perhaps, people interested in obtaining work in the University sought out others already employed there in the hope of advancing this interest, as well as to obtain first hand information about pay, conditions and so on.

We have no material to set against our findings, and it may be that similar figures would have been obtained if we had put our questions not about the university but about any other substantial local employer. We can do no more than record our own surprise that, in the sense discussed here, association between these universities and the local community is as extensive as we found it to be.

CHAPTER 9

Activities

A way in which we can expect town and gown to come together is by the university extending its inherent activities beyond its walls and into the local community. In Oxford the University's medical faculty has perforce to extend in this way, local people providing medical dons with patients and providing their students with examples for study and practice. In this perspective, local citizens will have a continual and lifelong association with their University. We have not looked at this association, although it may have bearing on the contacts made with dons and students which we do examine.[1] At Reading and York the matter is immaterial since neither has a medical faculty.

Before looking at teaching, we may mention briefly the community movement in Oxford. The University is famously connected with Canon Barnett and the settlement movement, which encouraged young men from the University to settle in poor areas to provide leadership and generally to foster contacts across class and economic lines.[2] At the time of our studies, the city had a network of fourteen community associations. Strongly supported by the local authority, the associations were located mostly in the east and south-east of the city, and were served by four full-time wardens and a director of community services. They are not, and are not intended to be, identical with settlements, but have sufficient in common with them to entitle an observer to expect the Barnett impulse to carry University people into membership and to be prominent in leadership.[3] There was a connection between St Anne's College and the Rose Hill association, but otherwise there seems to have been no leadership provided by the University or any connection between the University and the associations. The association in south Oxford was in walking distance of St Catherine's Society,[4] Pembroke and Christ Church colleges but there seems to have been no contact with them. The provision of amenity in many of the associations had, by the early 1960s, fallen below those achieved by even very poor working-class households, and this may have been a disincentive to membership[5]. But whatever the explanation, this

potential bridge between the University and local communities seems not to have been crossed.

In any concept of a university teaching must be acknowledged an inherent activity and, taking the Newman perspective, we must also include sport and artistic activities such as drama. We put questions to our samples to determine how far local communities were in contact with their university in at least providing students or audiences for these activities.

Teaching

There is a venerable tradition of university extra-mural teaching. From the time, at least, of F. D. Maurice and the Christian Socialists of the 1840s, a number of people in universities have been concerned to provide academic education for the general population, and particularly that part of it which has had little experience of education of any sort. Formal provision came with the University Extension Movement in the 1860s, and on an initiative of Benjamin Jowett, Oxford entered the scene in 1878 and later made institutional provision by the creation of a special department in 1892. The tradition has continued vigorously in Oxford and elsewhere, and in the year of our first survey more than 6,000 courses for the general public were provided in the country at large by university extra-mural departments, in addition to many others provided jointly with the Workers Educational Association. Neither Reading nor York had special extra-mural departments, although Reading provided some external courses and the public was permitted to attend some lectures. But both Reading and York were serviced principally by extra-mural departments from elsewhere. In addition to formal provision, many local and professional associations called on the university when seeking a speaker to address them on some special occasion or on or some particular topic, so we could reasonably expect a significant amount of town–gown contact to have been made in this way.

The question we put here and the distribution of replies are shown in Table 9.1. We asked if informants had *ever* attended, so an attendance however far in the past would have counted. We did not probe to ascertain if the lecturers were actually on the staff of the local university, so it is possible that lecturers from Leeds, for example, would have been included in the York replies, or from Oxford in the Reading replies. Column iv in Table 9.1 relates to a different question which we deal with below.

Table 9.1 (per cent)
Lectures

Have you ever been to a talk, lecture or class given by any of the dons?

	I Oxford	II Reading	III York	IV [York Only] *Future interest?*
Yes	10	14	4	33
No	87	85	94	65
DK	3	1	2	2

Clearly the large part of the population in each place had been left untouched by this sort of outreach effort, and the ideals of people such as F. D. Maurice and Benjamin Jowett had been but poorly realised. The figure 10 per cent for Oxford seems small in relation to the 14 per cent for Reading. All things considered, the Oxford figure would have been expected to be the larger and by a considerable measure. There seems no obvious explanation.

The 4 per cent for York (Table 9.1, column III) may seem large since the University was but recently established. Attenders at extra-mural activities are, as our figures indicate, not numerous, but they are famously enthusiastic. They are likely to start attending in the early stages of provision and to continue attending year after year. If this is the case, we would expect the figures for attendance to approach a ceiling quickly and then to remain stable. On this view, the York figure would represent an early stage of rapid growth destined to stabilise subsequently at a modest level.

We also asked all interviewees in York if they would be interested in attending in the future, since we might reasonably assume that any limits on provision at the time would disappear and extra-mural opportunities be extended as the University grew. The distribution of replies appears in column IV of Table 9.1. The large figure of 33 per cent declaring they would be interested stands in dramatic contrast to the figures of 10 per cent and 14 per cent who had at any time actually attended in the other two places. An expressed interest in enrolling for lectures and classes is probably like New Year resolutions, in that the expression is unlikely to be put into practice. But perhaps the figure ought not to be dismissed entirely. Given appropriate provision and advertising the demand might be larger than the figures for attendance in the other two places suggest, although never approaching the 33 per cent shown in Table 9.1.

Altogether, ninety-five York people declared an interest in lectures and we asked them which subjects would attract them. Seventy-seven, constituting 26 per cent of the total sample, gave us one or more subjects. The subjects when grouped were: history/archaeology 25 per cent; science/technology 23 per cent; music/art/drama 19 per cent; social studies 17 per cent; current affairs 14 per cent; other 47 per cent.

Drama and Sport

Although from the Newman perspective activities such as sport and drama were central to the university experience, they were still extra-curricular. And this was generally the case at the time of our studies, although there were examples of this sort of activity figuring in the formal curriculum: Birmingham University, for example, was a pioneer in recognising sport in this way. But universities, in some sense, were no different from other institutions whose members, coming together for one purpose, find additional shared interests and then make arrangements for them. From this perspective we can expect a community of interest extending beyond the university walls in a way, and to an extent we could not expect in the case of central academic activities. So, these 'amenity' activities should be particularly productive of contacts between town and the university.

Oxford was, generally, the best provided for amenity activity. It had a theatre, the Playhouse, which it reconstructed and reopened in 1963. In addition, many of the colleges and associated gardens provide ideal settings for shows of various kinds. The Oxford University Dramatic Society presented four productions a year, and the Opera Club one. There were also productions by the Experimental Theatre Club. Most colleges had dramatic societies producing at least one show a year. There were also numerous musical societies, and some long-established groups with open membership such as the Oxford Bach Choir, the Orchestral Society and the Choral Society. College chapels ensured that sacred music was well represented.

Most of the colleges had playing fields,[6] and there was a University athletic ground to the south-east of the city and a cricket ground and tennis courts to the north of the central area. Just south of the city centre there were facilities for rowing, including boathouses and barges. Cricket, rowing and rugby were probably the most important sporting activities and provision for other sports was less generous. The University had no swimming pool, for instance, and the indoor municipal pool was small and located in the outer suburbs.

Reading had a University orchestral society, a choral society and the Palestrina Choir, each giving two concerts annually, and an opera society staging one production a year. The student music club occasionally brought in professional musicians, and the University drama society presented plays. A major event associated with the University was the annual Reading Festival covering music, film and other aspects of the arts. Sports facilities were concentrated on the main Whiteknights campus, and the University had a boathouse on a fine stretch of the Thames where it organised an annual head of the river race, a large event attracting many competitors.

At York there is an interest in music encouraged by the University in a number of ways. There was a department of music, sometimes described as 'strong but avant-garde'. There was a University orchestra and choir and other groups, including one for medieval music. Performances open to the public were given frequently. There was a drama society running experimental sessions as well as producing plays. York also had a boathouse. It was on the Ouse, about a mile from the Heslington site.

At the time, York seemed to be fostering a rivalrous relationship with Lancaster University with, perhaps, the old Oxford–Cambridge model in mind.

Table 9.2 gives our question posed in relation to shows and concerts, together with the distribution of replies. Column IV of Table 9.2 gives the response when York informants were asked if they would be interested in attending in the future.

<div align="center">

Table 9.2 (per cent)
Plays and Shows

Have you ever been to any of the plays, shows or concerts
that university groups have put on here?

</div>

	I Oxford	II Reading	III York	IV [York Only] *Future interest?*
Yes	29	15	7	59
No	71	85	91	38
DK	0	0	2	3

In Oxford, contact at 29 per cent on this dimension is greater than in the other two places, and is noticeably greater than the comparable Oxford figure for lectures. In York it is larger than for lectures although still small, while in Reading there is little difference. The potential audience in York, standing at 59 per cent (Table 9.2, column IV), is huge, although the observations made above in relation to declarations of intent in respect of lectures and subsequent attendance at them need to be borne in mind here too. York respondents who professed an interest were then asked what in particular they would like to see. Plays were mentioned by 77 per cent, concerts by 32 per cent, variety shows by 15 per cent, musical comedies by 7 per cent. A further 13 per cent mentioned other items, although none was mentioned by a significant number.

All informants were asked if they had ever watched any university sports or athletic activities. Participation was largely a matter of watching, although Oxford United Football Club played on college grounds against teams drawn from college servants. The mixing of students actively with the town population in sport was limited; most University sporting links were inter-collegiate or with teams outside Oxford.[7] Interviewers were given special instructions in relation to the word 'watched', being told to probe to ensure that the informant had been present in person and had not, for example, just seen the Boat Race or the Varsity Match on television. In addition, interviewers were instructed to make a further distinction between 'watched' and 'seen'. To be accepted, a claim to have 'watched' needed to include an element of interest and purpose. This probe was designed to exclude respondents who happened to witness an activity merely because it lay in their path.

Table 9.3 gives the question used and the distribution of replies. Column IV of the table gives the replies evoked when York respondents were asked if they would be

interested in watching in the future. Subsequently we asked people who had watched something, what in particular they had watched. Those mentioning only one activity appear in Table 9.3 line 1, those mentioning two or more appear in line two of the table.

Table 9.3 (per cent)
Sports

Have you ever watched any of the university sports or athletic activities?

	I	II	III	IV [York Only] Future interest?
	Oxford	Reading	York	
Yes (one type of activity only)	42	23	4	22
Yes (two or more types of activity)	24	10	2	18
No	33	67	92	57
DK	1	0	2	3

Evidently, 66 per cent of our Oxford sample had watched University sports, and 24 per cent had watched more than one type of sport. Comparable figures for Reading are 23 per cent and 10 per cent, for York 4 per cent and 2 per cent. Our samples excluded people under twenty-one years of age. Sport is of particular interest to the young, so we can assume our figures here are a considerable underestimate of the true totals. Sport was also largely a male preoccupation. Taking men only from the samples, no less than 85 per cent in Oxford and 44 per cent in Reading declared they had watched some sport on at least one occasion. In York, 59 per cent said they would be interested in watching university sport in the future.

Our findings suggest sport is an important point of contact, and more important than lectures or drama and shows. In Oxford, the 66 per cent who have watched sport dwarfs the 10 per cent who have attended a lecture or class, and is much larger than the 29 per cent who have attended a play or show. In Reading, the 33 per cent who have watched sport is markedly larger than the 14 per cent who had attended a lecture, or the 15 per cent who had attended a play or show. The York figures for sport attendance are low, no greater for example than for those who have attended a lecture, and actually lower than for those who have attended a dramatic production. And the 40 per cent in York expecting to watch sport in the future seems small in relation to the 59 per cent with this expectation for drama. Perhaps it is small, too, compared to the 33 per cent who anticipate going to lectures, given the relative unpopularity of lectures suggested by the small numbers our figures show for people actually attending them.

Table 9.4 (per cent)
Type of Sports

Which type of activity have you watched most?

	Oxford	Reading	York
Rugby	46	33	30
Cricket	37	–	21
Rowing	28	27	–
Athletics	17	12	29
Soccer	16	27	39
Tennis	3	4	16
Hockey	–	14	–
Swimming	–	–	12
Other	9	27	27
N(= 100%)	154	66	108

Table 9.4 summarises the replies given when informants who had watched something were asked which activity they had watched most. Activities mentioned by only a small number are grouped together under 'Other' in Table 9.4. The York figures are not strictly comparable, as the question was put not only to respondents who told us they had actually watched something, but also to those who only declared an interest in watching.

Rugby, clearly, is popular everywhere, although it falls behind soccer in York. Cricket is popular, although Reading cricketers seem to have been invisible. Rowing appears significant, although in York no one expected to be interested in watching it. Athletics had a fairly large following, and some interest was shown in York. York provided a large figure for soccer, which also attracted interest in Reading. There was interest, too, in Oxford, although here soccer trailed behind rugby. Tennis appealed to a small minority in Oxford and Reading, and there was potential for it in York. Hockey was popular in Reading, and an interest was evident for swimming in York.

Local conditions must have had a bearing on our findings. Oxford had one public indoor swimming pool; it was small, and in the city's outskirts. York had four pools. This difference may have a part in explaining the contrast shown in our figures for interest in swimming. Charges, or lack of them, may have a part, too, in providing explanations for some of the features in the tables. First-class cricket is available in University parks in Oxford free of charge. Audiences are usually charged for attendance at plays and shows, and sometimes at lectures too, and charges will weigh down the cost side in the cost–benefit balance for potential spectators and audiences.

CHAPTER 10

The University's Physical Presence

Our three universities constituted a large physical presence in their city environments. In 1948, almost a quarter of the area within the City of Oxford was owned by the University or the colleges, and large areas lying immediately outside the city boundaries were also University or college properties.[1] University premises in Oxford dominated the town centre,[2] although there was no 'campus', nor any point which was the recognised academic centre. The University was a federation of colleges, each with its own site and buildings, and there were, too, museums, libraries, laboratories and departments all intermingling with non-University properties. In Reading[3] the principal location was Whiteknights Park, occupying 200 acres at the south-eastern edge of the town. The University also had farmland outside the city boundaries. The other important town site,[4] of some 8 acres, lay between Whiteknights and the centre of town. York University occupied[5] a main site of 170 acres at Heslington, just outside the city boundary to the south-east, as well as smaller properties in the city. Reading and York had embarked on construction programmes before our surveys, and their buildings in the main locations could be seen together as architectural wholes. This enabled us in some cases to put the same questions in both places. Oxford required a different approach, and we present those findings separately below.

Geography is of consequence, so we determined in terms of their own residence how far our informants were from their university, taking the Sheldonian Theatre as the centre point for Oxford, Whiteknights for Reading and Heslington for York. No more than 5 per cent in any of the three places lived within a half mile of these points. In Oxford 30 per cent lived within 1 mile and 47 per cent within 1½ miles. Comparable figures for Reading are: 24 per cent, 36 per cent; for York 18 per cent, 36 per cent. In these simple terms, therefore, Oxford is closer to its local community than either Reading or York.

Distance is an imperfect measure of access. In Oxford, the river system is a barrier between Cowley to the east and the city centre. The Thames flows through Reading west to east, and a railway runs parallel to the river to its south, constituting barriers

between the Caversham area and the University. The Kennet flows into Reading from the south, and separates the University from Southcote in the south-west. Similar points can be made in respect of York, which is cut by the Ouse and by railway lines coming to the city centre from the north, north-west and the south. Apart from geography, access is also influenced by public transport provision and by parking and road congestion. The extent to which the university is close to destinations, such as shops and theatres, to which citizens would travel in the ordinary business of life also bears on the degree they are put into contact with university premises. Given local geography, this consideration suggests that people in Oxford are 'closer' to the University than is the case in Reading and York.

Respondents in Reading were asked if they had ever been in Whiteknights Park, and 77 per cent declared they had. They were then asked if they had ever been in any other part of the University, and 36 per cent declared they had. We also asked if they had seen any of the new buildings in the Park, and 57 per cent claimed they had.

A different approach was adopted in York where some questions were used as 'filters', determining whether or not the person being interviewed would have a subsequent question put to him. We found 74 per cent claimed to have seen the new buildings at Heslington, 51 per cent claimed to have been on the Heslington site and 17 per cent claimed to have been in the buildings.

It seems anomalous that 77 per cent in Reading had been in Whiteknights, but only 57 per cent said they had seen the University buildings. It seems strange, too, that in York 51 per cent told us they been to the Heslington site, but 74 per cent claim to have seen the buildings. In Reading the fact that Whiteknights Park had been a feature in the city for many years before the University acquired it probably explains this difference. In York the University had been featured in the media and pictures seen here, particularly on television, may account for this apparent anomaly. These matters apart, it is striking that more than a third in Reading had been to some part of the University other than Whiteknights and more than half had seen the new buildings, and that in York more than half had been to Heslington and 17 per cent had at some time been inside University properties.

All those who claimed to have seen the university buildings were asked to give an opinion on them. The question and the response appear in Table 10.1.

Table 10.1 (per cent)
How the New Buildings Appear

On the whole do you find these new buildings:-

	Reading	York
(1) Attractive to look at?	78	74
(2) Unattractive to look at?	14	16
(3) Neither attractive nor unattractive to look at?	8	10
N(=100%)	119	206

Six people in Reading and nine in York felt unable to push their opinions into the categories offered. Of the remainder, it is apparent that some three quarters in each place declared the buildings attractive. Minorities of 14 per cent and 16 per cent found them unattractive, while further small groups were unwilling to commit themselves.

Our categories are clearly limiting, and some interviewees demanded to step outside them. One York citizen thought the word 'unattractive' wholly inadequate and insisted on substituting 'hideous'. In Reading some respondents qualified an overall view by commenting on particular points, one describing the chemistry building as 'hideous' and the library as 'bad'. We did not invite these comments, and they serve only to illustrate what might have emerged if we had explored the topic in more detail. The two distributions in the table are surprisingly similar given actual differences on the ground. Perhaps any cluster of new buildings would attract a similar distribution of opinion from the general public. Even if this speculation is correct, it is important to note that the new physical presence of the universities met with wide approval.

In Oxford, we read out to informants the names of nine institutions and the name of the street in which the principal entrance was located. For each they were asked if they had ever visited it and, if they had, if they had visited it in the previous twelve months. The institutions in the order presented are shown below. Figures in parentheses give the extent of properties and for museums the exhibition space. The numbers for visitors are from visitors books for the year prior to the survey[6].

Magdalen College (40 acres)

Magdalen College is a fifteenth-century foundation with 'new' buildings added in the eighteenth century. Among its attractions is a bell tower dominating the college frontage and providing the main feature of the eastern end of the city's High Street. There is a grove with fallow deer, a chapel with a celebrated choir and some fine

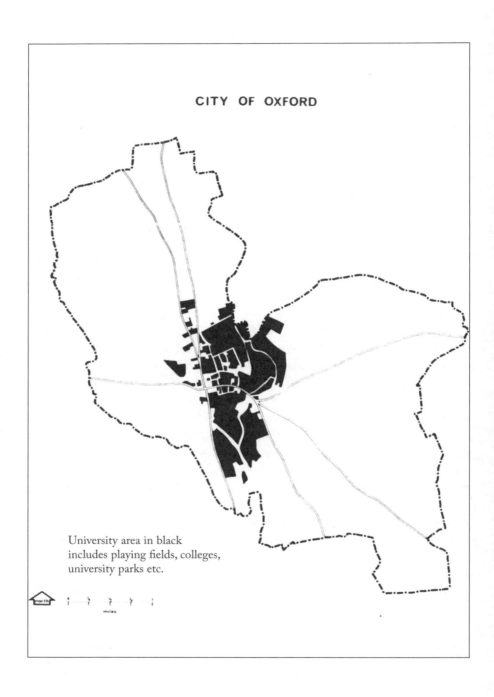

CITY OF OXFORD

University area in black
includes playing fields, colleges,
university parks etc.

portraits in the college hall. A bridge across the River Cherwell leads on to pleasant river walks.

Christ Church (65 acres)
In the chapel of Christ Church, founded by Cardinal Wolsey in the sixteenth century, there are some notable tombs and windows designed by Burne-Jones and executed by William Morris. The chapel is also Oxford's cathedral. Wren's famous Tom Tower sits over the main gate, while in the great hall are celebrated portraits of Queen Elizabeth I, Henry VIII and others. The adjacent Christ Church Meadow is a large area of rough pasturage usually occupied by grazing cattle. The public has access round the perimeter, which provides attractive walks and a fine view of the southern aspect of the city.

Worcester College (26 acres)
Worcester College was founded in the eighteenth century, and its main buildings are in the classical style of the time. The gardens contain some large and handsome trees and there is a lake with exotic water fowl.

St John's College (12 acres)
St John's is a sixteenth-century foundation. It has celebrated buildings and particularly lovely gardens laid out by Capability Brown.

Sheldonian Theatre (4,500 visitors)
The Sheldonian was designed by Wren in the seventeenth century, and is the scene of the University's annual Encaenia, at which honorary degrees are awarded, as well as other ceremonies. An attraction is a cupola providing extensive views over the city.

Museum of the History of Science (4,000 sq. ft., 7,000 visitors)

University Museum (Natural History, 18,800 sq. ft.; associated Pitt-Rivers Museum, Ethnology and Anthropology 12,410 sq. ft., 10,000 visitors.)

Ashmolean Museum (Art and Archaeology, 43,000 sq ft.)

Bodleian Library (Exhibitions of manuscripts, portraits and other items)

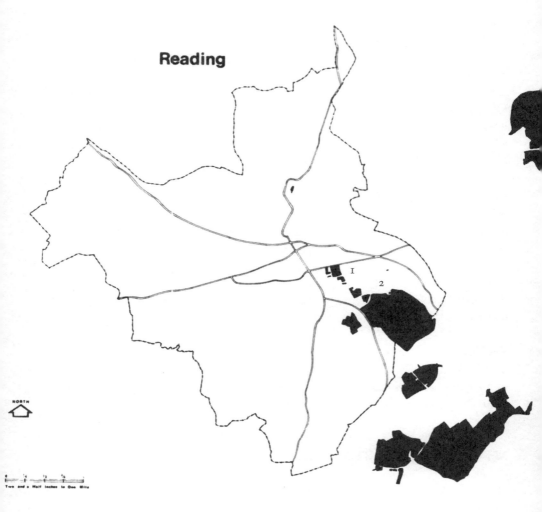

University areas in black.
1: London Road
2: Whiteknights Park

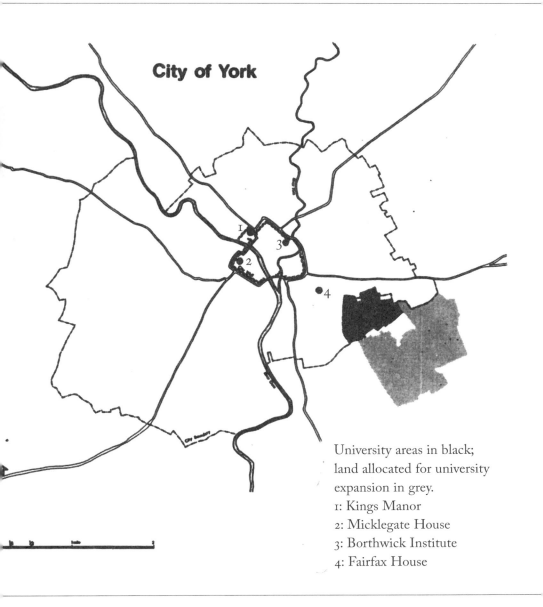

City of York

University areas in black;
land allocated for university
expansion in grey.
1: Kings Manor
2: Micklegate House
3: Borthwick Institute
4: Fairfax House

Table 10.2
Institutions Visited

I	II	III	IV	V
Institution	Ever Visited	Visited in Year Prior to Interview	Visited in year Prior to Interview	Column III / Column II
	%	%		
Christ Church	88	42	31,200	.48
Magdalen	77	32	23,800	.42
Ashmolean	67	19	14,100	.28
Worcester	59	17	12,600	.29
University Museum	54	11	8,200	.2
Sheldonian	50	6	4,500	.12
St John's	49	14	10,400	.29
Bodleian	34	6	4,500	.18
Museum of the History of Science	22	2	1,500	.09

Table 10.2, column II, shows the percentage who had ever visited for each institution. Table 10.2, column III, gives the percentage who had visited in the twelve months prior to interview. To give an idea of the actual numbers involved, we have projected our figures in column III onto the Oxford population aged twenty-one and over. The results appear in column IV,[7] where the figure 31,200 for Christ Church indicates that this number of local Oxford people had visited Christ Church in the course of the year. The comparable figure for Magdalen is 23,800, for the Ashmolean 14,100, and so on.

These figures relate to visitors and it is certain that some people visited more than once in the course of the year, so our figures must be underestimates of visits, as opposed to visitors. Assuming that the more frequently a place is visited, the larger will be the number who had visited recently, relative to the number who have 'ever' visited, then some idea of the importance of multiple visits can be given by expressing the figures in Table 10.2, column III, as ratios of the corresponding figures in column II. The ratios appear in Table 10.2, column v.

Christ Church, with a ratio of .48, and Magdalen with .42, stand out from the remainder, suggesting that they are not only visited by a large part of the population but that they are also visited relatively frequently. The Ashmolean, Worcester and St John's cluster as a second order in terms of frequency of visit.

The institutions are ranked in Table 10.2 in descending order according to the proportion of the population who have ever visited, and it may be noted that the figures in column v of the table depart from this order. The departures suggest that St John's attracts relatively few visitors but that those who do visit, visit often. The University Museum and the Sheldonian, on the other hand, attract a relatively large number of visitors who come but infrequently.

Table 10.3 (per cent)
Number of Institutions Visited

1.	Number of institutions	0	1	2	3	4	5	6	7	8	9
2.	Ever visited	8	5	9	8	10	15	17	10	9	9
3.	Visited in year prior to interview	40	19	15	9	9	5	1	1	0	1

Table 10.3 presents a conspectus of the material showing that 8 per cent had never visited any of the institutions, that 5 per cent had visited only one and so on. Table 10.3, line 3, shows that 40 per cent had not visited any in the year prior to interview and 19 per cent had visited only one.

We have drawn attention[8] to commensalism as a feature of university life, and the extent to which the local population has participated here may be regarded, if not as a measure, then as a reflection of relations between the University and the local population, drawing people into University premises at least and, to some extent, into University life more generally. Accordingly, we asked informants if they had ever taken lunch or dinner in any of the colleges, and 22 per cent told us they had. Some were, or had been, in the employ of the University, and this might be thought in some way to inflate this figure of 22 per cent. If we exclude all these 'employees' our 22 per cent falls to 19 per cent[9].

Reactions to these findings depend on the assumptions brought to their consideration. But we may bear in mind that our nine institutions under review represent no more than a fraction of the total, so our figures must represent but a proportion of all visits made. Further, our sample excluded all those under twenty-one years of age, so this must again result in an underestimate of the visits. On the other hand, all our nine places are of a character likely to attract visitors and some, Christ Church and the University Museum, for example, are in some sense public bodies not exclusive to the University. But when all these considerations are weighed, the flow of local people through these University premises is still strikingly high, over 90 per cent having at some time been personally present in at least one of the places and 60 per cent having been present in the year prior to interview.

Social Class and Money

There is a huge literature and much controversy on the subject of social stratification. Many sociologists follow Weber in recognising three strands in systems of stratification: class, status and power. Class relating to the possession of material wealth, status to the distribution of honour, power to being able to put intentions into effect. Contemporaneously with our own study, Halsey and Trow attempted to locate university teachers in terms of the Weberian categories and we draw on their findings[1]. For our own particular surveys it seemed unwise to assume a knowledge of Weberian ideas in the interviews, or even of Weber and his work at all, so we confined ourselves to asking about middle class and working class. These terms were part of the common vocabulary in British society[2] and were rather like health, in that everyone had some understanding of the terms and could, and did, talk frequently about them in ways found to be meaningful, but would still be hard put to provide a definition that would survive any sort of determined examination. Most people talking about class seemed to work with a mixture of Weber's categories, shifting the emphasis from one to the other as the occasion seemed to require. We found no one in our pilot interviews, nor in the subsequent surveys, who stared back at us in blank incomprehension when the topic of class was raised, or the terms 'middle class' and 'working class' used. Before presenting our survey findings on how local people see dons and students in terms of class, we glance at some of the relevant literature.

Much writing about universities describes, discovers, assumes or makes reference, oblique or direct, to social class. Elspeth Huxley, a student at Reading University in the inter-war years ventured into a Reading public house. She reports:

> The customers looked drab, pallid and grubby; they really did wear mufflers and cloth caps in those days, and no ties, and spat sometimes into corners, and had bad teeth to a man ... The working classes inhabited a different world from our own; a mysterious, slightly menacing and hostile world that most of us had little inclination to explore because, no doubt, of suppressed guilt;

there but for the grace of God went all of us, and there we might one day find ourselves if we were failures.[3]

Marris, in a study of university students, commented on the sense of isolation they felt because of their elite status, although they did their best to ignore a sense of privilege they could not comfortably acknowledge. A Leeds student told him:

It gives me a dreadful guilt complex when I walk down back streets because I feel there is nothing different about them. Before I wasn't very aware of class differences, but now I think, why should I be better off than they are? [4]

Emlyn Williams, the son of a Welsh publican, in his autobiography and in his play and film, *The Corn is Green*, gives the impression that getting to Oxford was the social equivalent of scaling Everest.[5] For Dennis Potter, the principal problem of being at Oxford was the tensions and general experience of transferring from a working-class neighbourhood and home.[6] The Tyneside industrialist Raymond Hicks, a graduate of the University of Wales, found, when a guest at a Cambridge college, that:

every one treated me very kindly but I was deeply aware that I was the product of the Welsh mining valley and didn't fit in with the polished atmosphere of Cambridge college life.[7]

Although all universities were seen as having something of a superior class status, there was also a perception of differentiation within the higher education system. When Leeds sixth-formers were asked to rank eight universities, they described Oxford as upper class; University College, London, as upper middle class; Essex, York, Reading and Leeds as middle middle class; and Constantine and Aston as lower middle class.[8] Many observers have commented on Oxford's position. William Hayter, writing of New College, notes:

… apart from a few boys on scholarships the College was filled up entirely with the sons of the well-to-do … the College was manned by Wykehamists and Etonians with a sprinkling of Harrovians and Rugbeians.[9]

Maurice Bowra noted, 'only those could come to Oxford who had private resources … real members of the working class were extremely few'.[10] The heads of colleges were at the apex of the social pyramid, and it is alleged that before the First World War the front entrance of Elliston and Cavell, the town's principal draper, was reserved for heads of colleges and canons of Christ Church, other customers being directed to a side entrance.[11] W. A. Spooner, Warden of New College until 1924, certainly lived in some style. On moving into the warden's lodgings he had a row of extra bedrooms built to accommodate his eleven indoor servants,[12] and he had stabling for four horses, a coach

house and accommodation for groom and gardener[13]. In 1935, twenty-two out of twenty-four heads of colleges had been educated at independent boarding schools or HMC day schools; in 1967, twenty-five out of thirty-three had had a similar school background.[14]

From 1911, the official census classified occupations according to a five-fold classification of social class.[15] For the 1951 census, professors and lecturers were placed in social class 2.[16] University professors were not specifically designated. They were a tiny group numerically at that time, and the term professor was used rather loosely. If they heard the term professor at all, most people would have come across it in the music hall or circus, where the common practice was to introduce an illusionist or some other performer with an unusual skill as Professor – or, perhaps, in shows such as the BBC's *Brains Trust*, where academics were introduced to perform similarly as clever entertainers. For the following census in 1961, university teachers as a whole were put in social class 1.[17] In 1964, the year of our Oxford survey, 20 per cent of university teachers were born into families in social class 1, and 31 per cent had been to a public school or a direct grant school.[18] Of Oxford and Cambridge dons, 29 per cent came from families in social class 1 and 54 per cent had attended public school or direct grant school. For 'minor redbrick' universities, the comparable figures are 20 per cent and 28 per cent.[19] Oxford (and Cambridge) dons, compared with those at other universities, had a high proportion with first class degrees and fellowships of the two principal learned societies.[20] These were large feathers in the academic cap, and although our local populations were probably unaware of them or their particular significance, some knowledge of them may have seeped out in a general way and contributed to an impression that dons generally, and Oxbridge dons in particular, were of some special consequence. As in all cities the residential areas in Oxford are socially differentiated,[21] the geographical pattern reflecting social class so that an address is a mark of social standing. In Oxford the superior areas of residence are to be found in the central and northern parts of the city. Of the dons living in the city, 80 per cent resided in these areas, including 20 per cent who lived in college.[22] Given the splendour of many college buildings, a college address could hardly be bettered.

So far as students are concerned, 18 per cent of university undergraduates in the country as a whole in the early 1960s came from homes in which the father was in a higher professional occupation, 71 per cent came from homes in which the father was in a non-manual occupation.[23] Only 25 per cent came from 'manual' homes, a proportion unchanged since the 1920s;[24] the proportion in Oxford in 1955 from 'manual' homes was 13 per cent; in the 'civic' universities it was 31 per cent.[25] In 1961 37 per cent of all undergraduates had attended independent or direct grant schools; for Oxford in 1964, this figure was 63 per cent;[26] for the 'smaller civic' universities in 1961 the figure was 23 per cent.[27] This differential recruitment, with its social implications, is frequently noticed. Often it is objected to as well. Michael Young, for example, exploded when he noted that Franks observed that only (*sic*) 45 per cent of Oxford closed awards went to boys from independent boarding schools.[28] There was also some evidence of a geographical pattern to Oxford recruitment, more students coming from the

south-east than from other parts of the country, and this might have an effect on the character of the student population.[29] It may also have been the case that provision for students in Oxford was rather more lavish and expensive than the provision for students in other universities. This was the burden of a complaint made to the Franks committee by Lord James of Rusholme, Vice-Chancellor of York University.[30]

The above is sufficient to illustrate that university dons and students were not recruited from the social class hierarchy in a random way, but that recruitment was biased towards the upper parts of the class system. It must not be supposed from this that representatives of the lower reaches of the social order were unknown, either in the universities as a whole or even in Oxford. In 1964 6 per cent of all dons came from families in social classes IV or V (semi-skilled or unskilled manual workers). The figure for Oxford and Cambridge was 2 per cent.[31] Of all students, 24 per cent came from 'manual' homes, and in Oxford the figure was 13 per cent.[32] And in Oxford working-class students may have been more in evidence than the figures we have been quoting suggest. In Oxford there were two whole colleges, Ruskin and the Catholic Workers College,[33] where the student body consisted not simply of the children of 'workers' but of workers themselves, plucked straight from field and factory. These two colleges were not formally and fully part of the University, but they functioned as such. Their students attended University lectures and were frequently, if not usually, tutored by the University dons. They sat University examinations and had access to the libraries and other facilities the University offers. Nor were they shrinking violets, lurking invisibly in the shadows, overawed by the University 'proper' and its socially superior dons and students. They were mature, i.e. significantly older than the normal run of undergraduates, and were mature too in the sense of having been toughened by experience in trade unions and other organisations. They made their presence felt. And a number of prominent Oxford dons, too, have had indisputably modest social origins. Joseph Wright, Deputy Professor of Philology and Tolkein's tutor before the First World War, worked in a mill from a very early age, teaching himself to read and write at night.[34] Bryan Wilson worked as a door-to-door clothing salesman in Leeds until tumbling almost by accident into University College Leicester.[35] Performing brilliantly in the examination hall and in research, he embarked on an academic career, becoming a Fellow of All Souls in 1963. Alan Bullock was Master of St Catherine's College. His father was a gardener.[36] Professor A. H. Halsey's father was a porter on the railways.[37] Geoffrey Marshall was Provost of The Queen's College. His mother kept a boarding house in Blackpool.[38] Alan Fox's father was a semi-skilled jobber in small engineering works in the east end of London. After a wide experience of Oxford,[39] Fox reported:

> Providing one's speech, dress, and table manners did not give offence, a working-class background created no obstacle.[40]

Of course these particular examples, striking as they may be, do not alter the overall statistical picture.

We turn now to impressions which our local town populations had of the university teacher in the matter of social class. We put the question appearing in Table 11.1 inviting informants to place dons in one of the six categories appearing in column 1 of Table 11.1, the first category being upper middle class, the second, middle middle class, and so on. The two categories, middle class only and working class only were not introduced by the interviewers. They arose because some respondents were unable to go beyond a general placement in the middle class or in the working class. The distribution of replies to our question is given in Table 11.1, columns 1, v and 1x. At the end of the interview we asked informants to give us details about themselves, and we put the same six social class categories to them, asking them to tell us in which of them they thought they came. Their replies are shown in Table 11.1, columns 111, v11 and x1.

Table 11.1 (per cent)
Social Class: Dons / Self

On the whole is it your impression that most dons are: upper; middle; or lower middle class: or upper; middle; or lower working class?

| | Oxford | | | | Reading | | | | York | | | |
	Dons		Self		Dons		Self		Dons		Self	
Upper middle	61		3		37		6		36		3	
Middle middle	21	89	20	38	28	73	21	44	38	79	15	25
Lower middle	2		12		6		16		5		7	
Middle only	5		3		2		1		0		0	
Upper working	2		9		3		12		6		12	
Middle working	1	3	34	57	3	6	25	46	3	9	49	69
Lower working	0		9		0		6		0		7	
Working only	0		5		0		3		0		1	
DK	8		5		21		10		12		6	

In Table 11.1, each figure to the right of the bracket is the sum of the figures to the left. Thus, in column 11 it is evident that in Oxford 89 per cent have placed dons in one of the middle class categories, 61 per cent of these placings being in the upper middle class, 21 per cent in the middle middle class, and so on. Looking at the figures within the middle class divisions, it can be seen that they are skewed. In Oxford 61 per cent are in the upper middle, and 21 per cent in the middle middle division. The comparable figures for Reading are: 37 per cent; 28 per cent; and for York: 36 per cent; 38 per cent. The summary percentages for dons make it clear that a large majority in each place perceives dons as being middle class, although small groups of

3 per cent in Oxford, 6 per cent in Reading and 9 per cent in York consider them to be working class. Relatively few respondents anywhere placed dons in the lower middle class division, although there seems to have been a greater tendency to do this in Reading and York than in Oxford. There is a distinct difference between Oxford and the other places in the figures for upper middle class, the figure of 61 per cent for Oxford suggesting that Oxford dons are seen as sitting relatively high in the class hierarchy compared with the other two places. But everywhere dons are perceived widely as being middle class, and within this class as placed in its middle or upper reaches.

In Oxford, a number of interviewers reported finding dissatisfaction with an aspect of the categories of class which they were presenting, and said that some of the people interviewed told them that they thought dons to be not middle class at all, but upper class. Our categories, obviously, made no provision for this and all these cases have been included in the upper middle class. We can only speculate as to how many would have used a category 'upper class' if we had provided it, but it does emphasise how dons are seen as being at the upper end of the social class scale, particularly in Oxford. No interviewers in Reading or York reported observations of this sort.

The numbers unable or unwilling to reply to these questions (Table 11.1, line 9) seem small, except for Reading where one in five made no reply in respect of dons. In Reading a number of our questions, including questions inviting impressions of the dons, produced a relatively high rate of 'don't know' or 'no reply'. Unless there was a failure of the interviewers to press these questions in Reading, and there is no reason to assume this, the figures here along with others, suggest that Reading University sat more 'distantly' in its town environment than did our other two universities.[41]

In Table 11.1 columns III, VII and XI show how our samples saw themselves in terms of the same class divisions. The contrast with how dons are perceived is striking. In Oxford, 38 per cent report themselves to be middle class as compared with 89 per cent who see dons in this way, and only 3 per cent see themselves as upper middle class compared with a figure for dons of 61 per cent.

Reading and York provide similar contrasts between self perception and the perception of dons, with dons being seen as middle class and the self as more working class. But there are differences. In Reading the 41 per cent reporting themselves to be middle class and only 46 per cent to be working class, together with the 6 per cent in the upper middle class category, suggest that Reading people saw themselves as rather more middle class than people in the other two places. York presents a contrast with only 25 per cent in the middle class categories and 69 per cent in the working class, suggesting that York citizens saw themselves as more working class than middle class.[42]

If we assume our categories represent a rank order of superiority–inferiority, with upper middle class at the top and lower working class at the bottom, we can produce the figures in Table 11.2.[43] The figures show how our respondents placed themselves in relation to dons: either above them, below, or on the same level in terms of social class.

Table 11.2 (per cent)
Social Class Comparison: Dons/Self

	Oxford	Reading	York
Dons placed above self	87	76	84
Dons placed same as self	13	19	14
Dons placed below self	0	5	2
N (= 100%)	209	157	253

Overwhelmingly, in each place the dons were seen as superior. In Oxford the figure is no less than 87 per cent, and no one at all placed dons below himself. The situation in York was close to that in Oxford. Reading respondents, seeing themselves somewhat differently and rather more elevated in the class scale than the respondents in the other two places, have, necessarily, to produce a difference in the comparisons. So, in Reading rather fewer placed dons above themselves, although even here the figure is still 76 per cent. And rather more (19 per cent) gave themselves the same position as dons. The proportion who placed themselves above the dons was 5 per cent.

We put the same question on social class, but this time in respect of students. The distribution of replies is shown in Table 11.3.

Table 11.3 (per cent)
Social Class: Students/Self

On the whole is it your impression that the University students here are: upper; middle; or lower middle class: or upper; middle; or lower working class?

	Oxford			Reading			York		
	Students	Self		Students	Self		Students	Self	
Upper middle	17	3		22	6		12	3	
Middle middle	31	20		24	21		30	15	
Lower middle	19	12		17	16		11	7	
Middle only	5	3		2	1		0	0	
	72	38		65	44		53	25	
Upper working	9	9		6	12		15	12	
Middle working	5	34		3	25		8	49	
Lower working	0	9		0	6		0	7	
Working only	1	5		0	3		0	1	
	15	57		9	46		23	69	
DK	13	5		26	10		24	6	

It is clear from Table 11.3 that rather large numbers appear in the 'DK' category for Reading and York. The figure for Oxford, at 13 per cent, is smaller but still fairly large. In all three places this figure is larger than the comparable figure for dons in Table 11.1. There is no reason to assume a particular reluctance to answer this question in respect of students, and it seems that students must be less visible on this dimension and they are certainly less visible here than dons. This is not surprising. Young people are not settled firmly in a job, at an income level or in status and style of life so there is an indeterminacy about their position. Also, by the time of our surveys, 'youth' was beginning to appear. Growing affluence among young people had created markets catering for them, especially in clothing and entertainment. Advertising diffused particular styles and fashions widely through the whole of the young population, swamping other distinctions and making any perception beyond 'young person' harder to come by. Further, students were mostly from outside the local community and so divorced from the home circumstances which might help people make the sort of judgement for which we were asking.

From Table 11.3 it can be seen that the majority in all three places puts students in the middle class. More do so in Oxford, rather fewer in Reading and fewest of all in York. In Oxford, 15 per cent place students in the working class, 9 per cent do so in Reading while in York no less than 23 per cent do so. As already noted, there are large differences in how our populations rate themselves. In York 69 per cent describe themselves as working class. The figure for Oxford is 57 per cent and for Reading only 46 per cent. These differences probably reflect the social composition of the three places, or some other local circumstance or consideration.

Comparing dons with students, it appears that dons are accorded a superior class position. For example, in Oxford 89 per cent describe dons as middle class but only 72 per cent describe students in this way. Within the middle class, 61 per cent of Oxford people see dons as upper middle class. This figure falls to 17 per cent for students. Similar descents are evident in Reading and York.

Table 11.4 (per cent)
Social Class Comparison: Students/Self

	Oxford	Reading	York
Students placed above self	63	64	65
Students placed same as self	8	9	8
Students placed below self	29	27	27
N (= 100%)	199	155	243

Assuming again that our categories represent an order of superiority/inferiority, we can see from Table 11.4 that almost two thirds of informants put students above themselves in terms of class. Rather more than a quarter put the students below

themselves, while some 8 per cent perceive an equivalence between self and student. The situation is very similar in all three places.

Glancing across Tables 11.4 and 11.3 to compare our results for dons with those for students it is evident there are differences, even though majorities everywhere put both dons and students above themselves in the hierarchy of class. However, in each place more respondents put students on the same level as themselves and considerably more put students below themselves than is the case with dons. This difference is more marked in the case of Reading.

Income, although not identical with class, is generally thought to be related to it, and on Weberian assumptions we would expect the two to be related. We asked informants to tell us what they thought the maximum salary was, before tax, first of a professor and then of a lecturer. The wording of the question is shown in Table 11.5.

Thinking that our subjects would be poorly informed about academic ranks, we prefaced the question by volunteering that professor was the highest rank and lecturer the lowest. Although this statement served our purpose, it is an over simplification at least. Heads of colleges in Oxford constitute a group superior in some way to professors and it is common for a professor to be 'promoted' to a headship. It was also questionable in the early 1960s when our study was undertaken and, perhaps, it is questionable still, whether a don in Oxford occupying a lectureship along with a fellowship in a college would be regarded, or would regard himself, as being at the bottom of the academic hierarchy or in any way in an inferior or subordinate position to a professor. There was, too, a great variety of titles and positions everywhere: demonstrator, tutor, research assistant, research officer and so on, which served further to cloud the situation. And there were other complications. Oxford had a medical faculty, and dons who are medically qualified are paid more than those not so qualified. They were also eligible for 'distinction awards'. For our purposes we ignore most of these complications. By the 1960s anyway, pressure from trade unions and other sources was tending in the matter of salary to assimilate all positions regardless of title into one or other of four categories – professor, reader, senior lecturer[44] and lecturer.

Taking the scales set by the University Grants Committee, we decided that the 'correct' answer to our question in respect of professors at the appropriate time of each survey would be:

Oxford: £4,700 p.a. or £90.40 per week;
Reading: £4,750 p.a. or £91.35 per week;
York: £4,990 or £95.96 per week.

We also took the University Grants Committee salary scale for lecturers to determine the 'correct' answer in respect of this group for Reading and York. For Oxford we were allowed to examine the conditions for two tutorial fellowships being advertised

at the time of our Oxford study. We calculated that when at the top of their scales, each incumbent would receive a college/university income in the lower reaches of the University Grants Committee professorial scale[45]. The figures we determined to be the 'correct' answers for lecturers were:

Oxford: £3,400 p.a. or £65.38 per week;
Reading: £2,505 p.a. or £48.20 per week;
York: £2,630 or £50.58 per week.

To put these figures in some sort of perspective, we give below the average weekly earnings of men aged twenty-one years or above in manufacturing and certain related industries[46] in the appropriate region and at the time of each survey:

Oxford: £960 p.a. or £18.47 per week;
Reading: £1,028 p.a. or £19.76 per week;
York: £1,049 p.a. or £20.18 per week.

Table 11.5 (per cent)
Estimates of Salaries

Now will you have a guess at what you think the maximum weekly salary of a (professor) here in (Oxford) is before tax?

	Professor			Lecturer		
£'s per week	Oxford	Reading	York	Oxford	Reading	York
0–20	8	8	6	32	31	28
21–30	14	16	18	25	26	37
31–40	16	14	25	16	14	14
41–50	14	13	16	6	→5	→4
51–61	13	13	8	3	2	5
61–70	3	5	3	→1	1	0
71–80	5	4	5	0	0	0
81–90	→1	→2	0	0	0	0
91–100	6	2	→4	1	0	0
101–	3	2	3	0	0	0
DK	17	21	12	16	21	12

The replies to our questions are shown in Table 11.5. The arrows indicate what we determined was the 'correct' answer in each case.

A striking feature of Table 11.5 is the extent to which incomes everywhere are underestimated. In Oxford and Reading 8 per cent and in York 6 per cent gave

professors £20 a week or less. This is about, or lower than, the average wage in manufacturing at the time and less than a quarter of what we have estimated to be the true figure. In each place almost a third of all our informants gave lecturers this weekly salary of £20 a week or less. From Table 11.5 it can be calculated that 73 per cent in Oxford, 73 per cent in Reading and 81 per cent in York gave professors a salary below what we estimated to be the 'correct' figure. Comparable figures for lecturers are: Oxford 82 per cent, Reading 71 per cent, York 79 per cent.

Income is a notoriously opaque subject and one which is not often a topic of ordinary, polite discourse. It also involves necessarily numbers, and perhaps for many people thinking on these lines would not go beyond 'a lot', or 'more than' or 'less than', so avoiding the precision of numbers altogether. And we do not know what replies we would have been given if we had asked about the incomes of, say, school teachers or policemen, or of any other readily identifiable group. It could be that incomes generally are underestimated, and that our findings simply reflect this. Even so, it does seem remarkable that our samples placed dons so high in the social class scale and so low in the income scale. It might be that these dimensions are not as closely related as common sense suggests. Or there might be some occupations, clergymen or social workers, for example, which are perceived in terms of this dissonance, and university teachers are to be numbered among them.

From Table 11.5, line 11, it will be seen that between 12 per cent and 21 per cent were unable or unwilling to answer. The figures of 21 per cent for Reading suggest once more that the Reading dons are less visible than dons in the other two places.

It is clear that no one, or very few, hit upon the precisely right answer. If we take this right answer in each case, together with the two adjacent or 'nearly right' answers, we have for professors: Oxford 12 per cent; Reading, 8 per cent; York, 7 per cent. For lecturers we have: Oxford, 4 per cent; Reading, 21 per cent; York, 23 per cent. The rather large figures here for Reading and York lecturers seem anomalous. But even with these figures, only small minorities had anything like an accurate knowledge of what the local dons earned, and even in the case of lecturers in Reading and York these minorities amounted to only a little more than one fifth of the total. In all three places the great majority had either no knowledge, or no accurate knowledge, and when invited to turn their minds in the direction of what the local dons earned gave figures which were far from the reality.

Although we did not anticipate dons being placed so low in terms of income, we thought there might be resentment directed at them on the grounds of the privileges that they were sometime seen to enjoy. Mr Ted Short[47] caught this attitude of resentment nicely. Speaking of the higher education sector, he referred to its '… lavish teaching ratios, its lawns, lakes and fountains, thirty-week year and so on …'.[48] Accordingly, we put to our samples the question shown in Table 11.6.

Table 11.6 (per cent)
Opinions on Dons' Pay

By comparison with other professional groups is it your impression that dons are: paid too much; paid too little; or paid about the right amount for the work they do?

	Oxford	Reading	York
Paid too much	6	2	3
Paid too little	26	34	24
Paid about the right amount	55	44	61
DK	13	20	12

It is clear that only small proportions declared dons to be paid too much. Even in Oxford the figure was only 6 per cent. Roughly a quarter in Oxford, and in Reading a third, actually thought them to be paid too little. But of those having an opinion most thought dons' pay to be about right for the work they do.

It will be noticed the question included the phrase 'by comparison with other professional groups ...', so answers have to be seen in this context. It could be that all professionals are thought to be overpaid, and dons along with them. But given the low estimate of dons' pay found in our surveys, these particular figures suggest that the sort of resentment that might be predicted from the attitudes held by Mr Short are not evident; not, at any rate, in our three university towns.

CHAPTER 12

Politics

Changes occurred in the City of Oxford in the 1920s which altered the environment in which the University had nestled rather comfortably for centuries. Until the First World War Oxford was overwhelmingly a university town, the University's presence and influence suffusing all aspects of the city's life. The University was the principal employer, and another large employer was the University Press. Jobs in the University were highly prized and the college servant was at the apex of the working-class social hierarchy. 'The college servants … wouldn't look at the likes of us,' said a local printer recalling those times.[1] The town was not very prosperous; it had always had a class of chronically poor, and unemployment was a problem. In the University long vacation some college employees were stood off, and some shops and businesses closed.[2] The possibility of railways appeared in the 1830s. Seen as something of a threat to the tenor of academic life, they were resisted for some time by the University. But eventually, and reluctantly, the University gave way, and a line was opened in 1844 with a station in the south of the city. The railways presented another threat in 1865, when the Great Western Railway proposed to establish a carriage works in Oxford. The proposal was much debated and there was considerable support for it in the city. The University sent a deputation to the GWR Board to object to its plan. The plan was dropped and the carriage works went to Swindon instead. Another threat to the tenor of academic life was taking shape before the First World War, although no one noticed it, or not, at any rate, as a threat. It was in the form of a tough local citizen named William Morris, later to become famous as Viscount Nuffield.[3]

Morris started business with a cycle and motorcycle repair shop in the city, and later he opened a garage. In 1913 he started producing motor cars at Cowley. During the First World War he obtained defence contracts which sustained and strengthened his business, so that when peace came he was in a position to step into the new motor car industry in a larger way. He did so decisively. By 1920 he was producing 2,000 of his model the Morris Cowley, and he opened a branch factory in north Oxford to produce radiators. By 1923 more than 20,000 cars a year were coming off the Cowley production line, and this figure rose to 55,000 in 1925. In the

following year an American company opened a plant, the Pressed Steel Company, in Cowley to produce car bodies. By 1936 these three associated plants were together employing some 10,000 workers, 30 per cent of the city's work force. By 1946 this figure was 15,000 and by 1963, the year prior to our survey, it was 27,000.

Labour requirements of this order quickly exhausted local manpower sources and immigrants from outside the city were drawn in, with a consequent increase of the city's population. About 50,000 at the end of the nineteenth century, the population grew to 97,000 in 1951. This increase, together with government programmes to remove slums and improve the quality of housing generally, stimulated a boom in local house building. Much of this was provided in housing estates, some of it private and some built and managed by the local authority.

The speed at which the new industry was established and the timing, during and immediately after a great war, meant that any resistance it might have met had no time to gather. After the Second World War the industry itself threatened to move away from the city. In our view, this was never a serious proposition but more of a ploy to put pressure on the local authority to provide more housing for an expanding work force. The idea was, however, much debated when it was taken up by Thomas Sharp in his celebrated plan for Oxford.[4] The debate continued until the early 1950s when removal of the industry away from Oxford was recognised as a thoroughly lost cause and the whole idea was abandoned.

The new industry not only brought about an expansion of the city, it also changed the character of the workforce with potentially large political consequences. Prior to the First World War the University had been the dominant employer, with its employees[5] dispersed over many small units. And these units were long-established, secure and strongly bonded in terms of personal contact and institutional loyalties. From another perspective they might be described as paternalistic. The new industry presented a sharp contrast. Its work was machine- and time-dominated, and it served a fluctuating market which could result in sudden lay-offs. It paid high wages, but the nature of the work it provided was what Marxists and others would describe as alienating, and the fluctuating market it served meant the work it offered had to be insecure. This new situation provided opportunities which attracted the attention of the Transport and General Workers' Union, and of communists and socialists. In 1934 an industrial dispute at the Pressed Steel Company was quickly seized on by the Transport and General Workers' Union, which provided strike pay even for non-Union members, and, through its widespread links, prevented Pressed Steel work from being transferred elsewhere. The strike was an outstanding success. The Union obtained recognition and a greatly increased membership.

On the political front, the new workers could be expected to be left-wing and so to provide a basis for challenging the Conservatives and Liberals who had been dominant hitherto.[6] The political potential of the inter-war housing programmes was noticed at the national level, and particularly by the Communist Party. The provision of large estates for working-class people concentrated and isolated them, often with few or no

amenities on their estates, and with only one landlord.[7] And since the landlord was often the local authority, questions of rent and the other problems of housing were taken straight into the political forum of the local council chamber. Thomas Sharp, one of many who commented on this situation, wondered that it had '... not long ago led to the bitterest kind of political upheaval'.[8] Oxford, with its flood of new workers together with a programme of estate building, could not fail to attract attention. Further, Oxford had additional features which made it a particularly promising and attractive target for the left. The University was an institution of international renown, and in every way tightly locked into the British establishment. Its activities attracted attention. The Oxford Union, for example, is, in a sense, no more than a student debating society in which the silliest propositions are often chosen for discussion so as fully to exercise the fancy and the wits of its young members. But when, in 1933, it debated and passed a motion declaring it would not fight for King and country, the event was widely noticed and taken as significant at a time when the Nazi movement was growing in Germany. So, political successes in Oxford could be expected to have a particular éclat and resonance in the wider society. And the University itself might be vulnerable. It employed large numbers to perform menial tasks for the sons of society's privileged. These college servants were famously loyal to their masters. But given contact with the new-style workers at Cowley, the college servant's 'false consciousness' could fall away, and so released he might somersault into a new, markedly radical set of social and political attitudes. Further, the University was, or could be presented as, a playground where young men of privilege were allowed to gambol and generally enjoy themselves for three years before moving on, according to taste, either to the Drones Club or to a position of power and privilege in business or government. Thousands of these young men descended on the city *en bloc* every October. So the University presented a target. G. T. Fowler, both a city councillor and young don, noted later that the wards in the eastern parts of the city had experienced '... years of political propaganda by the Labour and Communist Parties,' and that '... these Parties had an already fertile ground in which to sow their seed'.

> The population of that area [he continued] is largely made up of first and second generation Oxonions, attracted here over forty years by the prospect of secure employment and reasonable wages in the car industry. To them the traditions of the University mean nothing. The physical presence of the University crowding the centre of the City with a migrant student population, aloof and often arrogant, means a great deal to them, and they do not like it.[9]

Oxford, University and city together, presented a ripe plum of opportunity for left-wing politicians.

A young communist, Abe Lazarus, came to Oxford to help in the 1934 strike at the Pressed Steel Company. He had previously enjoyed a triumph at a strike at the Firestone Company, and in recognition of this was given locally the pseudonym, Bill Firestone.

He was a remarkable young man,[10] an attractive personality, dedicated, energetic, richly humorous and a fine orator. Olive Gibbs,[11] prominent with her husband in Oxford politics, Labour councillor, Lord Mayor and chair of CND, remembered Lazarus in the 1930s: 'Every Sunday night we went to meetings in St Giles run by the Communist Party. The main speaker was Abe Lazarus ... you could hear his voice from the Martyrs Memorial to the War Memorial ... it is said the dons in St John's used to tremble over their port at the imminence of the bloody revolution that was about to strike us.'[12]

Building on the momentum of the successful strike at the Pressed Steel Company, Lazarus and the Communist Party led the residents of the Florence Park Estate in protest at the conditions of their houses[13]. The estate had been built by N. Moss & Son, a local firm with which a councillor, Mr F. E. Moss, was connected. Lazarus had also noticed the problem of the Cutteslowe Walls,[14] which could be linked to the Florence Park protest. The walls had been built to separate a working-class council estate from an abutting middle-class private estate. A joint protest about both situations was held in the Oxford Town Hall in April 1935. Some 1,200 people marched in procession from their estates to attend the meeting, which was presided over by Patrick Gordon Walker, then a don at Christ Church and later to become an important Labour politician and minister. After the meeting, a pamphlet was distributed announcing that the Cutteslowe Walls would be demolished. A date was given for the demolition together with an invitation to attend, to participate in the demolition and to enjoy the music which was promised to accompany the demolition work.[15] On the appointed day, early in May 1935, some 2,000 people assembled at Cutteslowe. They were met by a police inspector backed by a row of constables in front of one of the walls. The inspector announced that anyone attempting to pass the constables would be arrested. But not, the inspector made clear, for demolishing the walls, but for assaulting the police. This put Lazarus and the demonstrators in a dilemma. Lazarus had been advised by no less an authority than Sir Stafford Cripps, probably the best-known KC in the country at the time, that the walls were illegal obstructions. If Lazarus and the demonstrators were prosecuted for demolishing them, they would achieve great publicity for themselves and the Communist Party. And they would almost certainly be acquitted. After much discussion, and after pleading in vain with the inspector to be allowed to go to the walls and pass the constables without assaulting them, the demonstrators gave way and dispersed.

A crowd of 2,000 is large, and shows the power of the left at that time[16] in being able to bring so many people on to the streets. Further, a crowd of this size could easily have swept aside the inspector and his handful of constables, and the whole scene could have taken on a very different character. That afternoon at Cutteslowe presented a moment of real choice for Lazarus, the demonstrators and behind them, the city as a whole. Perhaps the presence of numerous undergraduates in the crowd, some in fancy dress, gave the demonstration the flavour of a carnival or a student lark and Lazarus' own rich humour must have taken the proceedings in the same direction. But Mr Fox, Oxford's sagacious Chief Constable,[17] read the situation correctly. Before the demonstration had taken place, the council estate tenants at Cutteslowe had taken steps to repudiate the

Communist Party and direct action, and to pursue their interests on more orthodox lines. An announcement to this effect was made in the press immediately after the collapse of the demonstration. Perhaps, too, the left-wing surge occasioned by the success the previous year at the Pressed Steel Company was beginning to ebb and communist influence beginning to wane. Lazarus failed to win a seat on the Oxford Council. And the situation outside Oxford was having an impact. Ernest Bevin, General Secretary of the Transport and General Workers Union, which had been so effective in the 1934 strike, was implacably hostile to Communism. Nationally the Popular Front initiated by the Communist International in 1935 was repudiated by Labour, and its principal advocate, Sir Stafford Cripps, was subsequently expelled from the Labour Party. And as the 1930s progressed the economic depression began to abate, and in 1936 the appearance of Keynes' General Theory seemed to bring the depression and mass unemployment within the comprehension of social science, and within the bounds of effective social and economic policy. The repudiation of the Communist Party and direct action did not mean, though, that the left altogether was defeated. The Labour Party grew steadily in the post-war years. By the late 1950s it had become the largest party on the city council and in 1966, two years after our survey, Evan Luard, the city's first Labour MP, was elected. There were also numerous strikes in local industries, and the car industry in particular was notoriously prone to industrial stoppages. There was even a strike of college servants, although it was limited in extent and did not occur until the early 1970s.[18]

Dons were active in local politics and contributed to the growth of the left. G. D. H. Cole became Reader in Economics in the University in 1925, and Professor in 1944. He was a dominant figure nationally in Labour circles as well as being active locally in Oxford. R. H. S. Crossman, a don at New College, was leader of the Labour group on the city council and subsequently a Labour MP and minister. Other dons became city councillors and, as already mentioned, Evan Luard, also a don, became Oxford's first Labour MP in 1966.

At the same time as our studies in the early 1960s, Halsey and Trow looked generally at the politics of dons in some detail.[19] They found them to be to the left. When asked to place themselves in political terms 53 per cent of those answering the question declared themselves to be on the left and 5 per cent on the far left; 19 per cent placed themselves on the right and 1 per cent on the far right.[20] Only 35 per cent generally supported the Conservatives, while 41 per cent supported Labour and 14 per cent the Liberals.[21] The left-leaning politics of university teachers is well documented, and there have been various suggestions as to why they should be to the political left. Halsey and Trow point to '… the historical links in modern scholarship with the empirical, secular traditions of the Enlightenment …'.[22] There is, too, the more mundane consideration that dons are paid from the public purse and this normally produces a tilt to the left. But, whatever the explanation, it seems that dons generally are to the left of the political spectrum.

Halsey and Trow found some variation between university groups. At Oxford and Cambridge 52 per cent of the dons put themselves on the left while at 'minor redbrick' universities, in which Halsey and Trow put Reading, this figure was 57 per cent.[23] In

terms of party support, 38 per cent were Conservative and 40 per cent Labour at Oxford and Cambridge. At Minor Redbrick, 29 per cent were Conservative and 53 per cent Labour.[24] Surprisingly, therefore, at Reading, our 'minor redbrick', our figures in the tables below show the perception the local Reading people had of their dons seems to be further to the right than in either Oxford or York.

Halsey followed up the Halsey and Trow survey of 1964 with further surveys of university teachers in 1976 and 1989.[25] He found falls in Conservative support at both dates. In 1989, of those expressing party support only 15 per cent in Oxford and Cambridge were Conservative, as against 44 per cent for Labour. Comparable figures for all other universities together were 19 per cent Conservative, 36 per cent Labour; and for polytechnics, 18 per cent Conservative, 44 per cent Labour.[26] Poll surveys were showing Conservative support nationally fluctuating between 34 and 38 per cent,[27] so if the people in our three survey towns followed the national pattern, there was an even greater contrast between their own political stance and that of the university dons than at the times of our surveys. And if their view of the don as a Conservative remained unchanged, then the dissonance between that view and the reality was even sharper. Of course, views may change. In 1985, after waiting for some five years after Mrs Thatcher became Prime Minister, Congregation in Oxford considered whether it might offer her an honorary degree. It decided by a large majority (738 to 319) not to do so. This was not only a break with precedent but striking, too, in that Mrs Thatcher was an Oxford graduate and the first woman ever to hold the office of Prime Minister. Altogether, the refusal to give her a degree was a rebuff of a spectacular order and reverberations in the media were correspondingly loud and widespread. No one knows what was in the minds of the electors when they cast their votes, but the result can hardly be taken as a gesture of support for the Conservatives, and the attendant publicity may in Oxford have changed the view of the don as Conservative and perhaps changed it elsewhere too.

To determine how dons were seen in political terms in our three towns, we put the question shown in Table 12.1. The results appear in columns ii, vi and x of the table. Table 12.1 makes it abundantly clear that dons were seen by these local populations as Conservative. The figures for Oxford are particularly striking. No less that 76 per cent saw the local dons as Conservative, only 6 per cent as Labour and 3 per cent as Liberal. York was not far behind with 59 per cent Conservative, 13 per cent Labour and 6 per cent Liberal. The 13 per cent figure 'Other' in column x, line 5, for York seems suspiciously large, and there may have been some confusion here between 'Don't Know' and 'Other'. If we assume the two figures both properly belong in 'Don't Know', we have 22 per cent for this category and we will assume this to be the case. Thus, in both Reading and York something like a quarter was unable or unwilling to give an opinion on dons' political affiliations. The figure for Oxford at only 14 per cent suggests that the 'political' don was more visible here. The figures for Reading indicate that Reading citizens were more inclined to see to see dons as Labour (20 per cent), or Liberal (8 per cent) than in the other two places, but the image of the don in the public mind was still (46 per cent) preponderantly Conservative.

Table 12.1
Political Allegiance

Is it your impression that at the next General Election dons (university teachers) here will mostly vote:
Conservative; Labour; Liberal; or Other?

		Oxford				Reading				York		
I	II	III	IV	V	VI	VII	VIII	IX	X	XI	XII	XIII
	Dons	Self	1964	1966	Dons	Self	1964	1966	Dons	Self	1964	1966
	%	%	%	%	%	%	%	%	%	%	%	%
1 Con.	76	42	43	46	46	39	44	51	59	40	44	55
2 Labour	6	30	40	42	20	28	44	43	13	30	43	45
3 Liberal	3	7	17	12	8	11	12	6	6	5	13	–
4 Other	1	1	–	–	0	0	–	–	13	0	–	–
5 DK	14	20	–	–	26	22	–	–	9	25	–	–
N(=100%)	238	238	52,000	52,000	217	217	47,000	50,000	292	292	60,000	58,000

Perceptions do not necessarily accord with reality, and in this case the perception of the don as a political Conservative does seem to be at variance with the real situation. The disparity between dons' politics and the way their politics was perceived by the general public in terms, at least, of our surveys may be thought surprising too because many leading politicians on the left have been university teachers at some time in their careers, and one famous institution, the London School of Economics, has, or had, in the popular mind a reputation as a seedbed of socialist ideas and enthusiasms. Sidney Webb, a huge figure in the Labour movement, Labour MP and minister, and famous with his wife Beatrice as a champion of the Soviet Union, was, at one time, a professor. Attlee and Dalton, Prime Minister and Chancellor of the Exchequer respectively in the great Labour administration of 1945, were university teachers, as was Harold Lasky, one-time chairman of the Labour Party and in his day probably the most widely-known academic in the country. Harold Wilson, Labour leader and Prime Minister, Hugh Gaitskell, R. H. S. Crossman, Anthony Crosland, Lord Longford and Patrick Gordon Walker, major figures on the left in public political life were all at some time dons. And a number of dons, although not figuring in Parliament or elections, were both famous and known for their allegiance to the left. J. B. S. Haldane, famous as a scientist and widely known as a columnist in the Communist newspaper the *Daily Worker*, was one. The communists Eric Hobsbawm and Christopher Hill, both celebrated historians and widely known as authors of popular books and texts, were others.

We asked informants at the end of the interview to tell us how they expected themselves to vote at the next general election. The results appear in Table 12.1, columns III, VII and XI. Columns IV, VIII and XII of Table 12.1 show how votes were distributed between the parties in the general election of 1964. Columns V, IX, and XIII give the same information for the general election of 1966.

Looking at the way our informants intended to vote (Table 12.1, columns III, VII, XI), it is evident that in all three places dons are seen to the right of the position our informants took themselves, assuming, that is, that Conservative is to the right and Labour to the left of the spectrum. Glancing down the distribution of votes at the two general elections (Table 12.1, columns IV, VIII, XII, and columns V, IX, XIII) makes it clear that dons were also perceived as being to the right of the position the local populations actually took themselves on these two occasions.

The position in Reading is different, in that our Reading informants saw themselves as closer to the local dons in political terms than was the case in the other two places. A relatively small 46 per cent, for example, in Reading saw dons as Conservative and 39 per cent declared that they intended themselves to vote Conservative in the next election. Comparable figures for Labour are dons 20 per cent, with 28 per cent intending themselves to vote Labour.

Table 12.2
Political Allegiance: Dons/Self

	I	II	III	IV	V
			Oxford	Reading	York
	Dons	Self			
			%	%	%
1.	Conservative	Conservative	47	38	42
2	Conservative	Labour	33	20	28
3	Conservative	Liberal	9	4	4
4	Labour	Conservative	2	12	12
5	Labour	Labour	4	12	6
6	Labour	Liberal	1	4	1
7	Liberal	Conservative	3	1	3
8	Liberal	Labour	1	4	2
9	Liberal	Liberal	0	5	2
	N(=100%)		165	138	181

Table 12.2 shows the extent our informants' perception of dons corresponds with the perception of themselves, as revealed by their voting intentions. Line 1, for instance, indicates that in Oxford 47 per cent saw dons as being Conservative and intended themselves to vote Conservative at the next election. Line 2 indicates that 33 per cent who saw dons as Conservative intended themselves to vote Labour. Since many were unable or unwilling in these matters of politics to tell us about dons, or about themselves, or about both dons and themselves, the numbers on which the percentages in Table 12.2 are based are significantly smaller than the sample numbers. For example, the number 165 in column III represents only 69 per cent of the total Oxford sample.

Calling the people for whom we have all the relevant information 'politically aware', we can see from Table 12.2 that in Oxford and York, half this politically aware part of the population aligned itself across the party spectrum in the same way as it saw dons aligned. The remaining half, obviously, saw itself in these terms in opposition to the dons. Once again the position seems slightly different in Reading. Here rather more of the politically aware (55 per cent) were in alignment with their dons, and less (45 per cent) in opposition.

We have, then, a paradox. The evidence shows that dons are to the left politically. The people in our three university towns, among whom the dons live and work, perceive them to be to the political right. We take this matter up in our conclusion.

Conclusion

We have been concerned to establish the degree of contact local inhabitants had with their university, the opinions entertained of the university, and, given the acknowledged position of the universities in general and Oxford in particular, the opinions of local people in relation to social class and politics.

Although awareness of the university is implicit in our study and can be regarded as an aspect of contact, it is sensible to treat it as a separate category, and this we do below. These four broad concerns obviously run one into another, and are to be seen principally as a convenience for presentation. They are treated below in the following order: Awareness, Contact, Social Class and Politics, Opinions.

Awareness

Before the Reading survey, we asked a group of Reading academics what they thought the prospects of the study were. We were startled to be told we would find large numbers of local people unaware even of the University's existence. This turned out to be untrue. But there was substance in the observation. Taken together, our findings suggest that Reading University sat more distantly in its home town than the other two institutions. Looking at the answers to the questions[1] in which we pressed our subjects to tell us the particular ways in which the university made their city a better place in which to live, only 26 per cent in Reading, as opposed to 38 per cent in York gave one or more instances. When we put the same question on the civic instead of the personal dimension, comparable figures were: Reading 72 per cent, York 81 per cent. Replies to other questions show a relatively large proportion of Reading respondents in the DK category. Comparisons made between Reading and Oxford show Reading, again, as having relatively large numbers in the DK category, suggesting once more that it sat more distantly in its town environment. Given the facts of history and of relative size, this Oxford–Reading difference,

unlike the Reading–York difference, was to be expected. But our findings do not indicate that Reading people were unaware of their University. Virtually the whole population had heard of, and had seen, the Reading student rag. About a third of the Reading sample was aware of their University's distinction in agricultural studies. Many had been in Whiteknights Park, and had views on the architectural merits of the buildings there, and more than a third had been in University buildings other than those in Whiteknights Park. Our findings suggest that the impact of the University was less overall, perhaps more concentrated on particular features, and that awareness of the University in consequence sat differently in the minds of local Reading people.

But it would be surprising if there were no differences. Universities differ one from another, and towns vary in their history, economic conditions and social structure, so there is a local or 'community' dimension to be considered. Reading University received its charter when what we have called the Newman philosophy was in the ascendant. The regulations the University created at that time to monitor its students suggest that the town was seen if not as a threat, then as a diversion, tempting its charges away from their proper academic concerns. York came into existence at a different time and into a different world, and it came at a point in time, not gradually and crescively emerging from pre-existing forms and institutions. At York's birth a new philosophy was emerging, and the pressure group which promoted it had to sell the idea of the University to local citizens as well as to the University Grants Committee. This led to a general discussion of the place of the University in the town, its possible advantages and disadvantages. One consequence was to spread widely across the community awareness of the institution and its possible effects. It may be as the University gradually became a familiar and an accepted part of the town, so awareness of it and its details fell to the back of the local mind and, if repeated, surveys such as ours would discover responses assuming proportions something like those found in Reading.

The numbers able to name the Vice-Chancellor at both Reading and York were of the same order as those able to name the mayor in the average county borough. The figures may seem high. But Wolfenden of Reading and James of York were prominent on the national stage, and this level of awareness of the Vice-Chancellor probably fell when they departed the scene. We were surprised that 18 per cent of respondents in York were able to name a member of the academic staff. The unexpectedly large size of this figure may again be a product of the recent arrival of the University, and of the attendant publicity. Few people in York in 1967 had a realistic idea of the size of their University in terms of student numbers. Few had a conception of how it was to grow in succeeding years. But such estimates are perhaps not very meaningful. Outside their own particular sphere, few people think in terms of precise numbers at all. Further, the huge growth subsequently in universities and in the university sector as a whole was little anticipated anywhere.

Contact

The proportion claiming personal acquaintance at a rather minimal level and with at least one don was: Oxford, 35 per cent; Reading, 26 per cent,;York, 15 per cent. Comparable figures for students were: Oxford, 58 per cent; Reading, 37 per cent; York, 15 per cent. In Oxford 22 per cent claimed to have entertained at some time a student as lodger or guest. Of our Oxford informants, 12 per cent told us that they were, or had been at some time, employed in the University. This figure for Reading was 4 per cent, and for York 1 per cent. The proportion claiming to know, or to have known, an employee of the local university was: Oxford, 73 per cent; Reading, 42 per cent; York, 47 per cent. These figures indicate widespread threads of contact from the local populations into their university.

In respect of university premises, 77 per cent of our Reading informants claim to have been in Whiteknights Park. Whiteknights had been a Reading feature before the University came into existence, so this figure on its own is not very significant. But, in addition, 57 per cent claimed to have seen the University buildings at Whiteknights, so it seems safe to conclude that this proportion had been in Whiteknights when the University was in possession and a presence on the site; 37 per cent had been in other parts of the University, most probably the London Road campus or one of the University farms. At York 51 per cent had been on the Heslington site, and 17 per cent said they had been in the University buildings.

In Oxford, over 90 per cent of our respondents claim to have been in at least one of the twelve institutions we presented to them. Some of the institutions we put to informants were in effect public space rather than private University institutions, so they do not provide testing examples of the proximity of town to gown. Christ Church with its Meadow is an obvious example. Worcester and St John's colleges are of a different order. They have the typical appearance of 'total institutions'. They are enclosed spaces, entered only through portered gates. No one outside their particular fraternities could feel invited to enter. Yet 59 per cent of our sample claimed to have passed the porter at Worcester College at some time, and 49 per cent claimed similarly to have braved the St John's porter.

There is a venerable tradition of 'outreach' effort, in which teaching is taken by academics out of the university into the community. Oxford was a pioneer in this area, and founded in the late nineteenth century a department to be specially concerned with it. We found that 10 per cent of our Oxford sample had at some time attended one of these lectures or classes, or some other University provision on these lines. This proportion may seem small, particularly as the comparable figure for Reading was 14 per cent. Rather more had attended a play or show put on by the University. The figure for Oxford here was 29 per cent, and for Reading 15 per cent. Sport presents a different picture altogether. In Oxford 66 per cent, and 33 per cent in Reading, claimed to have watched a university sports event. Taking men only, no less than 88 per cent in Oxford and 44 per cent in Reading made a similar claim.

These figures are certainly an underestimate, since our samples excluded people under twenty-one years of age and sport is a preoccupation of the young. In York, the recent arrival of the University means that figures for actual attendance cannot be taken as meaningful, nor can the figures for the 'good intentions' of those expressing an interest in attending lectures and other activities in the future.

There is nothing comparable to universities so we have no figures to put against ours. If, however, we have in mind Newman's concept of a university as something like a retreat, properly detached from society and absorbed in its own concerns, then the degree of contact with the local community, both in terms of personnel and premises and in watching some activities, particularly sport, revealed by our figures must be thought surprisingly large.

There remains the question of the nature of contacts. Associations vary in their social and personal significance, and are structured accordingly. This is the point made so vividly by Hardy in *Jude*. Jude mixes cheek by jowl with the University students, 'Yet he was as far from them as if he was at the antipodes – they did not even see him, he to them was not on the spot at all …'.[2] Our findings have to be seen in this light. We have shown there is a thick network of association between the town and its university. But these associations are of a particular kind and significance, and are different from those within the university environment itself, for example. It is a commonplace of sociology, as well as of drama and literature, that people can be physically proximate, interactive and even in some sense intimate but still live in different social and mental worlds. The university is a separate world from its local community. If this is borne in mind it is possible to see Newman's concept of the detached university living on and flourishing in the midst of, and even in spite of, close associations with people and institutions outside itself.

Further, there is what might be called the 'literary question'. There is a huge volume of writing about Oxford. The town is conspicuous in this writing, but by its absence. Town is the Oxford '… never written about'.[3] Authors choose subjects which interest themselves and/or their readers. The conclusion must be the University in its various aspects is a matter of widespread interest in this literary context, and the town is not.

Social Class and Politics

It is well established that both dons and students are recruited disproportionately from the upper reaches of the class hierarchy. When rating dons in terms of social class our subjects placed them in its upper reaches. Where we were able to compare self ratings of class given by our respondents with those given to dons, we found that 87 per cent in Oxford placed dons above themselves. This figure for Reading was 76 per cent, for York 84 per cent. No one at all in Oxford placed dons below himself, although 5 per cent in Reading and 2 per cent in York did so.

The picture of students held by our subjects was rather different. Roughly a quarter of our subjects in Reading and York were unable or unwilling to answer the question and so, presumably, had no image sufficiently clear in their minds to make a judgement of students in terms of social class. The corresponding figure for Oxford was 13 per cent. In Oxford 72 per cent, 65 per cent in Reading, and 53 per cent in York put students in one of the middle class categories. Those putting students in a working class category constituted: 15 per cent Oxford; 9 per cent Reading; 23 per cent York.

When we put self assessments of class against those given to students the patterns which emerged were strikingly similar for all three places. A little less than two thirds placed students above themselves and rather more than a quarter placed students below themselves.

On some assumptions, it would be predicted that high ratings on social class would go with high ratings on income assessments. We found that the high rating for dons on class went with underestimates of their incomes. It has to be recognised that survey estimates of income have particular and severe difficulties and little weight can be placed on them as a reflection of incomes actually received. It may be the case that some occupations are seen in terms of a dissonance between class and income, clergymen and social workers might be examples, and that dons are to be numbered among them. But this is speculation, and we may remember that Butler and Stokes, in a national study taken immediately before our Oxford survey, found that attributions of class seemed to be related directly to occupation and having but a tenuous connection, if any, with income and wealth.

Halsey and Trow, in various studies, established that dons on the whole are on the left in politics. This is not how they were seen in our three towns. When asked to give an opinion on the political party position of dons, 76 per cent of our Oxford informants described them as Conservative, 6 per cent as Labour and 3 per cent as Liberal. Comparable figures for Reading are, 46 per cent; 20 per cent; 8 per cent. And for York: 59 per cent; 13 per cent; 6 per cent. In Oxford, 14 per cent, and rather less than a quarter in Reading and 9 per cent York replied 'don't know' to this question. If we disregard these 'don't knows' and concentrate on those who had an opinion, then 86 per cent in Oxford, 74 per cent in Reading and 91 per cent in York thought their local dons to be Conservatives. As in the case of income, the local image here seems at variance with the facts. We have no explanation as to why our informants perceive, or misperceive, dons in this way. As we indicated earlier, there have been plenty of left-wing dons, or former dons, prominent in public political life at the national level and in local political life in Oxford, so there have been plenty of instances in view. Our informants see dons as being placed high in the hierarchy of social class, and there may be an assumption that people so placed are likely to be right wing in politics – 'Toffs are Tories'. But this, again, is no more than speculation and we have no very plausible explanation as to why dons are seen in this way.

Opinions

I have already described how, arriving in Oxford in the early 1950s, I came by chance on an Oxford resident who had a deeply–rooted hostility to the University. This man seemed to have much in common with the character Jude in Hardy's famous novel, *Jude the Obscure*. Hardy's novel is a powerful and moving protest against the social exclusivity of the University, and by extension the limited provision of higher education generally. Surveying the history of Oxford suggested that in addition to the matter of social exclusivity, there were ample grounds for assuming an accumulating resentment of the University on the part of local citizens. Oxford's own Gladstone Professor of Government declared that some local citizens regarded the University as an excrescence. At the national level, too, many universities attract criticism over admissions policy and Oxford is a particular target in this respect. Given the facts of history and many aspects of the contemporary situation, it seemed, therefore, that there had to be a significant and, possibly, a deep well of local ill feeling against the university in Oxford, and that this situation would be paralleled in university towns elsewhere.

Our study suggests this was, if anything, the reverse of the case. At the personal level, 59 per cent of our informants in Oxford reported the town to be a better place because of the University, only 4 per cent declaring it to be a worse place. Comparable figures for Reading are: 41 per cent, 1 per cent; and for York: 36 per cent, 3 per cent. From the civic viewpoint, 77 per cent in Oxford thought the University to be an advantage to the town; only 6 per cent thought it a disadvantage. Comparable figures for Reading are: 88 per cent, zero; and for York: 81 per cent, 2 per cent. In each place, the great majority of our informants with young children said they would like them to go to university, although 8 per cent in Oxford, 18 per cent in Reading and 13 per cent in York declared they would not want them to go to their local institution. These figures have to be seen in the light of the then fashion for study away from home and the fact that the system of grants subsidised the fashion.

In Oxford, the questions of University representation on the city council and the amount to be paid by the colleges in rates were two issues which were thought at the time to be inflaming opinion against the University. We found almost half our Oxford sample unaware even that the University had special representation on the Oxford City Council. Of those who were aware, 86 per cent declared themselves in favour of it, and 13 per cent actually wanted University representation increased. We found 35 per cent to be unaware of the rates issue. Of those who were aware, 80 per cent thought the colleges should be made to pay more. The people of Oxford may, therefore, be said to have supported the University on representation and to have opposed it on rates, positioning themselves differently on the two issues. But even in the matter of rates, where the interests of the city and the University clearly conflict, it would be hard to argue that the issue roused any passion. Substantial minorities remained unaware of the disputes, and neither dispute inspired any

public demonstrations at all, and certainly nothing comparable to the large public demonstrations of the 1930s, when local issues brought large crowds on to the streets.

Not surprisingly, our findings indicate that the university in Oxford had a greater impact on its community than the universities in either Reading or York, but apart from some minor differences the general picture of approval apparent in Oxford was repeated in both the other places.

When asked what, in particular, were the advantages at a personal level the university brought, 18 per cent in Oxford mentioned architecture and 13 percent something which, for want of a better alternative, we classified as 'atmosphere'. Following fairly closely was employment and trade at 12 per cent. In York, employment and trade topped the list at 10 per cent. A shift to the civic perspective produced a different pattern. Here, the bread and butter issues of trade and employment came top of the list by a considerable margin in all three places. Following at some distance came the prestige that the presence of the university was seen as conferring on the town. Surprisingly, 16 per cent at Reading and 17 per cent at York mentioned civic prestige as opposed to only 10 per cent in Oxford.

When asked to turn their minds to the disadvantages the university occasioned for them personally, there were few responses. Overcrowding, traffic, rates, prices and students were mentioned in Oxford, although the figure for the largest response here (overcrowding) was only 9 per cent. There were few personal disadvantages mentioned in the other two cities, although 6 per cent in York mentioned students as a disadvantage. Much the same pattern emerged at the civic level with traffic, overcrowding, rates, prices and students heading the list in Oxford, with traffic at 11 per cent and students at 5 per cent. There were few disadvantages seen in Reading and York, although 12 per cent in York told us they saw students as a disadvantage. The objection to students everywhere was of a 'practical' nature, the effect they had, or might have, on crowding buses and other facilities, for example.

There remains the question of opinions we expected, but did not discover. Universities in general, and Oxford (and Cambridge) in particular, figure prominently in the English class system. For some, they symbolise and sustain it. Not surprisingly they attract attention on this account, and much obloquy from reformers who want social equality or, at least, social mobility unencumbered by considerations of class. The question of admissions to élite universities continues a matter of concern and controversy.

Our respondents were willing to categorise dons and students in class terms. Overwhelmingly they put dons in the higher categories, and in categories superior to themselves. To a less degree, this was true also in the case of students. This superior social class standing, clearly perceived by our subjects, did not occasion negative or hostile feelings. When informants were invited to tell us ways in which the university made their town a worse place, there was no trace of envy, resentment, dislike or hostility on account of social class. No one introduced phrases such as

stuck up, arrogant, proud, toffee-nosed, used to deflate or disparage claims to social superiority. There was even a small amount of evidence on the 'other side'. The lady in York, for example, who praised the University for bringing in 'a better class of people', or the man in Reading who thought his University brought in people 'of decent social standing and intelligence'.

In political terms, our subjects perceived dons as Conservatives. There was a substantial Labour vote in all three places, and in Oxford the Labour Party had been steadily increasing its representation on the city council, and the first Labour MP was elected in 1966. This perceived political position of dons, at variance with the position taken by a large part of the local population, seems again not to have been a cause of any hostile feelings. Certainly none were expressed to our interviewers when pressing their subjects to give opinions on the impact of the university on their town.

Nor did we find any evidence of envy or resentment at the attainment and/or privilege of the university people in educational terms. Dons and students are receiving, or have had, the best the country has to offer in the way of education. Half or more of our respondents in the three towns had left full-time education at fourteen, and a large majority had left by age fifteen. No more than 5 per cent had a child who was at, or had been at, university. In these terms the contrast between the university and its local community could hardly be sharper. Almost all those with children under eleven years of age told us that they would like their children to attend university, so it seems that a university experience was seen as desirable, and the advantageous position of the university population in this matter could hardly pass unnoticed. But if noticed, it does not seem to have occasioned resentment. When we asked our subjects to list the disadvantages their university brought themselves and their town in general, there was no evidence of Jude-like laments at their own relative educational deprivation, or of any envy in these terms of the university people. Terms such as egg-head, pointy-head, clever clogs, over-educated or anorak, frequently used to disparage or devalue real or claimed educational superiority, were entirely absent from our survey returns.

The late-Victorian Oxford portrayed by Hardy is in many ways the same as the inter-war Oxford portrayed by Waugh. The war years saw Oxford and the universities generally frozen into what then seemed this 'normal' pattern. Ex-service men and women were accommodated, increasing the size of the system but leaving its main features little changed. The responses we gathered from the local citizens in the 1960s were to the university as it was then, a seemingly changeless institution. But society as a whole was about to plunge into a period of profound change. These impending changes were casting a shadow over both Oxford and the total university system when we conducted our studies. The imminence of change, and the need for reform in the university, was recognised by the Robbins Report of 1963 and Oxford's own Franks Report of 1966. We have recorded these changes in the university and in society as a whole so as to highlight the features of the academic world as it then was. It is that old world and its inhabitants which we asked our subjects to view and consider. Now largely passed away, it may seem to some to be remote, and in some of its features decidedly odd.

The Surveys

We began in 1962–3, conducting pilot interviews in Oxford and preparing a questionnaire. We had for some years previously integrated a research experience in the teaching for sociology students in Oxford University's Department of Social and Administrative Studies (Barnett House). Five of these experiences had involved social surveys, four of them in Oxford. We were reluctant to employ university students in a study about universities, but encouraged by our experience in employing them in survey work we decided to do so. The students were post-graduates reading for a diploma at Barnett House, or mature non-graduates from Barnett House, Ruskin College and the Catholic Workers College. A grant from the Economic and Social Research Council enabled us to employ professional interviewers from Mass Observation for the York survey.

For Oxford a table of random numbers was used to select 300 names from a corrected version of the electoral roll. Each name was checked against a list of the resident members of the University. If found, such a member and his spouse, if he (or she) were married, would be discarded and replaced by another name drawn at random from the roll. For Reading the number on the roll was divided by 300 and York by 400. The dividend was used as an interval at which names on the roll were chosen for interview, the first name being chosen at random.[1] Interviews were conducted in Oxford in 1964, in Reading in 1965 and in York in 1967. Interviewers were ferried by car from Oxford to Reading. In Oxford they travelled by foot, by bicycle or by bus. Bus fares were refunded. Response to the surveys is shown in Table 1.

Table 1 (per cent)
Interview Results

		Oxford	Reading	York
(1)	Interview obtained	79.3	72.3	73.0
(2)	Interviewee away or removed	4.7	6.7	13.2
(3)	Interviewee dead or infirm	5.3	5.7	4.8
(4)	Interview refused	7.0	10.7	6.0
(5)	No contact established	3.7	4.6	3.0
	N (=100%)	300	300	400

The percentages of people actually interviewed are shown in Table 1, line 1. If the figures in lines 2 and 3 of the table are disregarded, we succeeded in interviewing 88.1 per cent in Oxford, 82.5 per cent in Reading and 89.0 per cent in York. Differences in the figures in line 2 may be accounted for, in part at any rate, by variations in ages of the electoral rolls.

In Oxford and Reading, interviewers were asked to give an account of refusals and non-contacts. For the most part these accounts seemed much the same as those to be expected in surveys generally, and reflected no hostility to the universities or any particular problems. There were, though, a small number of exceptions. In Oxford a University employee declined to cooperate because he thought his job might be affected. Another person refused to cooperate by way of protest against the felling of trees in his neighbourhood. The University, he said, was responsible. In a third case a dispute[2] occurred, and the interviewer was asked to leave. In Reading two people, although showing no hostility, refused to be interviewed, saying they had nothing of interest to say as the University was quite outside their experience and interests. We failed to persuade them otherwise. In this connection it may be noticed that the figure for refusals is relatively large for Reading (Table 1, line 4). Internal evidence from our surveys indicates that Reading people were less well informed and less concerned about their University than in the other two places. The Reading refusal figure probably reflects this.

We had 238 completed interviews for Oxford, 217 for Reading and 292 for York. Percentages in the text are generally based on these numbers. We mentioned in the Introduction that it is common practice to provide at the bottom of columns of percentages the numbers on which the percentages are based. In some cases, where the convenience of the reader dictates, we follow this practice. In others, to simplify the table we leave out the number base altogether. As already noticed the number base, i.e. the number of people successfully interviewed, is: Oxford 238; Reading 217; York 292. But in some instances the number is less. This is the case with subsets, arising usually because some informants have been 'filtered out' by an earlier question. Attention is drawn to these cases in the text and/or the relevant number(s) is given in the table.

We looked at particular questions to see if there was evidence of bias. It might be thought, for example, that if the university connection of interviewers was salient in the minds of informants, replies might be slanted toward ways that a university person might himself be expected to entertain. That is rather more favourable to what could be assumed to be the university's interest. We mentioned our university connection in introducing ourselves; we did not press it, we did not apologise for it, we took it for granted and so far as we could judge so did our interviewees. But if the sort of bias we are considering existed, we might expect it to be more evident in Oxford, where the university connection was clearest; rather less in Reading where the interviewers, although students, were not Reading students; and least in York where the interviewers had no university connection at all.

To test this, we took replies to eleven comparable questions from each of the surveys and ranked them according to whether they seemed more or less favourable to the university. Thus, Question One asked if the presence of the university made the town a better, a worse, or neither a better nor a worse place in which to live. The town providing the largest 'a better place' response (Oxford) was given rank 1, the town with the second largest (Reading) rank

2, and the third largest (York) rank 3. For open-ended questions, rankings were based on the proportion of respondents giving at least one reply. Question Three asked for ways in which the university made the town a worse place to live in. Here, and in comparable questions, we took the reverse rank order, the place providing the largest proportion given rank 3, and so on. The rankings are shown in Table 2. The questions can be found in Appendix 2.

Table 2
Attitudes to University

Question	Oxford Rank	Reading Rank	York Rank
1	1	2	3
2	1	3	2
3	3	1	2
4	3	1	2
5	1	3	2
6	3	1	2
7	1	2	3
24a	3	2	1
24b	3	2	1
24c	1	2	3

If the suggested bias from a university connection were in evidence, we would expect the rank order everywhere to be Oxford 1, Reading 2, York 3. It is apparent from Table 2 that this occurs in only three of the eleven cases. In two others it is exactly reversed. So far as it goes, this test indicates that the suggested bias was not in evidence. Also, we moved about in all parts of the three cities before the formal surveys talking generally to people about their universities, and then in a more focused way to pilot the questionnaires. The presence of the university seemed everywhere to be accepted without arousing much emotion, negative or positive. Students, we found, were generally regarded with good humour and appreciation. The characteristic which gave them particular appeal was youth. 'They liven the place up', as one man put it. Some people saw them through their own role as parents. One lady in York told us that she saw them at bus stops and worried about them lest, being away from home, they were not properly looked after and fed. This experience further encouraged us to believe that it would be possible to employ students. Given the results we think the belief justified.

APPENDIX 2

The Questionnaires

Immediately below we list the questions used in the Oxford survey. The questions appear here in the same order in which they were put to informants. Questions marked * were also used in the other two surveys. Those unmarked were used only in Oxford. Questions used in Reading only appear subsequently under 'Additional Questions: Reading' and questions used in York only appear under 'Additional Questions: York'. These variations in the basic questionnaire were necessary because some of the topics we covered were relevant to one or other of the three places, but not to the other two. The problem of university councillors, for example, arose only in Oxford. There was a rag in Reading but not in Oxford or York.

Differences between the three places also required, occasionally, a variation in the wording of questions. In Oxford in Question 1 we refer to 'the University and the colleges'. In Reading and York, in the parallel question, we referred to 'the University' only. Most of these variations are obvious and even trivial. The only one which might require attention is the use of the word 'don', unadorned in the Oxford survey but accompanied by a definition in Reading and York. This is discussed in the text where the replies from the relevant questions are presented.

In addition to the questions, the questionnaires contained some instructions to interviewers. Interviewers were told, for example, where to proceed in the questionnaire if a particular reply indicated that certain questions were to be 'filtered out'. These instructions were, however, kept to a minimum. The questionnaire was simple and not over-long; rather than complicate it by introducing instructions, we relied on briefing and practice interviews to familiarise the interviewers with our requirements.

Oxford Questionnaire

1*. Would you say that for you personally the fact that the University and the colleges are here makes Oxford: (a) a better place to live in? (b) a worse place to live in? (c) neither a better nor a worse place to live in?

2*. Can you tell me any ways in which the University and the colleges make Oxford a better

place to live in for you personally?

3*. Can you tell me any ways in which the University and the colleges make Oxford a worse place to live in for you personally?

4*. Would you say that for the city as a whole the presence of the University and the colleges is: (a) an advantage (b) a disadvantage (c) neither an advantage nor a disadvantage.

5*. Can you tell me any advantages for the city as a whole in having the University and the colleges here?

6*. Can you tell me any disadvantages for the city as a whole in having the University and the colleges here?

7*. If you had to move to another city, and if job and other considerations were about the same, would you: (a) prefer to go to a city which had a university? (b) prefer to go to a city which did not have a university? (c) not mind one way or the other?

8*. Would you say you felt (a) strongly (b) or not particularly bothered about your preference?

9. Do you know that the University elects its own councillors to the Oxford City Council?

10. Can you tell me how many councillors and aldermen altogether the University has on the Oxford City Council?

11. Are you personally in favour of having the University elect its own councillors to the Oxford City Council?

12. Do you think the number of University representatives on the city council should be: (a) increased (b) decreased (c) remain as at present?

13. Can you tell me any advantages which you think come from having special University representation on the city council?

14. Can you tell me any disadvantages which you think came from having special University representation on the city council?

15. Have you heard at all of the present controversy in the city about the amount of rates payable by the colleges?

16. Is it your opinion that the colleges should pay: (a) more in rates than at present? (b) less in rates than at present? (c) about the same in rates as at present?

17*. Are you employed by the University or any of the colleges?

18*. What is your job?

19*. Have you ever been employed by the University or any of the colleges?

20*. What was your job when last you were employed by the University (college)?

21*. Do you know, or have you ever known, anyone who has been employed by the University or any of the colleges?

22*. Is this one person, or more than one?

23*. Is it your impression that, taking all things together, the University and colleges are: (a) very good places to work? (b) about average? (c) not very good places to work?

24*. Compared with most other places in Oxford is it your impression that the University and colleges as places to work are: good; or about average; or not so good; as regards (a) pay? (b) working conditions? (c) security of employment?

25. Will you tell me if you have ever visited any of these places? Have you visited it in the last twelve months?

 (a) Magdalen College or gardens (High Street)

 (b) Christ Church or Christ Church Meadow (St Aldates)

 (c) Worcester College or gardens (Walton Street)

 (d) St. John's College or gardens (St Giles)

 (e) Sheldonian Theatre, Broad Street

 (f) Museum of the History of Science, Broad Street

 (g) University Museum, Parks Road

 (h) Ashmolean Museum, Beaumont Street

 (i) Bodleian Library, or any of its six branches

26. Have you ever had lunch or dinner in any of the colleges?

27*. Have you ever watched any of the University sports or athletic activities?

28*. Which type of activity have you watched most?

29*. Have you ever been to any of the plays or shows that University or college drama groups have put on here?

30*. Are you, or have you ever been, personally acquainted with any of the Oxford dons?

31*. Is this only one, or more than one?

32*. Have you ever visited or yourself been visited at home by any of these dons?

33*. Will you think of the three people you know best in Oxford, apart from relatives, and tell me if any of these are dons?

34*. Have you ever been to a lecture, talk or class given by any of the dons?

35*. On the whole is it your impression that most dons are:

 upper, middle, or lower middle class; or upper, middle, or lower working class?

 May I explain that a professor is the highest grade of don and a lecturer the lowest grade?

36*. Now will you have a guess at what you think the maximum weekly salary of a professor here in Oxford is before tax?

37*. Now will you have a guess at what you think the maximum weekly salary of a lecturer here in Oxford is before tax?

38*. By comparison with other professional groups is it your impression that dons are: paid too much: paid too little: or paid about the right amount for the work they do?

39*. Is it your impression that at the next General Election dons here will mostly vote: Conservative; Labour; Liberal; Other?

40*. Are you, or have you ever been personally acquainted with any of the University students here?

41*. Have you ever been visited at home by any of the University students?

42*. Have you ever had any of the University students staying with you as lodgers or guests?

43*. On the whole would you say that the University students here are:

 upper, middle, or lower middle class; or upper, middle, or lower working class?

44*. Are you, or have you ever been, personally acquainted with any of the college servants here?

45*. Are you: Married; Single; Widow(er); Other?
46*. Do you have any children under 11 years of age?
47*. How many?
48*. Would you like (him) to go to university?
49*. Would you like him to go to (Oxford) University?
50*. Do you have any children who are, or who have been, at a university?
51*. Was he at (Oxford) University?
52*. At what age did you leave full-time education?
53*. Have you taken any educational course either by correspondence or in any other way since leaving full-time education?
54*. In the coming General Election do you think you will vote: Conservative; Labour; Liberal; Other?
55*. On the whole would you say that you are:
upper, middle, or lower middle class; or upper, middle, or lower working class?
56*. What is your occupation?
57*. How long have you lived in Oxford altogether?
58*. Which of these age groups are you in?
–30 years: 31–40: 41–50: 51–60: 70–.

Additional Questions: Reading

1. Have you heard of the University of Reading?
2. Will you please tell me where it is situated?
3. Will you please tell me the name of the present or the last Vice-Chancellor of Reading University?
4. Would you say that Reading University is especially noted for any particular branch of research or teaching?
5. What would you say it is?
6. Have you ever been in Whiteknights Park?
7. Have you ever been in any other part of the University?
8. Have you seen any of the new buildings in Whiteknights Park?
9. On the whole do you find these new buildings (a) attractive to look at (b) unattractive to look at (c) neither attractive nor unattractive to look at?
10. Have you heard of the annual rag which the University students put on?
11. Have you ever seen anything of these rags yourself?
12. On the whole would you say that you approve of these rags; or disapprove; or not mind one way or the other?

Additional Questions: York

1. How many students do you think there are at present at York University?
2. How many students is it planned to take when completed in the early seventies?

3. Have you been to the University at Heslington since the building of the University began?

4. Have you ever been inside any of the University buildings at Heslington?

5. Do you think that in the future you will be interested in watching any of the University sports or athletic activities?

6. Which type of activity do you think you will be interested to watch?

7. Do you think that you will in the future be interested in going to any plays, shows or concerts put on by, or sponsored by, the University?

8. Which type of activity do you think you will be most interested to attend? Any more?

9. Will you please tell me the names of all the professors you have heard of at York University?

10. Do you think that you will in the future be interested in going to any lecture, talk or classes given by any of the dons?

11. What subjects do you think would interest you most for such lectures, talks or classes? Any more?

12. If you were to have room would you be prepared to take one or more University students as lodgers?

Notes

Chapter 1

1. To my relief, she also told me that the addressees given to me were people who had already been found to be, or were expected to be, difficult in one way or another.
2. Thomas Hardy, *Jude the Obscure*, London, 1951.
3. 'Christminster' in the book.
4. Op. cit., p. 100.
5. Op. cit., p. 138.
6. H. G. Wells, writing in *The Saturday Review*, 8 February, 1896, reprinted in Laurence Lerner and John Holmstrom, *Thomas Hardy and his Readers*, London, 1968, p. 136.
7. For details of the surveys see Appendix 1.
8. As a qualification to this 'positional' point, it may be noted that our surveys were undertaken some forty years before the Laura Spence case. The question of admissions to Oxford and Cambridge has since become much more acute because of changes in the whole university system. See Chapter 2.
9. Max Beloff, 'Oxford: A Lost Cause?', *Black Paper Two*, C. B. Cox and A. E. Dyson, (Eds)., London, 1969, pp. 135–6.
10. *Oxford Magazine*, 25 May, 1961. See Chapter 4.
11. See Chapter 2.
12. See Chapter 2.
13. See Chapter 4.
14. Alan Bennett, *Untold Stories*, London, 2005, pp. 390–391.
15. Humphrey Carpenter, *J. R. R. Tolkein. A Biography*, London, 1977, p. 54.
16. An undergraduate dining club made famous by Evelyn Waugh's portrayal of it as the 'Bollinger Club' in his novel *Decline and Fall*.
17. It has to be recognised that 'liveliness' in the student body is not confined to Oxford. In 1969 Essex County Council reduced its grant to Essex University by a symbolic one pound in protest at student behaviour, *The Guardian*, 5 March, 1969. And here is a description of the installation of R. A. Butler as Rector of Glasgow University: '… a partially exploded flour bag sailing dais-wards in a graceful curve past a "Welcome to Rochdale" banner struck the temple of an exceedingly fed-up-looking clergyman in full canonicals. A jazz band was going flat out with tearaway traditional stuff in the gallery … A flour bag struck the Rector full on the forehead and pandemonium broke loose. A student leapt to the front of the balcony with a fire extinguisher and trained it

on the platform spraying indiscriminately. The dignitaries sprang up with brandished fists and cries of protest …' *The Times Educational Supplement*, 28 February, 1958. A similar description is given of the installation of James Robertson Justice as Rector of Edinburgh University.

18. Now Lord Hattersley. Former Labour MP, Minister and Deputy Leader of the Labour Party.
19. *Any Questions*, BBC 1, 15 February 2007.
20. Compton Mackenzie, *My Life and Times. Octavo Three 1900-1907*, London, 1964, p. 59.
21. Richard Ollard, *A Man of Contradictions*, London, 1999, p. 27.
22. C. M. Bowra, *Memories 1898–1930*, London, 1966, p. 114.
23. Angus Wilson, in *My Oxford*, Ann Thwaite, (Ed.), London, 1977, p. 92.
24. Maurice Wiggin, *Memoirs of a Maverick*, London, 1968, pp. 120–121.
25. Ernst Honigmann, *Togetherness*, Newcastle upon Tyne, 2006, pp. 79–88.
26. BBC Radio 4 broadcast, *The Learning Curve*, 14 May 2007.
27. Selina Hastings, *Evelyn Waugh*, London, 1995, pp. 84–87.
28. Kingsley Amis, *Memoirs*, London, 2004, p. 103.
29. Canon H. Montefiore, reported in, *The Times*, 14 October 1968.
30. Humphrey Carpenter, op. cit., p. 123.
31. Richard Ollard, op. cit., p. 35.
32. In an interesting paper Richard Whiting addresses the same question from a different perspective. See his, 'University and Locality', in *The Twentieth Century*, (Brian Harrison, Ed.), Volume 8, in *The History of the University of Oxford*, Oxford, 1994, pp. 543–576.
33. Committee on Higher Education, *Higher Education*, Cmnd 2154, London, 1963.
34. University of Oxford, *Report of Commission of Enquiry*, Oxford, 1966.

Chapter 2

1. Clark Kerr, *The Uses of the University*, Cambridge, Mass., 1963.
2. J. H. Newman, *The Idea of a University*, I. T. Ker, (Ed.), Oxford, 1976. For a spirited defence of this position see, Bryan Wilson, 'The Needs of Students', in *Eighteen Plus*, Marjorie Reeves, (Ed.), London, 1954, pp. 44–85.
3. Kenneth R. Minogue, *The Concept of a University*, London, 1973, p. 27.
4. G. H. Hardy, *A Mathematician's Apology*, Cambridge, 1940, p. 90.
5. Address to the British Association for the Advancement of Science, 1933.
6. Eric Lax, *The Mould on Dr Florey's Coat*, London, 2005, pp. 206–8.
7. Op. cit., pp. 270–3.
8. W. H. G. Armytage, 'A University for Brighton', *British Journal of Educational Studies*, Vol. V., May 1957, pp. 168–9.
9. A. Temple Patterson, *The University of Southampton*, Southampton, 1962, p. 127.
10. Op. cit., p. 158.
11. Arthur W. Chapman, *The Story of a Modern University*, London, 1955, p. 39.
12. Op. cit., pp. 264–73.
13. It seems astonishing now that two of the universities founded in the 1960s (York and Kent at Canterbury) were modelled on the Oxbridge college system in spite of the huge cost this implied.
14. Bruce Truscot, *Redbrick in these Vital Days*, London, 1945, p. 108. Cited by F. Musgrove, *The Migratory Elite*, London, 1963, p. 102.
15. Harold Perkin, *Key Profession*, London, 1969, p. 124.
16. It was raised to sixteen years in 1972.
17. Edward Shils, 'The University, the City and the World: Chicago and the University of Chicago', p. 211, in *The University and the City*, Thomas Bender, (Ed.), N. York, 1991.

18. Erving Goffman, *Asylums*, Harmondsworth, 1961.

19. Humphrey Carpenter, *J. R. R. Tolkein. A Biography*, London, 1977, p. 154.

20. Dacre Balsdon, *Oxford Life*, London, 1957, p. 16.

21. The rules for various dates are given in J. C. Holt, *The University of Reading*, Reading, 1977, Appendix 7.

22. I am grateful to the Keeper of the Archives, Bodleian Library, for providing a copy of these rules.

23. Keith Thomas, 'College Life. 1945–1970', p. 208, in, *The Twentieth Century*, (Brian Harrison, Ed.), Vol. 7, in *The History of the University of Oxford*, Oxford, 1994. Thomas provides an account of the transformation of Oxford college life after Robbins.

24. Arthur S. Fleming, 'The Interchange of Talent Between Government and the Universities', Voice of America, Forum Lecture, No. 18, n.d.

25. Clark Kerr, op. cit., p. 89.

26. George Psacharapoulos, 'The Profitablity of Higher Education: a Review of Experience in Britain and the United States', in H. J. Butcher and Ernest Rudd, *Contemporary Problems in Higher Education*, Maidenhead, 1972, p. 364. The paper referred to was by P. C. Glick and H. P. Miller, in the *American Sociological Review*, Vol. 21, 1956, pp. 307–312.

27. Herbert S. Parnes, *Forecasting Educational Needs for Economic and Social Development*, OECD, 1962, p. 7.

28. Keith Thomas, op. cit., p. 190.

29. Joseph A. Soares, *The Decline of Privilege*, Stanford, 1999, p. 76. Soares provides a detailed account of Oxford's shift to science and to academic merit in student selection.

30. A. H. Halsey, *Decline of Donnish Dominion*, Oxford, 1992, p. 131.

31. Zachary Leader, *The Life of Kingsley Amis*, London, 2006, pp. 198–200. Joan Bakewell, *The Centre of the Bed*, London, 2003, p. 109, gives another sad example from Cambridge. Julia Briggs, who as an undergraduate became pregnant in 1964, is said to be the first person in Oxford to have escaped being sent down for pregnancy. 'Obituary', *Daily Telegraph*, 20 September 2007.

32. Nuffield College began admitting men and women on entirely equal terms in 1945. It is a graduate college so was probably not regarded as a precedent.

33. H. Thomas, (Ed.), *The Establishment*, London, 1959.

34. John Sparrow, 'Revolt and Reform in Oxford, 1968–9', in *Black Paper Two*, C. B. Cox and A. E. Dyson, (Eds), London, 1969, p. 126.

35. See Chapter 5.

Chapter 3

1. Michael Beloff, *The Plateglass Universities*, London, 1968, p. 151.

2. This may seem surprising in view of the large amount of land the University occupied. See map, p. 90.

3. Michael Beloff, op. cit., p. 33, reports a similar experience trying to find his way to the University of East Anglia.

4. We assumed that everyone in Oxford would be aware of the University.

5. At the time of our studies Oxford had no permanent Vice-Chancellor, the post being undertaken in rotation by heads of colleges.

6. It is reported that 90 per cent of the inhabitants of Heidelberg, a town roughly the size of Reading or York, would be unable to name the Rector of their university. See, Edmund W. Gilbert, *The University Town in England and West Germany*, Chicago, 1961, p. 47.

7. *Report of the Committee on Homosexual Offences and Prostitution*, London, 1957, Cmd. 247.

8. A further 5 per cent gave names of people not members of the academic staff.
9. Hugh Philp, et al., *The University and its Community*, Sydney, 1964, p. 72. The authors are confident that the survey can be taken as representative, but the response rate was only 44 per cent so there must remain a faint suspicion at least that there may have been a bias in the response in favour, perhaps, of the more literate and educated respondents.
10. David Butler and Donald Stokes, *Political Change in Britain*, London, 1970, p. 455.
11. Mary Horton, *The Local Government Elector*, London, 1967.
12. Op. cit., p. 24.
13. Op. cit., p. 17.
14. The Sydney survey revealed a general interest in university research. Philp, et al., op. cit., p. 74.
15. From an interview conducted with Lord James and the University Registrar. On other occasions Lord James gave different figures, so his mind was probably more open on this matter than his remark here suggests. Subsequently student numbers reached 11,000.
16. See Chapter 6.

Chapter 4

1. A measure of the change in attitude over the time since our surveys is that one could then use this phrase without any feeling of unease. Now it is incumbent to explain that 'man' is to be understood in the inclusive sense of 'mankind'.
2. For a detailed account of local politics, see: Robert Waller, 'Oxford Politics, 1945–1990', in R. C. Whiting, (Ed.), *Oxford. Studies in the history of a university town since 1800*, Manchester, 1993.
3. Oxford's first Labour MP was elected in 1966.
4. The Hebdomadal Council comprised eighteen members elected by Congregation. Congregation is the official governing body of the University. It consists of those members of Convocation who are teachers or administrators in the University. As already noted, Convocation is the general body of those holding MAs or higher degrees.
5. Subsequently a Labour MP and Minister of State at the Department of Education and Science taking special responsibility for Higher Education.
6. The arguments are nicely put in G. T. Fowler, 'University Members of the City Council', *The Oxford Magazine*, 25 May, 1961, pp. 371–2.
7. *The Oxford Magazine*, 29 October, 1964, p. 43.
8. Subsequently a life peer and Provost of Queen's College.
9. *The Oxford Times*, 10 April, 1964.
10. C. A. Cooke, 'Colleges and Rating', *The Oxford Magazine*, 14 March, 1963, p. 246.
11. *Report of the Committee on the Rating of Charities and Kindred Bodies*, Cmd. 831, London, 1959. Usually referred to as the 'Pritchard Report'.
12. The Pritchard Report, para. 15.
13. F. C. Padley, *Recollections ...*, manuscript, Reading University Library, 1963, p. 14.

Chapter 5

1. Letter from Oliver Sheldon, *Yorkshire Evening Press*, 14 August 1946.
2. Viscount Esher, *York: a Study in Conservation*, London, 1968, p. 3.
3. 14 August 1946.
4. *Yorkshire Evening Press*, 5 October 1946.
5. Op. cit., 4 October 1946.
6. Op. cit., 9 October 1946.
7. Op. cit., 7 December 1946.

8. *Northern Echo*, 19 April 1947.
9. *The Yorkshire Post*, 9 July 1947.
10. *Yorkshire Observer*, 24 June 1954.
11. *Yorkshire Evening Press*, 4 September 1959.
12. Op. cit., 16 October 1959.
13. Op. cit., 6 February 1960.
14. *Yorkshire Post*, 25 August 1959.
15. V. A. Heigham, 'A University at York', *The Contemporary Review*, Vol. 196, 1960, pp. 118–127.
16. *Yorkshire Evening Press*, 6 February 1961.
17. *Yorkshire Post*, 12 July 1960.
18. *Yorkshire Evening Press*, 25 August 1959.
19. *Yorkshire Evening Press*, 4 July 1962.
20. *Yorkshire Post*, 17 June 1960.
21. 25 August 1959.
22. *Yorkshire Evening Press*, 25 August 1959.
23. 31 August 1959.
24. Loc. cit.
25. *Yorkshire Evening Press*, 31 October 1963. *Northern Echo*, 5 November 1963.
26. *Northern Echo*, 16 May 1964.
27. Roger McMeeking, 'The University as Consumer', *Perspective: East Yorkshire*, Sept.–Oct., 1967, p. 549.
28. *Yorkshire Evening Press*, 4 March 1965.
29. *Yorkshire Evening Press*, 2 May 1965.
30. *Yorkshire Evening Press*, 14 May 1966.
31. *Yorkshire Evening Press*, 3 May 1966.
32. *Yorkshire Evening Press*, 26 May 1966.
33. *Yorkshire Evening Press*, 17 November 1966.
34. *Yorkshire Evening Press*, 11 January 1967.
35. *Yorkshire Evening Press*, 27 January 1967.
36. *Yorkshire Evening Press*, 18 March 1967.
37. Yorkshire *Evening Press*, 26 January 1967.
38. There was one person in Reading. The zero figure appears because of rounding.

Chapter 6

1. See Chapter 5.
2. See Chapter 4 for opinions on the Reading rag.
3. Local rates were clearly of particular concern in Oxford. It is dealt with in detail in Chapter 4.
4. See Chapter 11.

Chapter 7

1. See Chapter 4.
2. See Chapter 8.
3. The questions were varied appropriately in each place. In Oxford the colleges were explicitly included.

Chapter 8

1. James Attlee, *Isolarion*, London, 2007, p. xvi.
2. Ann Thwaite, (Ed.), *My Oxford*, London, 1977.
3. Op. cit., p. 209.
4. Op. cit., p. 194.
5. Ronald Hayman, (Ed.), *My Cambridge*, London, 1977.
6. Gwen Raverat, *Period Piece*, London, 1952, p. 47.
7. Tom Driberg, *Ruling Passions*, London, 1977, p. 75.
8. Op. cit., p. 71.
9. He does mention strolls by the river with a local milkman.
10. Dacre Balsdon, *Oxford Life*, London, 1957 and *Oxford Now and Then*, London, 1970.
11 See for example, C. M. Bowra, *Memories 1898–1939*, London, 1966; Compton Mackenzie, *My Life and Times, Octavo Three 1900–1907*, London, 1964; Dennis Potter, *The Glittering Coffin*, London, 1960; Emlyn Williams, *George*, London, 1961.
12. H. Trevor-Roper, *Letters from Oxford*, Richard Davenport-Hines, (Ed.), London, 2006, pp. 130–132. Stone was history tutor and Fellow at Wadham College.
13. Op. cit., pp. 66–71, 191–2, 288–302.
14. Isaiah Berlin, *Flourishing. Letters 1928–1946*, Henry Hardy, (Ed.), London, 2004, pp. 565–7, 571.
15. Op. cit., passim.
16. Birkenhead, Earl of, *The Prof. in Two Worlds*, London, 1961, pp. 141–2. Both sides engaged KCs although the matter never came to court, the college, Christ Church, conceding.
17. R. F. Bretherton, 'Population', in *A Survey of the Social Services in the Oxford District*, A. F. C. Bourdillon, (Ed.), London, 1938, p. 33.
18. The proportion for women students was 70 per cent. *Oxford University, Report of Commission of Enquiry*, (Franks Report), Vol. 2, Oxford, 1966, p. 35.
19. Alan Bennett, *Untold Stories*, London, 2005, p. 239.
20. Op. cit. p. 295.
21. Ronald Hayman, op. cit., p. 115.
22. Ronald Hayman, op. cit, p. 194.
23. See Chapter 1.
24. Our pilot interviews in Oxford suggested the word 'don' was generally understood and could be used without a sense of strain or affectation. The subsequent survey confirmed this. We were less confident about this in Reading and York and so rephrased the question on acquaintances as follows: 'Are you, or have you ever been, personally acquainted with any of the University teachers, or dons as they are sometimes called?'
25. Anthony Howe, 'Intellect and Civic Responsibility', in R. C. Whiting, (Ed.), *Oxford*, Manchester, 1993, p. 41. See also Elizabeth Peretz, 'Infant Welfare in Inter-war Oxford', in the same volume pp. 131–145, and Brian Harrison's tribute to Miss C. V. Butler in 'Miss Butler's Oxford Survey', in *Traditions of Social Policy*, A. H. Halsey, (Ed.), Oxford, 1976, pp. 27–72. Perhaps the last line up of these formidable ladies before the disappearance of the domestic servant was for the Barnett House Evacuation Committee. See, *London Children in War-Time Oxford*, London, 1947.
26. Material in this section comes from, or is calculated from, figures in: The Committee on Higher Education, *Higher Education*, London, 1963, Cmd. 2154. There are various problems, including those of definition. We think that the figures we give here are not to be taken as exact although we think they are of the right order.
27. Franks, op. cit., p. 306. Another factor bearing on personal associations in a variety of ways is residential distribution by social class and educational level. The higher social classes and educational levels were concentrated in central and north Oxford. See, Peter Collison and John Mogey, 'Residence and Social Class in Oxford', *American Journal of*

Sociology, 64, 1959, pp. 599–605. Peter Collison, 'Occupation, Education and Housing in an English City', *American Journal of Sociology*, 65, 1960, pp. 588-97.

28. The figures in lines 4 and 5 of the table have a different base as the questions were put only to those who had claimed an acquaintance. It may be noted too that the question about visits is different from the parallel question about dons, since we asked only about visits received from students and not about visits paid. We assumed that most students would be living in lodgings or university accommodation and it seemed that that the question of visits paid would be unlikely to arise.

29. See Chapter 5.

30. A similar caution needs to be borne in mind in respect of the figures relating to students.

31. Hugh Philp, et al., *The University and its Community*, Sydney, 1964, p. 74. The response to this survey was rather small and it seems possible that the result was biased in the direction of people who might be expected on various grounds to have contact with the University or to be aware of it in some way.

32. See Chapter 6.

33. Dons are not considered here nor are students.

34. There were in addition 231 administrators and librarians on the academic (i.e. for dons) salary scale.

35. We have excluded a number of institutions such as Mansfield College which, although associated with the University in some degree, and in various ways, were not fully part of it.

36. D. E. C. Eversley and J. M. Blackman, 'Student Numbers and Total Town Population', *Universities Quarterly*, Vol., 15, 1961, p. 30.

37. Figures for Oxford include both college and University employees.

Chapter 9

1. See Chapter 8.

2. Canon and Mrs S. A. Barnett, *Practicable Socialism*, London, 1915.

3. See Peter Collison and Edmund Cooney, 'Leadership in Community Associations', *International Review of Community Development*, No. 6, 1960, pp. 163–171. These Community Associations were unusual among voluntary societies in that the leadership was overwhelmingly working class. It may be that leadership from the middle class dons was not welcome.

4. The premises were subsequently occupied by Linacre House, later to become Linacre College.

5. 'No don or student would tolerate for a moment a common room appointed to community centre standards.' Peter Collison, 'Amenity Standards in Community Centres', *Social Service Quarterly*, Vol. 34, 1960–1, p. 107.

6. Widely dispersed in the central and near central parts of the city and occupying much land. See, *Handbook to the University of Oxford*, Oxford, 1969, map facing p. 320.

7. R. C. Whiting, 'Association and separation in the working class 1920–1970', in *Oxford*, R. C. Whiting, (Ed.), Manchester, 1993, p. 156.

Chapter 10

1. Edmund W. Gilbert, *The University Town in England and West Germany*, Chicago, 1961, p. 6.

2. See map, p. 88.

3. See map, p. 90.

4. There are also large sites outside the city for agriculture and associated activities. See map, p. 90.
5. See map, p. 91.
6. The book for the Sheldonian had been discontinued some time prior to the survey.
7. Figures in Table 10.3, column IV for the University Museum, the Sheldonian and the Museum of the History of Science may be compared with those taken from visitors books and given above. Although we cannot assume that everyone signs the visitors book, our survey figures should be lower because they take no account of people below the age of twenty-one, of multiple visits and by visits from people not resident in Oxford. With the exception of the figures for the Sheldonian, which are the same in each case, the figures are indeed lower. The interior of the Sheldonian was renovated in the year prior to our survey. The renovation was much discussed and admired and this must have increased the number of visitors accounting for what seems a surprisingly large number uncovered by our survey. The visitors book at the Sheldonian had been discontinued before our survey. Our figure (1,500) for the Museum of the History of Science is low compared with the figure (7,000) calculated from the visitors book. There is no obvious reason for this although it might be that the Museum has a high proportion of non-local visitors and perhaps numerous visits from school parties and others under the age of twenty-one.
8. See Chapter 2.
9. Excluding six respondents who failed to answer one or both of the relevant questions.

Chapter 11

1. A. H. Halsey and Martin Trow, *The British Academics*, London, 1971.
2. Looking at this matter in a national survey two political scientists commented, '… virtually everyone accepted the conventional class dichotomy between middle and working class … it seems to be deeply rooted in the mind of the ordinary British citizen.' David Butler and Donald Stokes, *Political Change in Britain*, London, 1974, p. 69.
3. Elspeth Huxley, *Love Among the Daughters*, London, 1968, p. 123.
4. Peter Marris, *The Experience of Higher Education*, London, 1964, p. 162.
5. Emlyn Williams, *George*, London, 1961.
6. Dennis Potter, *The Glittering Coffin*, London, 1960.
7. Raymond Hicks, *An Odyssey, From Ebbw Vale to Tyneside*, Newcastle upon Tyne, 2005, p. 152. From distinctly working class origins in early life Hicks performed brilliantly at the University of Wales and went on to a successful career in engineering and industry.
8. A. G. Watts, *Diversity and Choice in Higher Education*, London, 1972, p. 104.
9. William Hayter, *Spooner*, London, 1977, p. 121.
10. C. M. Bowra, *Memories 1898-1939*, London, 1966, p. 336.
11. Hayter, op. cit., p. 110.
12. Op. cit., p. 106.
13. Op. cit., p. 106.
14. Peter Collison and James Millen, 'University Chancellors, Vice-Chancellors and College Principals,' *Sociology*, Vol. 3, January, 1969, pp. 80–81.
15. Class I, professional, etc., occupations (e.g. bank manager, doctor); Class II, intermediate occupations (e.g. librarian, school teacher); Class III, skilled occupations (e.g. postman, police constable); Class IV, partly skilled occupations (e.g. caretaker, gardener); Class V, unskilled occupations (e.g. newspaper seller, lift attendant).
16. GRO, *Classification of Occupations, 1950*, London, 1951.
17. GRO, *Classification of Occupations, 1960*, London, 1960.
18. Halsey and Trow, op. cit., p. 216.
19. Loc. cit. Halsey and Trow place Reading University in their minor redbrick category.

20. Halsey and Trow, op. cit., pp. 217–221.

21. See, Peter Collison and John Mogey, 'Residence and Social Class in Oxford', *American Journal of Sociology*, Vol. 64, 1959, pp. 599–605. Peter Collison, 'Occupation, Education and Housing in an English City,' *American Journal of Sociology*, Vol. 65, 1960, pp. 588–97.

22. University of Oxford, *Report of Commission of Inquiry*, (Franks Report), Oxford, 1966, Vol. 2, p. 396.

23. Committee On Higher Education, *Higher Education*, (Robbins Report), Appendix Two (B), Cmnd. 2154, II–I, London, 1963, p. 4.

24. Op. cit., p. 5.

25. Op. cit., p. 429.

26. Op. cit., p. 430.

27. Op. cit., p. 9.

28. 'Up Schools,' *New Society*, 2 April 1970. Only two and a half percent of children attended public schools.

29. Franks, op. cit., p. 80.

30. Franks, Vol. 1, p. 162.

31. Halsey and Trow, op. cit., p. 216.

32. Robbins, op. cit., p. 429. The proportion for Cambridge was 9 per cent.

33. It was renamed Plater College in 1965 and closed down altogether in 2005.

34. Humphrey Carpenter, *J. R. R. Tolkein. A Biography*, London, 1977, pp. 55–56.

35. Personal communication.

36. Alan Bullock, *Building Jerusalem*, London, 2000, p. 6. Later in life he became a Minister in the Unitarian Church.

37. A. H. Halsey, *No Discouragement*, London, 1996, p. 12.

38. Proceeding of the British Academy. *Biographical Memoirs of Fellows*, IV, Oxford, 2005, p. 133.

39. He was successively student at Ruskin College, undergraduate at Exeter College, research student at Nuffield College, tutor at Ruskin College, research fellow at Nuffield College and finally, university lecturer in the Department of Social and Administrative Studies.

40. Alan Fox, *A Very Late Development*, Coventry, 2004, p. 236.

41. See the observations made in this connection in our Conclusion, pp. 115-122.

42. This could be accounted for by regional differences. Runciman found a difference in class self rating, with manual workers in the north more inclined to describe themselves as working class than those in the midlands and the south. See, W. G. Runciman, *Relative Deprivation and Social Justice*, London, 1966, p. 166.

43. We were not everywhere able to provide the appropriate comparison; in such a case, for example, where a respondent reported himself to be upper middle class and dons as simply middle class. The numbers where we could make comparisons are shown in the table, the percentages are based on these numbers.

44. Some years before our study Oxford had abandoned the senior lecturer grade, although some dons still in 1964 carried the title 'Senior Lecturer'.

45. An advertisement for a tutorial fellowship confirmed this to be the case. See, *The Times*, 30 October 1970. Working from UGC figures Halsey and Trow give for 1964 £3,400–£4,445 as the range for professors. For lecturers they gave £1,400–£1,505. See, A. H. Halsey and Martin Trow, *The British Academics*, London, 1971, p. 178.

46. Dons' earnings as a ratio of the earnings in manufacturing fell substantially in the decades before our surveys. See, Halsey and Trow, op. cit., p. 173.

47. One time Minister for Higher Education.

48. *The Times*, 5 April 1972.

Chapter 12

1. J. M. Mogey, *Family and Neighbourhood*, London, 1956, p. 5.
2. C. Violet Butler, *Social Conditions in Oxford*, London, 1912, pp. 81–8.
3. P. W. S. Andrews and E. Brunner, *The Life of Lord Nuffield*, Oxford, 1954. For an excellent account of Lord Nuffield's impact on Oxford see, R. C. Whiting, *The View from Cowley*, Oxford, 1983.
4. Thomas Sharp, *Oxford Replanned*, London, 1948, pp. 79, 213.
5. These employees seem prototypical 'deferential traditionalists' as described by David Lockwood in his paper, 'Sources of Variation in Working-Class Images of Society', in *Working Class Images of Society*, Martin Bulmer, (Ed.), London, 1975, pp. 19–20.
6. Apart from twelve University members the city council was made up in 1934 as follows: Conservatives 28, Liberals 17, Independents 9, Labour 1, Ratepayers Association 1.
7. The Becontree and Dagenham estate had a population equal to the whole of Oxford and attracted much critical attention. See, Terence Young, *Becontree and Dagenham*, London, 1934.
8. Thomas Sharp, *Town Planning*, Harmondsworth, 1940, p. 88.
9. *Oxford Times*, 10 April, 1964.
10. He is commemorated by the Abe Lazarus Library in Ruskin College.
11. Olive Gibbs, *Our Olive*, Oxford, 1989.
12. Broadcast, BBC Radio 4, 8 November 2004.
13. See, *The Oxford Rent and Housing Scandal. Who is Responsible*, Oxford, 1935.
14. Peter Collison, *The Cutteslowe Walls*, London, 1963.
15. Possessing a car Gordon Walker transported the musical instruments to Cutteslowe for the occasion.
16. In the early 1960s a meeting in Oxford to discuss a local rates issue affecting every household in the City and addressed by a leading government minister, Mr Keith Joseph, was poorly attended. See Chapter 4.
17. Another example of this fine officer's sagacity is provided by the advice he gave Professor Cobb when as an undergraduate Cobb was embroiled in a murder case and facing extradition to the Irish Free State. See, Richard Cobb, *A Classical Education*, London, 1985, pp. 103–4.
18. R. C. Whiting, 'Association and separation in the working class, 1920–1970', in, *Oxford*, R. C. Whiting, (Ed.), Manchester, 1993, p. 154.
19. A. H. Halsey and Martin Trow, *The British Academics*, London, 1971.
20. Op. cit., p. 403.
21. Op. cit., p. 404.
22. Op. cit., p. 402.
23. Op. cit., p. 434.
24. Loc. cit.
25. A. H. Halsey, *Decline of Donnish Dominion*, Oxford, 1992.
26. Op. cit., p. 237.
27. Op. cit., p. 236.

Chapter 13

1. See Chapter 6.
2. Thomas Hardy, *Jude the Obscure*, London, 1951, p. 100.
3. James Attlee, *Isolarion*, London, 2007, p. xvi.

Appendix 1: The Surveys

1. The number of academics at Reading and York seemed too small to justify an attempt to exclude them from the survey. In the event, the name of one member of the academic staff at Reading was chosen. This interview was abandoned. The number of names chosen for Reading was 301, so the abandonment had the effect of reducing the number of attempted interviews in Reading to 300.
2. Over the rates issue (see Chapter 4). The interviewer was an aggressively intelligent young man, highly articulate and talkative and said to be a debating star in the Oxford Union. After this, his first attempt at interview, he decided his talents lay outside the area of social surveys. We did not discourage this view.

Index